RINGLING
THE ART MUSEUM

MITCHELL MERLING

THE JOHN AND MABLE RINGLING MUSEUM OF ART
THE STATE ART MUSEUM OF FLORIDA
2002

This publication was generously supported by the Scott Opler Foundation,
the Woman's Exchange of Sarasota County, The Palmer Foundation, Ina Schnell,
the Kress Foundation, and Walter D. Serwatka and Constance L. Holcomb
with matching funds from the McGraw-Hill Companies Foundation.

Printing and Separations by Serbin Printing, Inc., Sarasota, Florida
Robin K. Clark, Project Director
Judy Webster, Designer
Michael Hamel, Color Separations
Jim Keen, Production Manager

All photography unless otherwise listed by Giovanni Lunardi Photography and Terry Schank.

PUBLISHER'S CATALOGING-IN PUBLICATION DATA

The John and Mable Ringling Museum of Art.
Ringling: the Art Museum/Mitchell Merling.
192p. 26cm.
Includes bibliographical references and index.
ISBN 0-916758-39-7: (paper)
ISBN 0-916758-43-5: (hardcover)
1. Art–Florida–The John and Mable Ringling Museum of Art–Catalogs. 2. The John and Mable Ringling
Museum of Art–Catalogs. 3. Ringling, John 1866-1936–Art collections–Catalogs. I. Title II. Merling, Mitchell.

N742.S5A84 2002 708.15961 Library of Congress Control Number: 2002093780

Dr. Mitchell Merling has been Curator of Art at the Ringling Museum since 1997. A specialist in Venetian art from
1600–1800, he received his Ph. D. at Brown University in 1992. His previous publications include contributions
to collection and exhibition catalogues for the National Gallery of Art, Washington, including *Italian
Paintings of the Seventeenth and Eighteenth Centuries*, 1996 and *The Glory of Venice*, 1994.

FRONT COVER
Detail, Peter Paul Rubens, *The Triumph of Divine Love*, c. 1625, SN 977

BACK COVER
Peter Paul Rubens, *The Triumph of Divine Love*, c. 1625, SN 977

RINGLING
THE ART MUSEUM

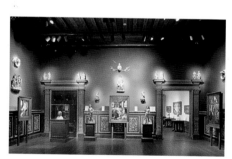

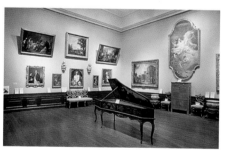

LAST WILL AND TESTAMENT
OF JOHN RINGLING

"I, John Ringling, a resident of Sarasota, in the State of Florida, do hereby make, publish and declare this my last Will and Testament… To the State of Florida, I give, devise and bequeath my art museum and residence at Sarasota, Florida, now respectively known as 'The John and Mabel [*sic*] Ringling Museum of Art' and 'Cad D'a' Zan' [*sic*] together with all paintings, pictures, works of art, tapestries, antiques, sculptures, library of art books, which may be contained in said museum and/or residence or which may properly belong thereto…said museum shall always be known as 'The John and Mable Ringling Museum of Art' without power in any one to change said name…"

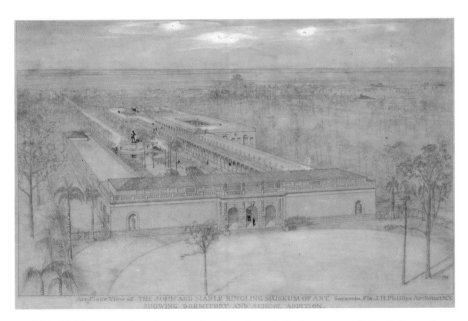

J.H. Phillips, pencil and watercolor drawing of airplane view of The John and Mable Ringling Museum of Art showing dormitories and School addition, 1928.

EXECUTIVE DIRECTOR'S COMMENTS

When he died in 1936, John Ringling left to the State of Florida one of the great art collections in America—displayed in a grand Italianate museum, which he also donated along with his magnificent mansion, the Cà d'Zan (Venetian dialect for "House of John"), and his sixty-six acre estate on Sarasota Bay.

A circus museum was later added by the Museum's first director, A. Everett "Chick" Austin, Jr., to commemorate Ringling's epic place in American culture. Later still, an 18th-century theater from Asolo, Italy, was acquired to provide the grounds an elegant venue for live performances.

In 2000, the State of Florida transferred stewardship of the Ringling to Florida State University, adding to its existing performance center across the street and establishing one of the largest and most unique university cultural facilities in America. This amalgamation formed the FSU/Ringling Cultural Center, an initiative to wed the Ringling's aesthetic and historical assets to the University's performing arts—drama, dance, and music—through collaborations and educational programs.

Our educational mission extends to you, the reader. Not since 1986 has the Ringling Museum published a guide to its collection. This book offers an introduction to the most important paintings, sculptures and objets d'art in our collection, while updating what we have learned about them over the years. If you have visited this magnificent Museum, we hope this guidebook extends the pleasure of your experience. If you have not been here yet, please do come—I am certain you will find the time exceptionally well spent.

John Wetenhall, Ph. D.
Executive Director

AUTHOR'S PREFACE AND ACKNOWLEDGEMENTS

North Corridor of Museum of Art

To enter The John and Mable Ringling Museum of Art is a truly awesome experience. The scope and magnitude of the collection is an overwhelming achievement that must be attributed to a great visionary, John Ringling. It is hoped that this book, the first to illustrate examples from almost every collecting area of the Museum, will enable this unique and profound collection to become better known to both visiting and reading audiences. The images on these two pages reflect the recent reinstallation of the Museum galleries, of which I had the privilege of designing and implementing.

I wish to thank the many individuals and organizations that have assisted me. Thanks must go to Ina Schnell, the catalyst of this project, who through her dedication and generosity brought together the people and resources necessary to turn this book from dream to reality. My colleagues at the Museum have supported me in all ways, including Françoise Hack, Curatorial Assistant; Linda R. McKee, Head Librarian; and Deborah Walk, Curator of the Circus Museum and Historical Resources; they have provided invaluable assistance and stimulating conversations. Françoise, Linda, Aaron De Groft, Ph. D., Deputy Director and Chief Curator; and Constance L. Holcomb, Publisher; read the manuscript numerous times, made valuable suggestions and saved me from major errors (though remaining ones are entirely my own).

Rebecca Engelhardt and Heidi Taylor, of the Collections Management Department, assisted with records and coordination of images. New photography was specially commissioned from Giovanni and Chris Lunardi and Terry Schank. Thanks to Chief Conservator Michelle Scalera for conservation and examination of works in this book. The comments of Preparator Joseph Arnegger; Conservation Technician Dave Piurek; and Chris Sampson provided artists' perspectives. Grants for this project were written by Paula Parrish, Manager for Institutional Giving; and Lee Bosserman. The Education Department also assisted with the example of its endeavor to bring these distant works to a popular audience.

Special thanks are due to Museum volunteers who did admirable research on works of art as part of the Docent Liaison program: Rhea Andrews, Mary Donikian, Gerry Enck, Jane Peterson, Janet Robinson, Nan Russell, Barbara Sweeney and Dina Whitney. Marvita Badenhausen is fondly remembered for her special contribution. Volunteers Jan Silberstein and Shirley Marein and student interns Emily Guttridge, Kelly Dart, James Glisson, Kathy Short, Erica Spruill, Lana Burgess and Amanda Speight are very deeply appreciated.

Other thanks must go to scholars and colleagues from other museums who are too numerous to name, as well as former Ringling staff members Leslie Ahlander, Cynthia Duval, Joseph Jacobs, Mark Ormond and Laurie Ossman. Community members who assisted this project include Annie Solomon, Corcaita Cristiani, Jill Strode, Dr. Arthur Ancowitz, Ina Schnell and Jim Peebles of The Scott Opler Foundation. Jill Chamberlin, Special Assistant to the President, FSU, facilitated many processes.

The entire manuscript was professionally edited by Frank Stephenson. Robin Clark and her staff at Serbin Printing, including designer Judy Webster, did an amazing job. Funding for this project came from public and private sources, including Dr. Malcolm and Mrs. Toby Bick, Kajak, Inc., Mrs. Anne Bladstrom, Mrs. Gioia Brock and Dr. Arland Christ-Janer. Major support for this publication was provided by the Scott Opler Foundation, the Woman's Exchange of Sarasota County, The Palmer Foundation, Ina Schnell, the Kress Foundation, and Walter D. Serwatka and Constance L. Holcomb with matching funds from the McGraw-Hill Companies Foundation.

Mitchell Merling, Ph. D.
Curator of Art

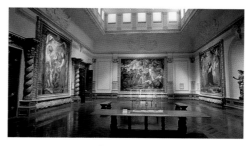

Rubens Gallery

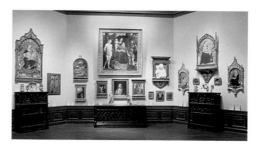

Italian Renaissance Gallery

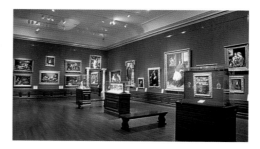

Italian Baroque Gallery

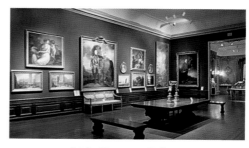

18th-Century Gallery

JOHN RINGLING (1866–1936) was born in McGregor, Iowa, on May 31, 1866, the sixth of seven surviving sons and daughter born to August and Marie Salomé (Juliar) Ringling. Five of the brothers joined together and started the Ringling Bros. Circus in 1884.

Although John began his career performing as a clown, he quickly moved to overseeing the circus route. The acquisition of the Barnum & Bailey show in 1907 made the Ringling brothers a dominant force in the American circus scene. Profits from this boom period of the circus gave Ringling the initial wealth he then invested in railroad lines, Western Oil and some thirty other business enterprises. He also invested in Madison Square Garden in New York and became a member of the board of directors.

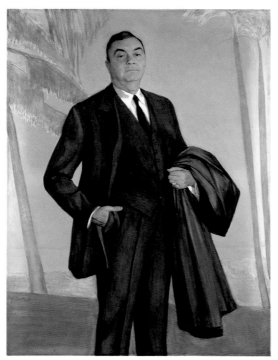 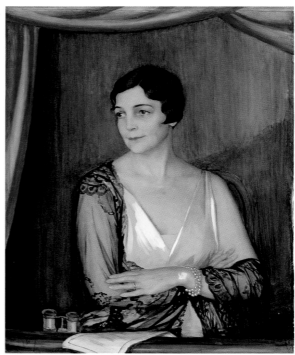

Fig. 1 **Savely Sorine**
Russian, 1878–1953
Portrait of John Ringling, 1927
Watercolor on paper, 61⅛ x 45⅜ inches
Bequest of John Ringling, 1936, SN 413

Fig. 2 **Savely Sorine**
Russian, 1878–1953
Portrait of Mable Ringling, 1927
Watercolor on paper, 37 x 30 inches
Bequest of John Ringling, 1936, SN 414

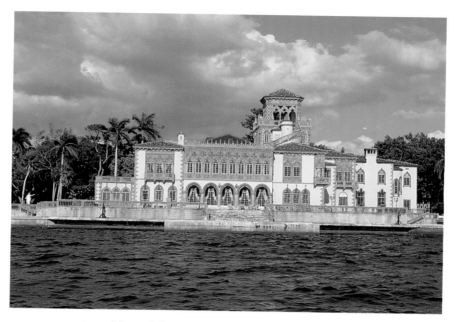

Fig. 3. View of the Cà d'Zan mansion from Sarasota Bay.

In the 1920s, Ringling joined the rush of the Florida land boom, buying and developing land on the Sarasota Keys, later called the Ringling Isles. As the Gulf Coast's most prominent entrepreneur, he attempted to make Sarasota a more fashionable metro-resort than those on Florida's popular east coast. By the mid-1920s, Ringling was listed as one of the twenty wealthiest individuals in the United States.

After his marriage to Mable Burton in 1905, Ringling began quietly accumulating an art collection to display in their homes in New York City; Alpine, New Jersey; and Sarasota. They found in New York's crowded auction rooms a rich source of furnishings, tapestries and paintings from the homes of wealthy and prominent families. In 1924, the Ringlings began construction on their new Sarasota home, Cà d'Zan (Fig. 3). This was also the year John met Julius Böhler, a German art dealer who was a friend of Albert Keller, the General Manager of the Ritz-Carlton Hotel in New York. In the 1920s, the Ringlings, who traveled annually to Europe to locate and audition new circus acts, now began buying art in earnest. By 1925, Ringling hired New York architect John Phillips and set about building his museum (Fig. 4, 5, 6).

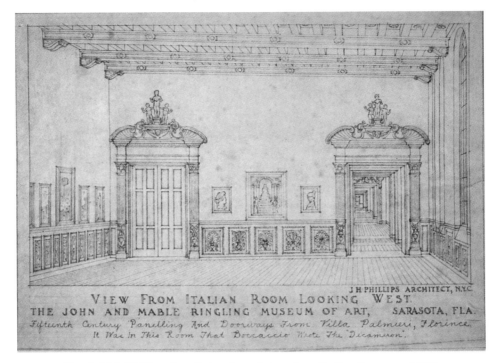

Fig. 4. J.H. Phillips. Pencil drawing of view from Italian Room, c. 1927.

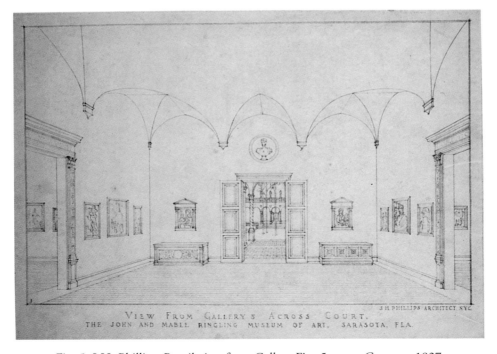

Fig. 5. J.H. Phillips. Pencil view from Gallery Five 5 across Court, c. 1927.

In the spring of 1926, Ringling made two enormous purchases that would not only set the tone of greatness and firmly cement the Old Master scope of the art collection, but also dictate some of the actual shape of the Art Museum. Before the plans were even drawn for the Museum, he purchased three complete rooms designed by Richard Morris Hunt from the Gilded Age Astor mansion located at Fifth Avenue and 65th Street in New York (Fig. 9), along with paintings, furniture and architectural furnishings that he later integrated into the fabric of the Art Museum.

A month after this, Ringling and Böhler acquired from ancestors of the Duke of Westminster at Grosvenor House in London, four immense tapestry cartoons painted on canvas by the Flemish Baroque artist, Peter Paul Rubens (Fig. 7). These large, pedigreed, royal works became the conceptual cornerstone of the art collection and the physical cornerstone of the Art Museum building with their display in the first two rooms of the Museum in Ringling's Rubens Galleries.

In keeping with the theme of greatness in his art collecting, in 1928, Ringling purchased from The Metropolitan Museum of Art in New York, some 2800 objects of Greek, Roman, Cypriot and Egyptian antiquities (Fig. 8). That year he also bought the Parisian Gavet Collection of over 300 examples of Late Medieval through Early Renaissance fine decorative art, sculpture and religious liturgical objects from the Vanderbilts' Marble House in Newport, Rhode Island (Fig. 10).

Besides these large groups of works, between 1925 and 1931 Ringling acquired in total over 600 Old Master paintings from the Late Medieval through the 19th century. They include thirty-three works of art from the Holford sales in London, one of which he personally attended in 1928 (Fig. 14). The excitement surrounding his collecting of major works, such as Rubens' *Pausias and Glycera*, is shown by the coverage it received in such distinguished journals as *Art Digest* (Fig. 13).

Fig. 6. J.H. Phillips. Detail of watercolor and pencil drawing of Museum east entrance façade, 1928.

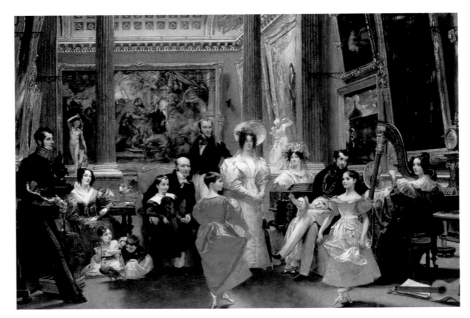

Fig. 7. Cartoons from *The Triumph of the Eucharist* series by Peter Paul Rubens
as seen in an 1831 painting of Grosvenor House, London by Charles Robert Leslie.

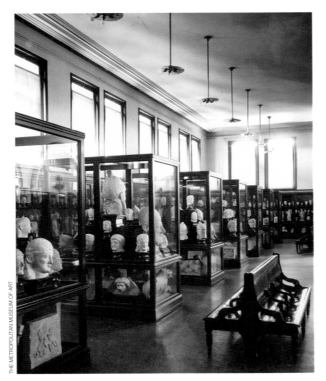

Fig. 8. Limestone and terracotta sculpture
from the Cesnola Collection on display at
The Metropolitan Museum of Art, 1907.

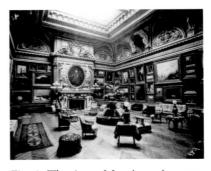

Fig. 9. The Astor Mansion: view east
into the art gallery-ballroom, c. 1907.

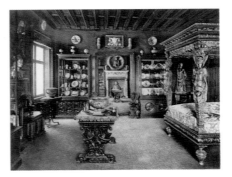

Fig. 10. The Emile Gavet collection
displayed in his Paris apartment. Illustrated
from the 1889 catalogue by Emile Molinier.

The Museum's opening in 1930 garnered international attention and praise. It was the subject of a full-page spread in *The New York Times* (Fig. 12). The author of the article emphasized not only the strength of the collection, but also the beauty and impressiveness of the building and its interiors.

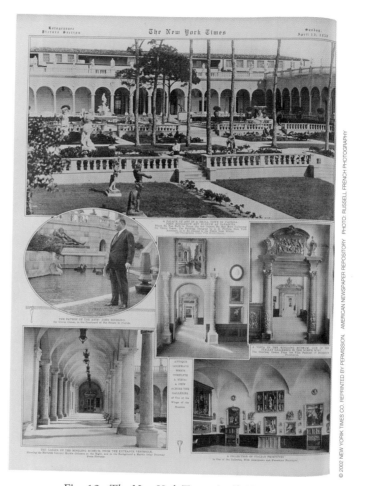

Fig. 12. *The New York Times*, April 13, 1930, rotogravure picture section.

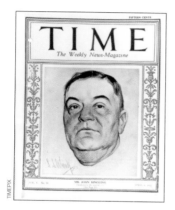

Fig. 11. Cover of *Time* magazine, April 6, 1925 with drawing by S. J. Woolf.

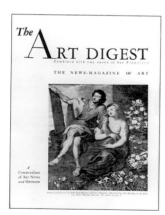

Fig. 13. Cover of *Art Digest* magazine, November 1, 1930, with Peter Paul Rubens' *Pausias and Glycera*, purchased by John Ringling in 1930.

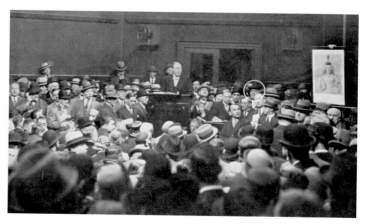

Fig. 14. The second Holford Sale, at Christie's in London, May 15, 1928. John Ringling is identifiable to the right of the auctioneer's podium.

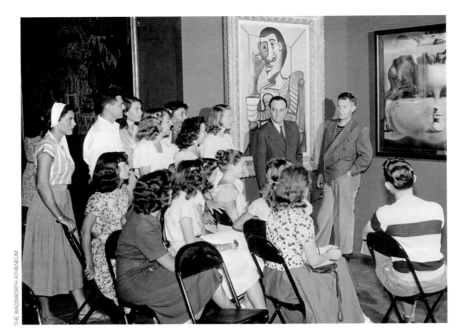

Fig. 15. Julien Levy and Chick Austin discuss 20th-century art with students in the first annual seminar organized in conjunction with Florida State University, at the *Masterpieces of Modern Art* exhibition, Sarasota, April 1948.

Upon John Ringling's death in 1936, he left his legacy to the people of Florida. The Museum and its collection remained subject to litigation over Ringling's estate for ten years. In 1946, the State of Florida formally took possession of the Museum and hired as director one of the most adventurous museum professionals of the 20th century, A. Everett "Chick" Austin, Jr., former director of the Wadsworth Atheneum (Fig. 16). Like Ringling, Austin bridged the worlds of popular entertainment and high art. He not only cultivated friends from the performing arts, such as Bette Davis and George Balanchine (Fig. 17), but emphasized spectacle at the Ringling by purchasing and constructing the Asolo Theater and opening the Circus Museum (Fig. 18 and 19).

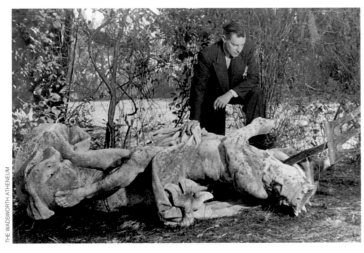

Fig. 16. Chick Austin and *Neptune*, on the grounds of the Ringling Museum, Sarasota, 1947.

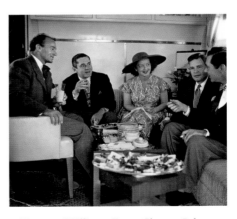

Fig. 17. William Grant Sherry, John Ringling North, Bette Davis, Chick Austin and Henry Ringling North aboard the JOMAR, John and Mable Ringling's private railroad car, c. 1948.

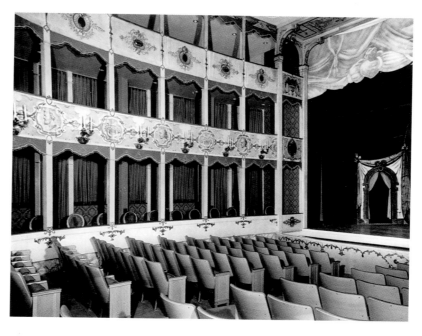

Fig. 18. Interior,
The Asolo Theater,
Sarasota, c. 1958.

However, Austin did not neglect modern art: he brought exhibitions of major works by artists such as Picasso and Dalì to the Museum, and inaugurated public educational programs to bridge the gap between these abstruse-seeming creations and the new audience (Fig. 15). Subsequent directors and curators have expanded and transformed John Ringling's and Chick Austin's dreams and ambitions. The Ringling Museum of the 21st century is internationally recognized not only for its exemplary Renaissance and Baroque paintings and Cypriot antiquities, but also for its Circus Museum, historic mansion, the Koger Collection of Chinese ceramics, decorative arts and a growing 20th-century collection.

Fig. 19. Interior, Museum
of the American Circus,
Sarasota, c. 1948.

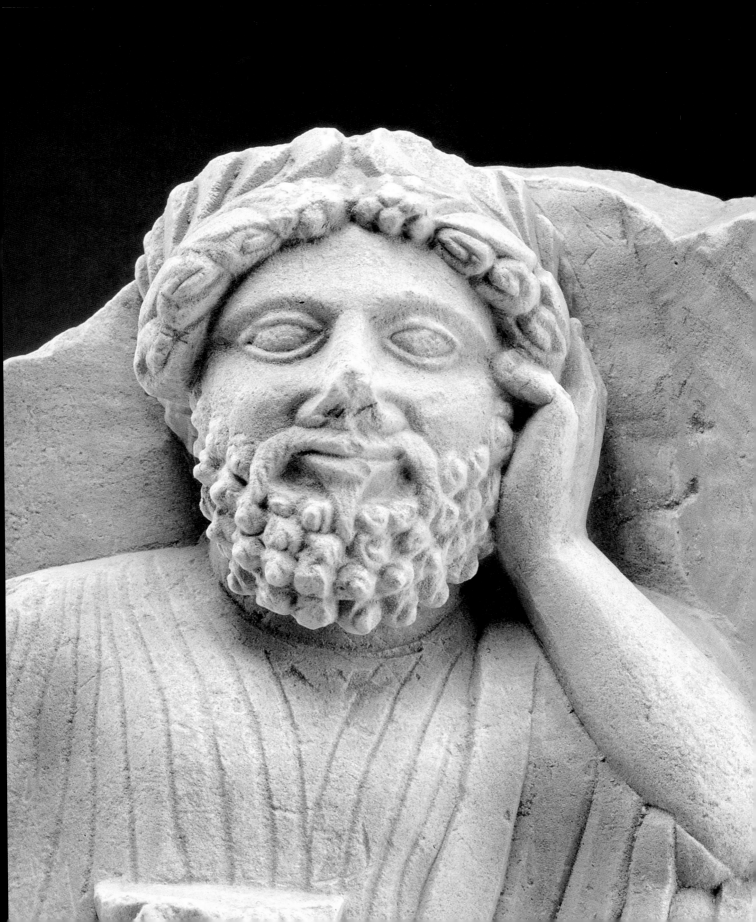

THE ANCIENT WORLD
Antiquities and Cypriot Collection

CYPRUS is an island in the Mediterranean that has always served as a crossroads for cultural and historical forces flowing between the continents of Europe, Africa and Asia. The earliest inhabitants sailed to the island as early as 9000 B.C. In the third millennium B.C. the rich copper resources of the island began to be exploited (giving the island its name). Social organizations became more complex and chiefdoms emerged on the island. In the second millennium B.C. urban centers arose in Cyprus at Enkomi, Kition and elsewhere—possibly due to increasing trade with Egypt, the Levant, and the Minoan and Mycenaean cultures of the Aegean.

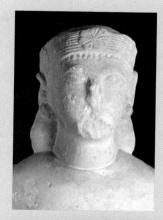

Around 1200 B.C., an influx of refugees from the Aegean established a Hellenic presence on the island. To this day, the inhabitants are still mainly Greek-speaking. In the 10th century B.C., Phoenician (modern-day Lebanon) colonists set up communities on southern Cyprus. In subsequent centuries, the Greek and Phoenician kingdoms of Cyprus fell under the sway of the Assyrians, the Egyptians and the Persians. Cyprus then became a part of the Macedonian Greek kingdom of Ptolemy, one of the generals of Alexander the Great. When the last Ptolemaic monarch—Cleopatra—and her ally Mark Anthony were defeated by Octavian of Rome in 31 B.C., Cyprus became part of the Roman Empire.

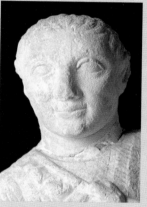

The core of the Ringling Museum's important collection of classical antiquities was formed by John Ringling's sensational purchase in 1928 at auction of a large number of works from The Metropolitan Museum of Art, New York. This purchase was the first sale of ancient art to make front-page news and added credibility to Ringling's plans to create a world-class art museum in Sarasota. "General" Luigi Palma Di Cesnola, American Consul to Cyprus, collected these works during the 1860s and 1870s. A flamboyant self-promoter, Cesnola became the first director of The Metropolitan Museum of Art in 1879, and his collection of Cypriot antiquities was the showpiece of that institution when it opened its doors on Fifth Avenue. John Ringling not only sagaciously bought at one stroke a comprehensive survey of a major Mediterranean culture, he also doubtlessly realized the cachet and publicity the purchase would bring to his plans for the Museum. He may well have also appreciated the playful spirit that Cypriot artists lavished upon their sculpture and vase-painting for over 4,000 years.

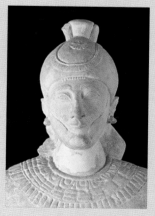

CYPRIOT POTTERY

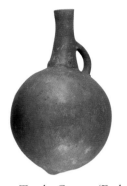

Lapatsa Tomb, Cyprus (Early Cypriot: about 2,500 B.C.)
Jar
Ceramic (Red Polished Ware),
19 ¾ x 12 x 12 inches
Museum acquisition, 1974, SN 74.30

In 1965, the Ringling Museum commissioned Dr. J. R. Stewart to undertake an excavation on the Lapatsa Tomb 15 on the northern coast of Cyprus. Excavations were completed in 1972 and part of the collection came to the Museum in 1974.

This tomb group shows pottery from the earliest phase of the Bronze Age in Cyprus (c. 2500 to 1050 B.C.). In this period, the pottery was made by hand, not thrown on a wheel, and the main ceramic types were Black and Red Polished wares. The example shown here is Red Polished Ware of the earliest type. Although this spouted container has no painted or incised decoration, its perfectly round globe shape impresses with its simplicity and strength as well as inspires admiration for the skill of the potter.

Most Cypriot pottery resembles standard types of other Mediterranean pottery traditions in their shapes and decoration. The most distinctive attribute of Cypriot pottery is creativity and humor—well evident in the examples here. A typical jug for carrying water is transformed into a highly original and witty form by having the spout decorated to resemble a woman carrying a similar jug. Also whimsical are the spouted vessels (*askoi*) in the shape of animals. Illustrated below are examples resembling an unknown animal decorated with reliefs representing its offspring, a duck and a ram.

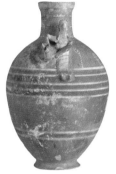

Cyprus (Cypro-Classical: 450 to 400 B.C.)
Jug with Spout (protome) of a Woman Holding a Jug
Ceramic (Bichrome Red Ware),
14 ½ x 8 ½ x 8 ¾ inches
Bequest of John Ringling, 1936, SN 28.625

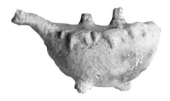

Cyprus (Middle Cypriot:
1725 to 1650 B.C.)
Animal Shaped Vessel (askos)
Ceramic (White Painted Ware),
4 1/16 x 6 ¾ x 3 ⅜ inches
Bequest of John Ringling,
1936, SN 28.50

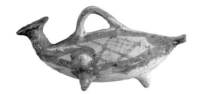

Cyprus (Cypro-Geometric:
950 to 850 B.C.)
Duck Shaped Vessel (askos)
Ceramic (White Painted Ware),
3 ⅞ x 7 ½ x 3 ½ inches
Bequest of John Ringling,
1936, SN 28.381

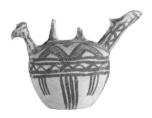

Cyprus (Middle Cypriot:
1725 to 1650 B.C.)
Ram's Head Shaped Vessel (askos)
Ceramic (White Painted Ware),
4 ½ x 6 x 3 ¼ inches
Bequest of John Ringling,
1936, SN 28.94

AMPHORAE

Amphorae were large ceramic vessels used in antiquity as containers for commodities such as oil, olives and wine. They were made in two distinct types. Transport amphorae were regularly shipped to ports of call throughout the Mediterranean. They were pointed at the bottom to stack them more efficiently on board ships. Later, during Roman times, the handles of these transport amphorae were stamped with official seals to verify their contents—as in this example. Storage amphorae could have either pointed or flat bottoms but unlike the transport amphorae that had small necks to prevent spillage and to keep pests out of the commodities, these had larger openings for ease of serving. They were usually decorated—as here—with elaborate geometric patterns.

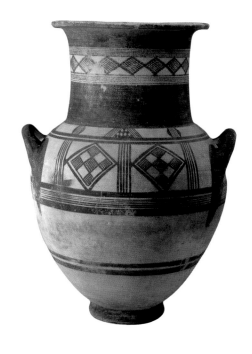

Mediterranean,
about 2nd century B.C.–1st century A.D.
Transport Amphora
Ceramic
31½ x 12½ x 12½ inches
Bequest of John Ringling, 1936, SN 28.1040

Cyprus (Cypro-Archaic I),
about 750–c. 600 B.C.
Storage Amphora
Ceramic (White Painted Ware)
30½ x 21½ x 20 inches
Bequest of John Ringling, 1936, SN 28.154

SCULPTURE

During the Cypro-Archaic period (750 to 475 B.C.), large-scale sculpture made of readily available local limestone first appeared. Erected as lasting offerings near temples, the statues represented either the worshipper (also called a votary) or the deity worshipped. Many (as is presumed in the bearded man, right) depict soldiers, a group especially desirous of divine protection. Others, such as the seated "temple boy," served an unknown function—possibly relating to fertility or to the protection of male children by the gods. The examples on this page demonstrate the range of foreign styles and motifs including Phoenician, Egyptian, Cretan and Greek employed by Cypriot sculptors.

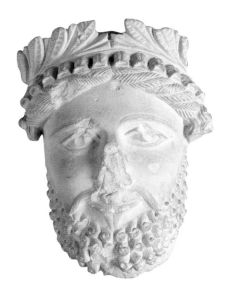

Cyprus (Cypro-Archaic: 560 to 480 B.C.)
Head of a Bearded and Wreathed Man
Limestone (with traces of polychrome),
12 x 9⅜ x 5⅛ inches
Bequest of John Ringling, 1936, SN 28.1757

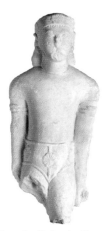

Temple Golgoi, Cyprus
(Proto-Cypriot: 560–520 B.C.)
Male Figure in the Cretan Style
Limestone,
18⅜ x 7¾ x 4¾ inches
Bequest of John Ringling,
1936, SN 28.1749

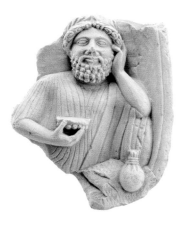

Cyprus (Cypro-Classical:
400 to 300 B.C.)
Relief of a Banqueter
Limestone,
17¼ x 15 x 6⅞ inches
Bequest of John Ringling,
1936, SN 28.1910

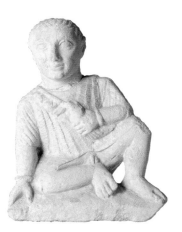

Cyprus (Hellenistic: about
325–50 B.C.)
Seated Temple Boy
Limestone,
12 x 9¼ x 4½ inches
Bequest of John Ringling,
1936, SN 28.1909

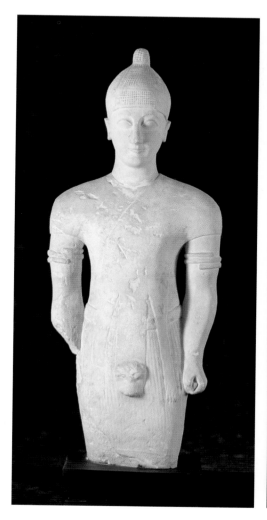

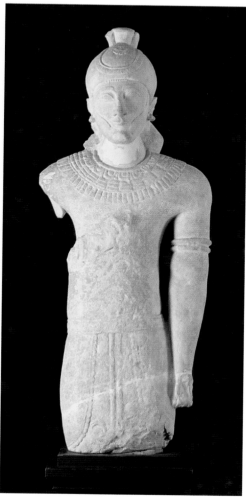

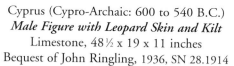

Cyprus (Cypro-Archaic: 600 to 540 B.C.)
Male Figure with Leopard Skin and Kilt
Limestone, 48½ x 19 x 11 inches
Bequest of John Ringling, 1936, SN 28.1914

Cyprus (Cypro-Archaic: 560 to 520 B.C.)
Male Figure with Egyptian Headdress
Limestone, 50 x 20 x 10¼ inches
Bequest of John Ringling, 1936, SN 28.1913

These are the two most impressive full-length and life-size ancient statues in the Ringling collection. Although these figures are dressed in foreign-style clothing, they reflect the influence of Archaic Greek statuary in their stylized poses, symmetrical composition and half-smiles. Purists usually disparaged such sculptures because they were mixtures of costume styles and sculptural conventions and thus, did not consistently reflect a single culture. This view does not take into account their historical interest as testaments to the cross-fertilization of cultures in the Mediterranean world, nor does it do justice to the exceptional quality of the sculptures themselves which have a warmth that is sometimes lacking in "purer" examples.

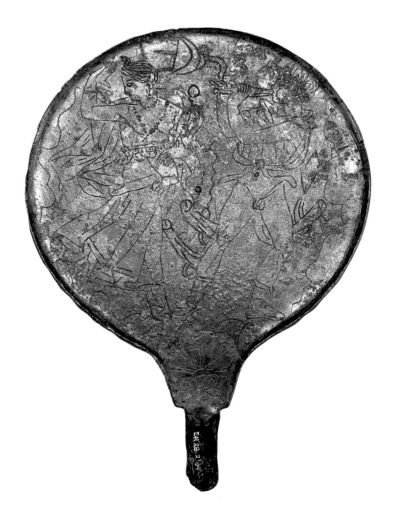

Italy (Etruscan: about 300 B.C.)
Mirror Depicting Dancers
Bronze, 8⅜ x 6 x ⅛ inches
Bequest of John Ringling, 1936, SN 28.2164

This erotically decorated mirror was made in Southern Italy (Eturia). Fanciful and elaborate mirrors such as this not only served everyday use but also often followed their owners to their tombs. Though age and dirt have discolored the metal, it was originally shiny and bright with its incised ornamentation easily visible. The decoration shows a Dionysiac scene of a dancing *maenad* (female follower of Dionysus) and a satyr playing the double pipes. The satyr wears a cloak of phalluses, which (though its purpose has not been fully explained) doubtlessly alludes to fertility rituals.

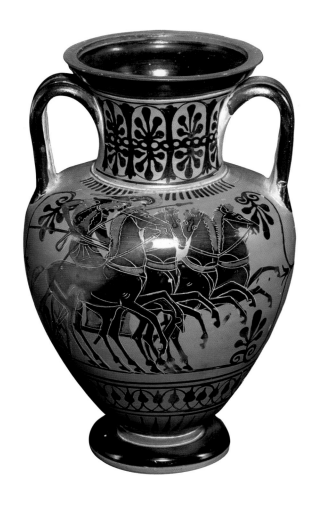

Attributed to the **Edinburgh Painter**
Greek (Classical: about 500 to 480 B.C.),
Amphora Depicting a Chariot, Two Warriors, an Old Man, and a Woman
Black-figure ceramic, 10½ x 6½ x 6½ inches
Gift of Manual Ortiz, Jr., SN 1487

The black-figure technique of decoration was perfected in Athens during the sixth century B.C. The Edinburgh Painter was a late practitioner of this style and used a mixture of red-figure technique and white paint in some details. This vase shows a lively *quadriga* (four-horse chariot) carrying armored figures on the main face while the reverse shows a conclave of warriors and civilians or gods. The painter's skill is exemplified in the quick-paced movement of the horses and their excited expressions.

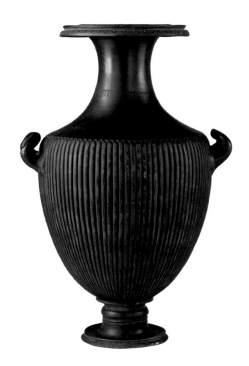

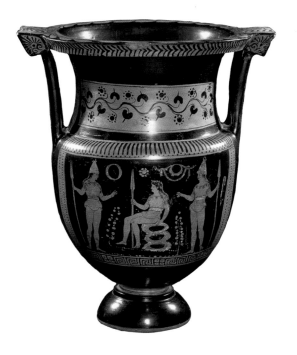

Athens, Greece (Late Classical: about 350 B.C.)
Water Jar (Hydria)
Ceramic (Black-Glazed Ware),
18 x 11¼ x 11¾ inches
Bequest of John Ringling, 1936, SN 28.836

A *hydria* is a vessel for carrying water. In Athens red-figured decoration gradually gave way to plainer, black-glazed wares in the fourth century B.C. Many of the elegant black-glazed vases imitate the shapes and details of more valuable metal vases and mirror the sheen of silver vessels in their glossy surfaces. How far in sophistication Mediterranean culture traveled from the simplicity and forthrightness of the Bronze Age Cypriot example, on page 18, while retaining the values of elegance and utility.

Attributed to the **Varrese Painter**
Italy (Apulia, active mid-fourth century B.C.)
Column Krater
Red-figure ceramic, 22 x 18 x 15½ inches
Gift of Mrs. Charles J. Espenshade, 1964, SN 1693

A *krater* is a large vessel for mixing wine and water. This type is named after its column-like handles. The decoration of this face of the vase shows a seated Amazon (or perhaps Oscan) warrior with two attendants. Apulia was a prosperous Greek settlement in Southern Italy. Its pottery types mimicked those of mainland Greece but were painted with greater freedom and more elaborate decorations and form, evident in this example's exuberant floral decoration and freely handled drawing.

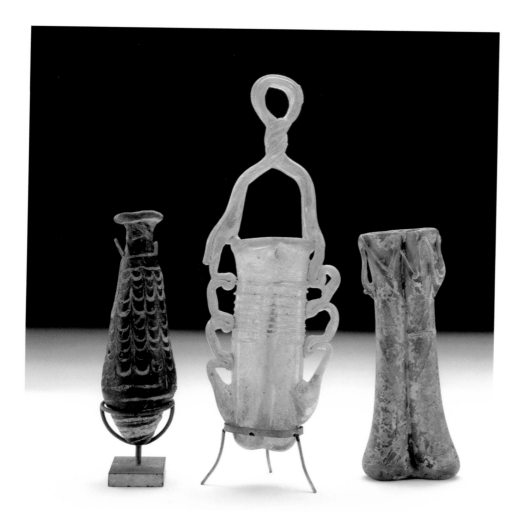

Mediterranean	Roman Empire	Roman Empire
(Fourth Century A.D.)	(Fourth Century A.D.)	(Fourth Century A.D.)
Alabastron	*Double Unguentarium*	*Double Unguentarium*
Core formed blue glass with white glass threads in a scallop pattern, h. 4⅝ inches	Blown blue-green glass with added glass threads, h. 4⅞ inches	Blown blue-green glass with high twisted glass handle and applied glass threads, h. 4 inches
Bequest of John Ringling	Bequest of John Ringling,	Bequest of John Ringling,
SN 28.1562	SN 28.1474	SN 28.1439

Ringling purchased almost 100 ancient glass pieces from the collection of The Metropolitan Museum of Art at the same 1928 sale at which he bought the Cypriot material. These were collected by the famous French archaeologist Julien Gréau and given to the Metropolitan by J. P. Morgan. Ancient glass was made by two techniques illustrated here. Core-formed glass was a heavy glass painstakingly formed on an iron core. Blown glass was a later innovation capable of being more freely shaped, clearer in color, but also was decorated with additional strips of melted glass. The shapes of the examples illustrated here were used to hold ointments and perfumes.

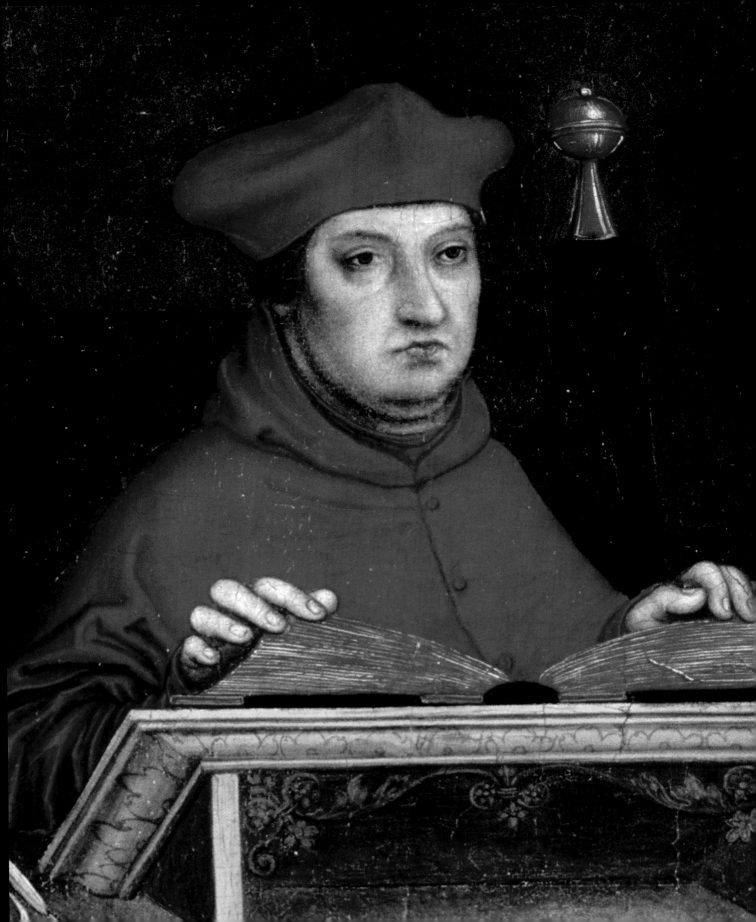

THE RENAISSANCE IN NORTHERN EUROPE
The Age of Cranach

DUTCH, Flemish and German art shared many common characteristics from the Middle Ages until Northern Europe was divided by religious differences in the middle of the 16th century. During that time, art of these regions was usually Catholic and predominantly produced for the purpose of devotion. *The Virgin and Child in an Apse* by a follower of Robert Campin is one example of such work.

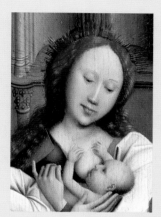

In style, early Renaissance art in Northern Europe followed traditions established during the Middle Ages in the French courts of Burgundy. The early 16th-century elaborate wood sculpture of the Virgin in this chapter derived its style from the monumental Gothic stone sculpture of cathedral façades. The early Austrian painting, *A Family Group Adoring the Veil of Veronica*, followed precedents found in precious and elaborate manuscript illumination.

Northern European Renaissance style was primarily naturalistic in detail and highly decorative in design. The motifs were often derived from animals or vegetation. Some of the works during this period also show the beginnings of influence from the idealized and classical art of Renaissance Italy. For example, Cornelis van Cleve's *Nativity* shows the direct influence of Raphael.

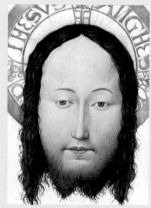

In the middle of the 16th century, however, Northern Europe was divided by politics and religion into Catholic and Protestant territories. Beginning in 1568, the Protestant Northern Netherlands, generally called Holland, began the revolt against its Spanish Catholic rulers in the Southern Netherlands.

These political and religious conflicts were then reflected in the artistic expression of these lands, and they no longer shared artistic characteristics of the early Renaissance. Lucas Cranach, an artist in the Protestant camp, portrayed the leader of the Protestant Reformation many times. However, he also served Catholic masters, such as Cardinal Albrecht of Brandenburg, whose portrait is one of the highlights of the Ringling Museum.

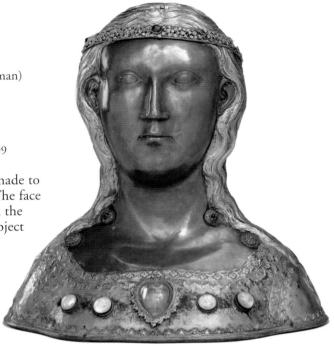

Northern Europe (Franco-Flemish or German)
15th century
Head Reliquary
Copper-gilt and semi-precious stones,
15¾ x 14¹⁵⁄₁₆ x 8½ inches
Bequest of John Ringling, 1936, SN 1099

This exquisite object is an elaborate casing made to hold relics of an unidentified female saint. The face was originally painted to resemble flesh, and the remains were placed inside the head. This object may have been made in Cologne, Germany, and perhaps it represented the virgin martyr St. Ursula, patron saint of that city.

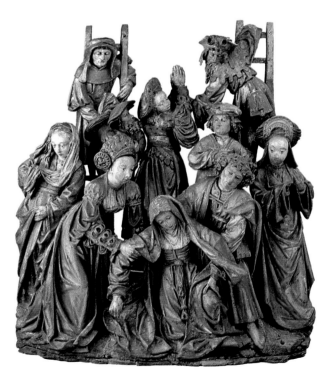

Southern Netherlands
Early 16th century
The Virgin Fainting at the Deposition
Polychromed and gilded wood,
24⅜ x 22 x 8 inches
Bequest of John Ringling, 1936, SN 1580

This sculpture was part of a large multi-paneled altarpiece. Such altarpieces typically measured over ten feet high and sometimes contained scores of painted and sculpted scenes. Even as a single panel apart from the whole altarpiece, this relief shows how such small finely carved figures achieve monumentality, movement and emotion. The Virgin's grief at the death of her Son is vividly expressed in her posture and agitated drapery.

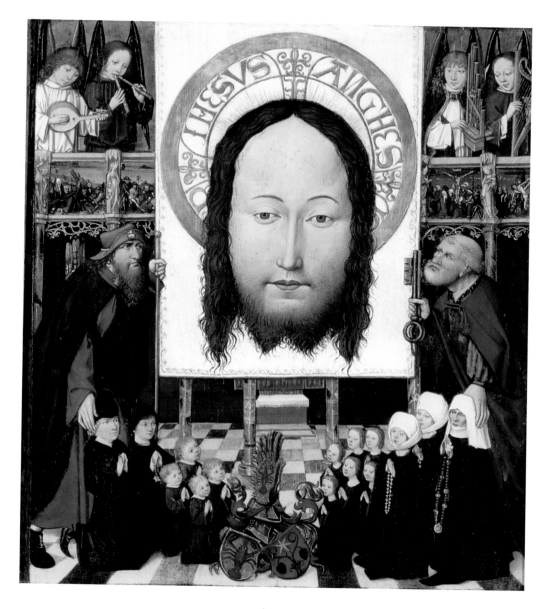

Austria
Late 15th century
A Family Group Adoring the Veil of Veronica, c. 1490
Oil on panel, 31½ x 27 inches
Bequest of John Ringling, 1936, SN 304

This Austrian painting demonstrates very well the devotional function of art in the early Renaissance period. A family worships in a church-like setting protected by St. James and St. Peter. They are being shown a representation of the Veil of Veronica, a miraculous veil considered to depict the first true likeness of Christ. Above the family, angels play music from the carved balcony. The frieze carvings on the railing resemble the style of the sculptural relief of *The Virgin Fainting at the Deposition* on the opposite page.

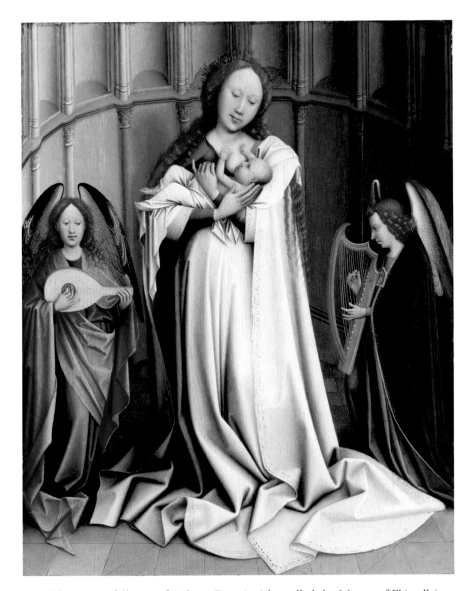

16th-century follower of **Robert Campin** (also called the Master of Flémalle)
Early Netherlandish, c. 1377–1444, active in Tournai
Virgin and Child in an Apse, c. 1539
Oil and tempera on panel, 18⅛ x 13⅞ inches
Bequest of John Ringling, 1936, SN 196

This is one of more than thirty nearly identical panels that replicate a painting made around 1425 in the workshop of the famous Flemish painter Robert Campin. Scientific analysis of the wood in this panel reveals that it dates to about 1539, over 100 years after the original. The existence of so many copies of this famous image gives testimony to the excellence of Campin, while also demonstrating the importance of this particular type of image in private devotional prayers. This image was especially popular with followers of St. Birgitta, a 14th-century Swedish mystic theologian who encouraged communion with the Divine through the contemplation of certain images.

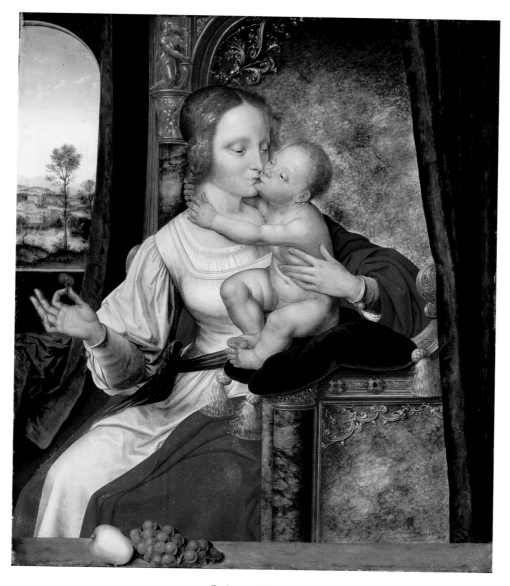

Quinten Metsys
Early Netherlandish, 1465–1530, active in Antwerp
Madonna of the Cherries, 1520s
Oil on panel, 29½ x 24¾ inches
Bequest of John Ringling, 1936, SN 200

In this enchanting picture, Quinten Metsys contrasted the simple intimacy of the kissing and playful mother and child with the imposing carved and gilded marble throne on which they sit. The apple and grapes on the ledge no doubt refer to man's fall, as in Adam eating the apple, and to salvation, as in the grapes of Eucharist wine. The cherries represent the fruit of heaven. The picture may represent the Virgin and Child together in a privileged realm; they alone were exempt from original sin. Compare this with the follower of Campin's painting on the opposite page. Metsys evolved a more classical type of feminine beauty while retaining the freshness of emotion characteristic of earlier Northern art.

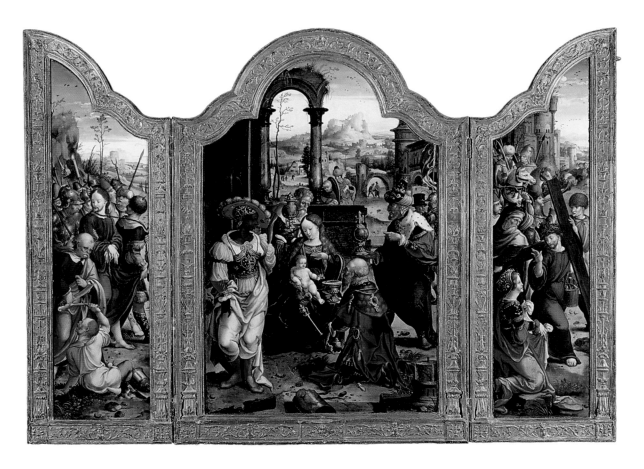

Circle of **Pieter Coecke van Aelst**
Early Netherlandish, 1502–1550, active in Antwerp
Triptych: *Christ Arrested in the Garden of Gethsemane* (left),
The Adoration of the Magi (center),
Christ Carrying the Cross (right), 1520s
Oil on three shaped panels, 36 x 40¼ inches
Bequest of John Ringling, 1936, SN 203

This three-paneled altarpiece poignantly juxtaposes episodes from the beginning and
end of Christ's life. The central panel shows the Christ child adored by three kings who,
according to tradition, represent regions of the earth: Europe in the foreground, Africa
on the left, and Asia on the right. The outer panels show Christ's arrest and the walk to
His execution. The artist carefully exhibits His dignity and calm, in sharp contrast to the
ugliness and brutality of His tormentors. The artist has attempted to evoke Antiquity
with elaborate settings and costumes, even though a typical northern landscape is in
the background. When closed, the panels show an Annunciation scene, which is the
announcement of Christ's conception. It is painted in *grisaille*, a technique of painting
in tones of gray to imitate sculpted reliefs.

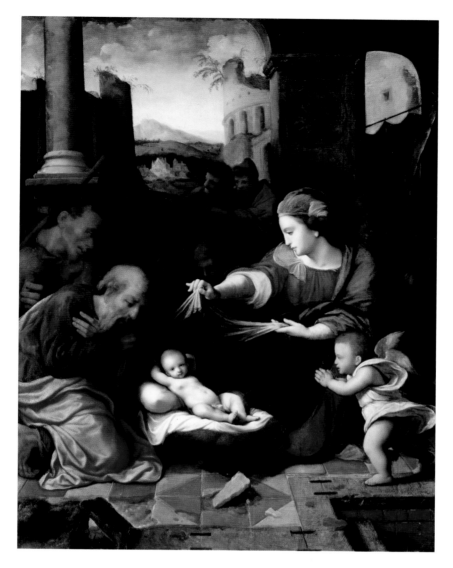

Cornelis van Cleve
Early Netherlandish, 1520–1574, active in Antwerp
Nativity, c. 1540
Oil on panel, 42⅞ x 32⅝ inches
Bequest of John Ringling, 1936, SN 201

The supremely beautiful and serene Madonna lifts a veil to display the amusingly self-confident Christ child. They are in a setting of grandiose ruins including a structure that recalls the Roman Coliseum. Although Cornelis van Cleve may never have traveled to Italy, he sought monumentality comparable to that of Italian Renaissance masters. In fact, he based this composition on a Madonna by Raphael. If one compares Van Cleve's treatment of the figures with the same group in the *Adoration* panel on the opposite page, it seems immediately evident that Van Cleve is more interested in the figures, their personalities and interactions than in the elaborate theatricality of the scene as a whole.

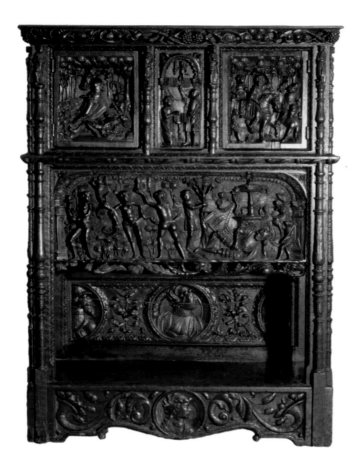

These Renaissance furniture pieces are typical of northern 16th-century style, a blending of classical and medieval forms. The cupboard, in particular, shows the mixture of religious and secular imagery. A powerfully carved Annunciation group is in the center of the upper register, while below, the mythological subject of the Judgment of Paris is observed. This depiction is most amusing because Paris is anachronistically shown as a medieval knight and the goddesses as Renaissance ladies.

Northern Europe
16th century
Chair
Wood, 48 x 21⅜ x 20 inches
Bequest of John Ringling,
1936, SN 1525

Northern France
First half of the 16th century
Cupboard
Walnut, 57¹⁵⁄₁₆ x 42⅜ x 17 inches
Bequest of John Ringling, 1936, SN 1068

The Ringling Museum has an exceptional group of Renaissance furniture and sculpture originally collected by the Parisian 19th-century collector, Emile Gavet. When it later belonged to the Vanderbilt family, it was displayed at Marble House, their Newport, Rhode Island mansion. John Ringling acquired the Gavet collection from Alva Vanderbilt Belmont in 1928.

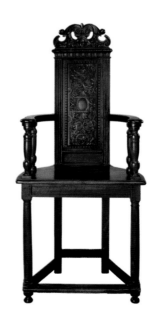

Jan Mertens the younger
(also called Jan van Dornicke and "The Master of 1518")
Early Netherlandish, active in Antwerp, c. 1510/20
Adoration of the Magi, 1520s
Oil on panel, 48 x 32 inches
Gift of Mr. Karl A. Bickel, 1973, SN 927

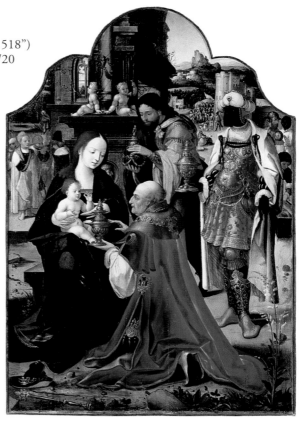

The "adoration of the magi" was a favorite subject of Early Netherlandish artists who favored the elaborate and elegant style of painting now called "Antwerp Mannerism." This painting exhibits an influence of the classical revival in Italian Renaissance art on Flemish painters, as in the ornate classical architecture and the detailed armor of the Moorish magus. Notice the difference between the idealized face of the Virgin in this painting and the plainer features of the *Virgin and Child in an Apse* by the late follower of Robert Campin on page 30. It is not surprising that this painting is similar in style to the triptych on page 32 by an artist from the Coecke van Aelst circle, since Mertens and Coecke were related by marriage.

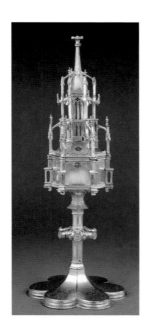

Germany (Cologne)
15th century
Ciborium
Gilt-copper, 17 inches
Bequest of John Ringling, 1936, SN 7076

Elaborate gold vessels, called *ciboria*, were used for the preservation and display of the consecrated bread, or Host, for the Mass. They were produced in quantity during the late–Gothic period, just prior to the Renaissance. As this example illustrates, these precious objects mimic the architectural forms of the great churches of the same period. A similar architectural monstrance in which the Host is displayed in a container of glass is shown in the 17th-century painting by Peter Paul Rubens, *The Defenders of the Eucharist*, on page 115.

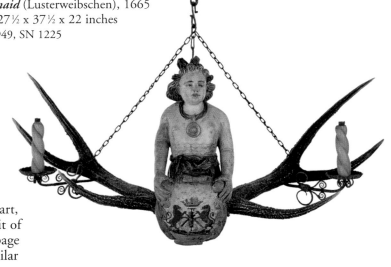

Germany
17th century
Hanging Lamp in the Form of a Mermaid (Lusterweibschen), 1665
Polychromed and gilded wood, 27 ½ x 37 ½ x 22 inches
Museum purchase, 1949, SN 1225

Hanging lamps in the form of mermaids were commonly made in Renaissance Germany for important places such as guild halls. A. Everett Austin, Jr., the first director of the Ringling Museum, who served from 1946 to 1952, bought this example. Austin, widely recognized for his imaginative approach to presenting art, thought to enliven Cranach's portrait of Cardinal Albrecht on the opposite page by juxtaposing it with an object similar to one in the painting.

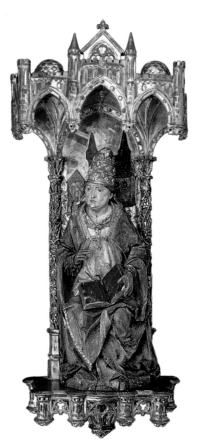

Germany
Late 15th century
Saint Gregory
Polychromed and gilded wood in an elaborate niche,
35 ½ x 14 ¼ x 8 inches
Bequest of John Ringling, 1936, SN 5030

This carving of St. Gregory is similar to Cranach's portrait of Albrecht. Both pieces of art depict seated clerics in the act of writing. Here, the highly individualized features of St. Gregory are an indication of the artist's extreme naturalism, even though this statue is not known to be a portrait and is unlikely to have represented a living person.

Lucas Cranach I
German, 1472–1553, active in Saxony
Cardinal Albrecht of Brandenburg as Saint Jerome, 1520s
Oil on panel, 45 ¼ x 35 ¹⁄₁₆ inches
Bequest of John Ringling, 1936, SN 308

During the Renaissance, St. Jerome was considered the archetype of the religious scholar. Although he had been a cardinal, he retired from his church career to translate the Bible into Latin. This panel shows a cleric from Renaissance Germany, Cardinal Albrecht of Brandenburg, in the guise of St. Jerome. Portraits in which individuals represented themselves as religious or mythological figures informed the viewer not only of the physical appearance, but also of the beliefs and values of the sitter. It is ironic that Cranach portrayed Albrecht so many times— Cranach was the artist closest to Martin Luther (1483–1546), while Albrecht was one of Luther's fiercest religious opponents.

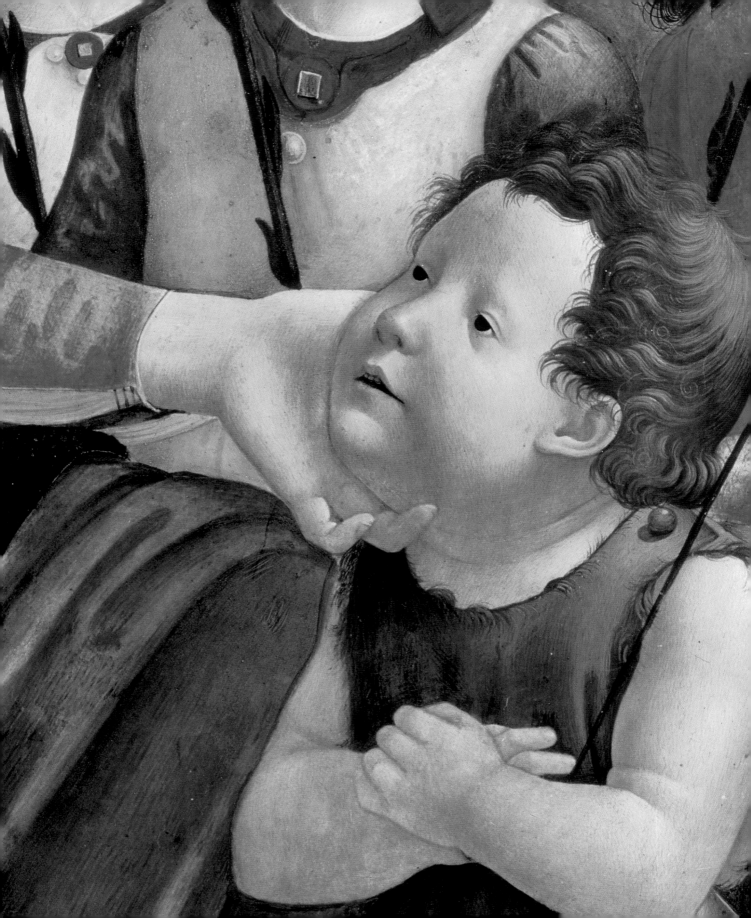

THE RENAISSANCE IN CENTRAL ITALY

From the Age of Giotto to the Age of Michelangelo

RENAISSANCE ART in Italy evolved over a period of 300 years from a highly artificial and stylized art in the 14th century, during the time of Giotto and Cimabue, to the fully monumental and classical art of the High Renaissance beginning in the first half of the 1500s.

The earliest works, such as the 14th-century *Enthroned Madonna* by Giovanni del Biondo, were painted on gold backgrounds with figures delineated by heavy outlines. They were evenly lit and not constructed in perspective. By contrast, later artists in the early 1500s who depicted similar subjects show balanced and dynamic compositions, naturalistic landscapes seen in perspective and large figures in classical poses, such as the *Madonna of the Dragonfly* by Bernardino Luini.

The Italian Renaissance idealized and attempted to imitate classical antiquity. Ancient Rome was regarded as a time when art reached perfection and held a central place in society. Attempts by Renaissance rulers to evoke the ancient past are recorded in paintings such as Piero di Cosimo's *The Building of a Palace*, which shows an ideal building in classical style being erected in a barren landscape.

In the later 16th century, followers of Michelangelo and Raphael created a sophisticated style of art now called Mannerism. Powerful and rich families such as the Medici, the Strozzi and the Salviati, who dominated the urban culture of Renaissance Italy, championed Renaissance forms and ideals for propagandistic purposes. Artists such as Francesco Salviati catered to these influential families and created works for them that emphasized social position, power and wealth. Mannerist decorative arts such as the Strozzi throne also contributed to the aggrandizement of powerful families as displays of artistic sophistication and richly worked materials.

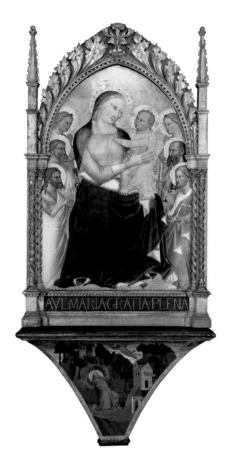

Giovanni del Biondo
Italian, flourished 1356–1399, active in Florence
Madonna and Child with Saints and Angels, c. 1380/90
Tempera on panel, 55¼ x 19½ inches
Bequest of John Ringling, 1936, SN 6a

This small altarpiece is of a type called *sacra conversazione* in Italian, meaning "sacred conversation." In these "conversations" the Madonna and infant Jesus are shown surrounded by saints. Here, John the Baptist is on the lower left with an animal skin garment and cross-shaped staff; Peter is above him with a key. John the Evangelist is on the right with a book and a cup; Paul is above him with a sword. Despite the overall severity of Giovanni's style he conveys the tender relationship between Mary and Jesus through gesture and glance.

Andrea (di Marco) della Robbia
Italian, 1435–1525/28, active in Florence
Madonna and Child
Glazed terracotta in a carved, painted, and gilded frame, 26⅞ x 19⅝ inches
Bequest of John Ringling, 1936, SN 1393

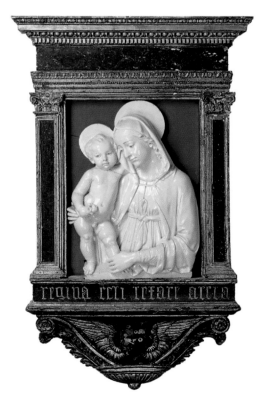

Andrea della Robbia contributed greatly to the evolution of Renaissance style in Europe by championing innovative techniques for depicting traditional subjects. This relief, for example, is meant to recall carved marble rather than the inexpensive terracotta of which it was made. This sophisticated rendition is developed from classical prototypes, but is no less touching and sentimental in its depiction of the tender relationship between the Virgin and her Son than the Giovanni del Biondo altar (above) painted a century earlier.

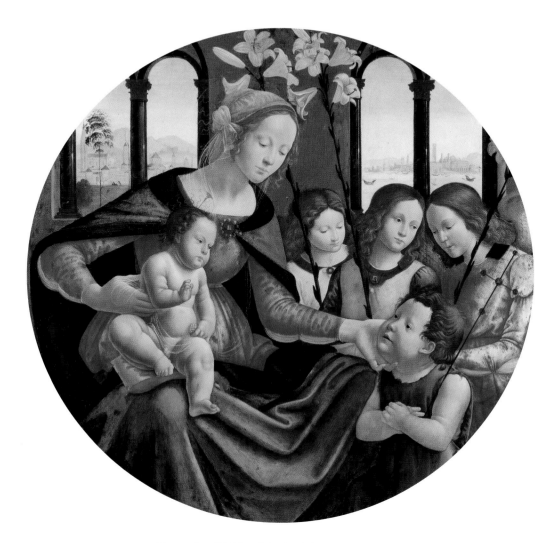

Domenico Ghirlandaio (and family workshop)
Italian, 1448/9–1494, active in Florence
Madonna and Child with Saint John and Three Angels, c. 1490
Oil on round panel (tondo), 37 inches
Bequest of John Ringling, 1936, SN 20

This painting presents the Madonna as a wealthy, contemporary-looking matron playing with her Son, a common pictorial conception in the Renaissance. Only the presence of angels and the prominent lilies, symbolic of the Resurrection, reveal the sacred context. A very accurate view of Venice is seen through the window. It is possible that the artist never visited Venice, but rather derived this image from a print or drawing. The view of Venice has never been adequately explained. Perhaps this panel was painted for export to a Venetian client or as a souvenir of Venice for a Florentine merchant. This is the best of many versions of the subject painted in Ghirlandaio's workshop. It is usually assumed that Ghirlandaio's brother-in-law, Bastiano Mainardi, participated extensively in these works.

Scholars have connected *The Building of a Palace* to a series of works by Piero di Cosimo that depicts important episodes from the early history of mankind. Whether or not this painting belongs to that particular series, it certainly portrays an episode from the distant past–the construction of an impressive building complex in an otherwise barren setting. It may also represent the origins of architecture or an allegory of the art of building. It has been suggested that such views of imaginary classical buildings in landscape settings represent the Renaissance ideal of the cultural wealth of prosperous cities ruled by great princes such as the Medici. Note the artist's skillful use of perspective to suggest the immensity of this palace.

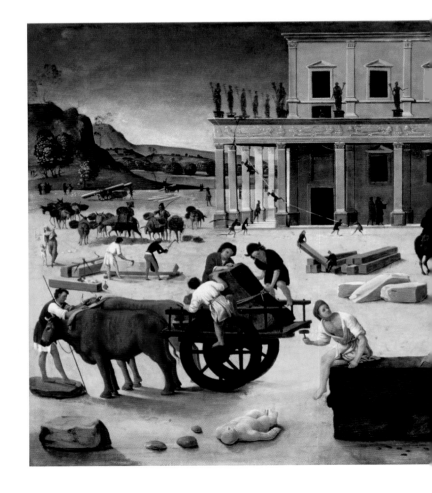

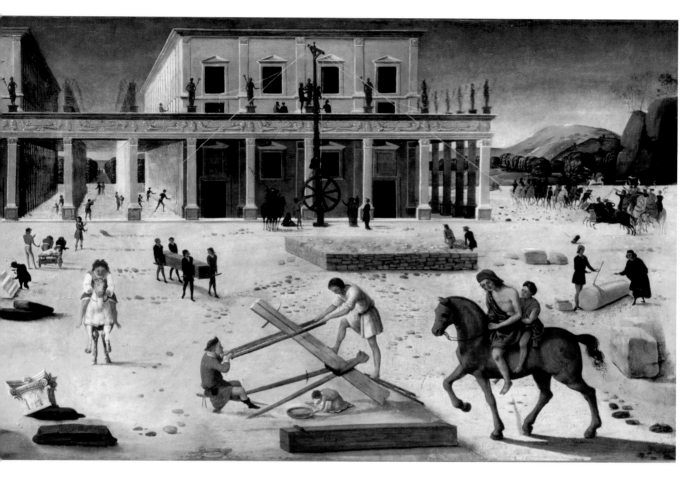

Piero di Cosimo
Italian, 1461/62– c. 1521,
active in Florence
The Building of a Palace, c. 1515/20
Oil on panel, 32 ½ x 77 ½ inches
Bequest of John Ringling, 1936, SN 22

Scheggia (Giovani di ser Giovanni Guidi)
Italian, 1408–1486, active in Florence
A Battle between Romans and Gauls, mid-15th century
Tempera on panel, 17 x 61½ inches
Bequest of John Ringling, 1936, SN 13

This panel is probably from a wedding chest or *cassone* in
Italian. It is typical of a type of painting used to decorate
ornate and expensive pieces of furniture used to transport
a bride's trousseau to her new home on the occasion of her
marriage. The scene shows a battle between the armored
Romans, identified by their banners bearing the initials
S.P.Q.R., and barbaric, nude, wild-looking Frenchmen, or
Gauls, whose banner sports a rooster. The white horse on
the left bears the arms of a branch of the Medici family.
Thus, the panel was probably made for an ally or aspiring
friend of the Medici hoping to demonstrate a close
relationship to the politically influential clan.

Baccio d'Agnolo (Bartolommeo d'Agnola di Donato Baglione)
Italian, 1462–1543, active in Florence
Throne from the Strozzi Palace, c. 1511
Carved, inlaid, and gilded woods (mainly walnut), 117 x 102½ x 36¾ inches
Bequest of John Ringling, 1936, SN 1514

This ceremonial throne-like seat was commissioned to celebrate the marriage in 1508 of two Florentines of prominent birth—Filippo Strozzi and Clarice de' Medici. Family symbols such as the Strozzi crescents and the Medici spheres, or *palle* in Italian, are present throughout the elaborate carving.

In the 19th century, the throne was sold from the Strozzi palace. It relates to a set of furnishings ordered by Strozzi in 1511 from Baccio d'Agnolo, a pupil of Michelangelo, a woodcarver and an architect of great repute. Piero di Cosimo may have provided Baccio with designs both for the elaborately carved ornamentation and for a large painting, now lost, for the back panel. Renaissance individuals seated on this throne must have presented an imposing appearance indeed.

After a design by **Marco Dente**
Italian, active c. 1493–1527
The Annunciation
Reverse painting on glass (*verre églomisé*), 13 x 11½ inches
Bequest of John Ringling, 1936, SN 1513

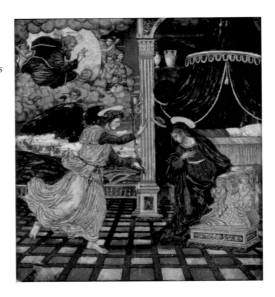

The technique of *verre églomisé*, painting on the underside of glass, is similar to that of engraving. Indeed, many such compositions can be traced directly to prints that were circulated widely in the early 16th century. *The Annunciation* is based on a print by Marco Dente, a pupil and assistant of the engraver Marcantonio Raimondi (c. 1480–1534). The Virgin bows modestly as Gabriel rushes to bring her the news that she will bear the Son of God. In the left corner, God himself appears in a burst of clouds, raising his arm in a gesture of blessing. This work is notable for its bold perspective, brilliant coloring and for its depiction of an upper-class interior.

Workshop of Giorgio Andreoli
Italian, c. 1465/70–1555, active in Gubbio
Plate with a Dead Child, c. 1525
Tin-glazed earthenware (maiolica), 10½ inches
Bequest of John Ringling, 1936, SN 7022

The imagery in the center of the dish is a *memento mori*, or a reminder of death. The sleeping or dead child and the skull in the foreground allude to the fragility of life. Such elaborately decorated dishes served a function that was representational or commemorative rather than useful.

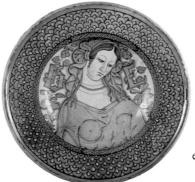

Italy (Deruta)
Charger with Woman and Initials GE, c. 1520–1530
Tin-glazed earthenware (maiolica), 16⅝ inches
Bequest of John Ringling, 1936, SN 7044

In contrast to the death imagery of the plate above, this dish celebrates life in the person of a beautiful young woman with the unexplained initials G.E. Although her features are stereotypical, the real woman who had these initials no doubt existed. Perhaps this plate was made to commemorate a marriage.

Francesco Granacci
Italian, 1469–1543, active in Florence
The Assumption of the Virgin, c. 1515
Oil on panel, 90 x 81 inches
Bequest of John Ringling, 1936, SN 24

According to Christian legend, the Virgin gave her belt, or girdle, to St. Thomas upon her Assumption, or rise to Heaven. This holy relic was very popular in Florentine art because it was said to be housed in a chapel near Florence, in the city of Prato. This altarpiece was painted for the Medici chapel in San Piero Maggiore, Florence. The 16th-century critic, Giorgio Vasari, extravagantly praised this painting. He said that the figures of the kneeling St. Thomas and the Virgin were so full of grace that they were worthy of Granacci's friend, Michelangelo himself. Indeed the poses of these figures recall the powerful three-dimensional forms of Michelangelo's paintings.

Domenico Puligo was a follower of Raphael and Andrea del Sarto, known for his sweet-faced figures and for his exquisite but sometimes bizarre sense of color. Here, the classical balance of the composition is enlivened by the poses of the figures and the contrasting colors. St. Quentin, left, holds the spits with which he was impaled at his martyrdom. St. Placidus, a companion of St. Benedict, wears the costume of a Benedictine monk. It is interesting to compare the ornament that decorates this throne with the Strozzi throne by Baccio presented earlier in this section.

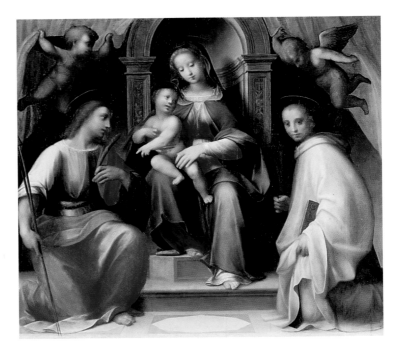

Domenico Puligo da Pescia
Italian, 1492–1527, active in Florence and Genoa
The Virgin and Child in Majesty with Saints Quentin and Placidus, c. 1521/22
Oil on wood panel, 60 ¹⁵⁄₁₆ x 67 ⁵⁄₁₆ inches
Bequest of John Ringling, 1936, SN 28

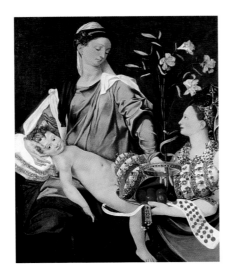

Benedetto Pagni
Italian, 1504–1578, active in Rome,
Mantua, and Florence
The Medici Madonna, 1547
Oil on wood panel, 68 ⅛ x 55 ⅝ inches
Bequest of John Ringling, 1936, SN 34

The Renaissance historian Giorgio Vasari described this painting in 1568 as "a personification of Florence offering to the Virgin the symbols of the grandeur of the house of Medici." These symbols include the six *palle*, or spheres, in the dish; the genealogical scroll; the tiaras of the two Medici popes; and the crown of the Duchy of Tuscany. The pairing of the crown with the lilies represents the alliance through marriage of the Medici with the royal family of France. The artist's portrayal of the figure of Florence is a visual pun, the flowers in her hair being "flora." The Virgin is shown as an almost arrogantly aristocratic figure, unlike the often-humble Madonnas typical of the period. This portrayal is, therefore, suited to its purpose as a symbol of the Medici's wealth and power.

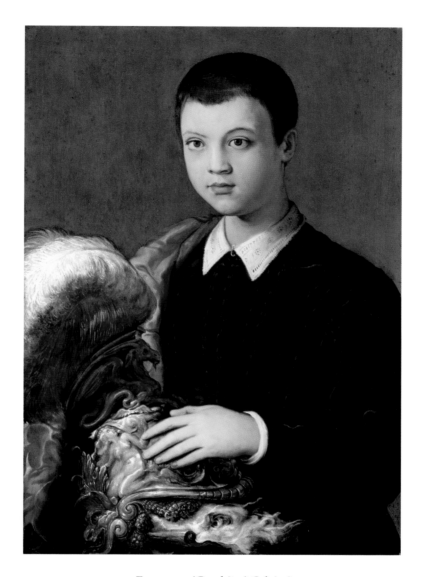

Francesco (Cecchino) Salviati
Italian, 1510–1563, active in Florence and Rome
Portrait of an Aristocratic Youth (Gian Battista Salviati?), c. 1543–1544
Oil on panel, 27⁷⁄₁₆ x 19 inches
Gift of Mr. and Mrs. E. Milo Greene, 1961, SN 733

Francesco Salviati's artistic ideals are those of Mannerist art. The highly finished and polished surfaces make the sitter seem like a marble bust come to life. The elaborate helmet held by the youth is an excellent example of Mannerist decorative design. In fact, the painter Salviati designed such ornamental armor for his aristocratic patrons. Although the sitter was originally thought to represent a child of the Medici family, he has recently been identified as a cousin from the Salviati family, whose name the artist adopted because he was so closely identified with them. In this portrait, Gian Battista, who died young, is perhaps showing his allegiance to the Medici family, since the helmet he holds is decorated with symbols of the Duke of Florence, Cosimo de' Medici.

THE RENAISSANCE IN VENICE AND NORTHERN ITALY
The Age of Titian

IN NORTHERN Italy, far from the centers of Rome and Florence, artists such as Leonardo da Vinci and Giorgione originated a new kind of painting that was radically different from Florentine and Roman art of the same period. It was less artificial and far less reliant on classical models than the paintings by Raphael and Michelangelo and their followers.

Although he was trained in Florence, Leonardo developed his most radical treatments of movement and color in Milan in paintings such as *The Last Supper*. The leader of the Venetian school, Giorgione, introduced soft contours, free brushwork, less formal compositions and subject matter from everyday life.

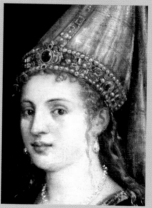

Giorgione's student, Titian, was even more innovative in using free, calligraphic brushstrokes. While the styles of Titian and his Venetian followers seemed uncontrolled and messy to some contemporary critics, it was, in fact, highly considered and intended to enhance the illusion of presence and movement. The effects of Titian's techniques were best appreciated when the pictures were seen from a distance; the dynamic brushwork was not intended to be enjoyed for its own sake, as in modern art.

Two trends developed out of Titian's art. On one hand, his disciple, Paolo Veronese, achieved excellence in creating lyrical movement, chromatic harmony, and bright light in his paintings. On the other hand, the Tintoretto and the Bassano families created compositions that were dramatically lit and often set at night. The Bassano family also created an international vogue for secular subjects such as scenes of peasant life, animals and still lifes. Their compositions led directly to the illusionism, dark lighting and forthright naturalism characteristic of later Italian artists such as Caravaggio as well as of Dutch and Spanish Baroque artists.

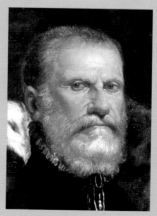

Bernardino Luini
Italian, c. 1480/1485–before 1532, active in Milan and the province of Lombardy
The Madonna of the Dragonfly (Madonna and Child with Saints Sebastian and Roche), c. 1520/22
Oil on panel, 68¼ x 60⅝ inches
Bequest of John Ringling, 1936, SN 37

Bernardino Luini, a follower of Leonardo da Vinci, achieved the Renaissance ideal of balance, clarity and harmony in this altarpiece. The majestic, yet smiling figures of the Virgin and Child are seated on a large rock, rather than on a grandiose throne seen in other Renaissance paintings such as that of Puligo's *Virgin and Child* in the previous section. Their attitudes and drapery, however, are sculptural in conception. The physique and pose of the partially nude Sebastian on the left also recall ancient Greek and Roman statuary. Both St. Roche and St. Sebastian were usually invoked against the plague. Therefore, this altarpiece might have been created and venerated during a time of illness. The dragonfly in the foreground might represent Satan, or evil in general, or the Orient, from where the plague was supposed to have originated.

Gaudenzio Ferrari
Italian, 1475/80–1546, active in and around Milan
The Holy Family with a Donor, c. 1520/25
Oil on wood panel, 60⅛ x 45¼ inches
Bequest of John Ringling, 1936, SN 41

This painting illustrates the relationship of various Biblical figures to
the Divine. The dignified figures of Mary, crossing her open palms,
and of Joseph, doffing his hat and kneeling, give the impression that
they have spontaneously become aware of the holiness of their Son.
The angels below reverentially coddle and adore Christ, while those
above proclaim his divinity. The solemn figure on the left was probably
the patron who commissioned the artist to paint him as a cleric in
perpetual prayer. Ferrari's painting recalls Leonardo, particularly in
the hair and faces of the cherubs.

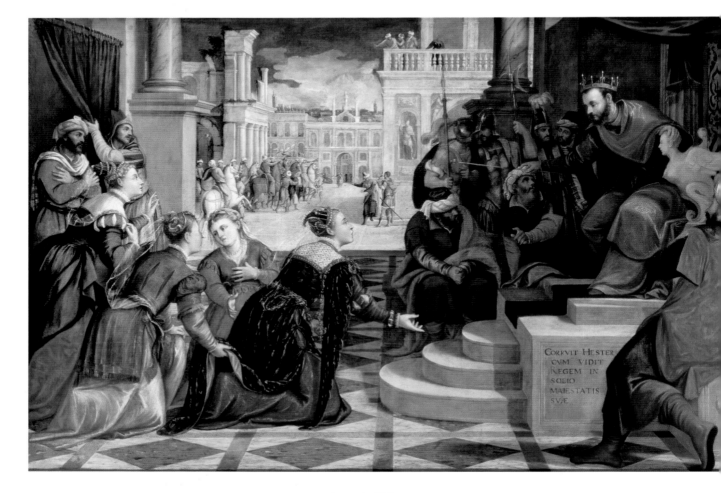

Antonio Palma
Italian, c. 1510–1575, active in Venice
Esther before Ahasuerus, 1574
Oil on canvas, 67 x 123 inches
Bequest of John Ringling, 1936, SN 85

Esther was a Jewish heroine who saved her people from an extermination plot instigated by Haman, a government official of Susan, capital of Persia. She exposed Haman's murderous intrigue and saved the Jewish population. In this painting, Esther daringly appears unsummoned, and therefore at great peril to herself before her husband, the Persian king Ahasuerus. The figure of Esther also resembles the female figure usually used to symbolize Venice in contemporary paintings. For this reason, as well as for its prominent inscription, this painting has been interpreted as commemorating the visit of the French king Henry III to Venice in 1574. The figure of Esther would thus represent Venice beseeching the French king, represented as Ahasuerus, for military aid against her enemies.

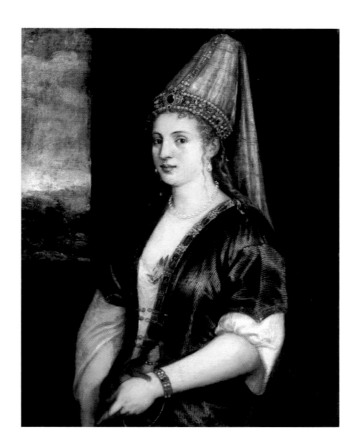

Titian (Tiziano Vecellio)
Italian, c. 1485(?)–1576, active in Venice
La Sultana Rossa, 1550s
Oil on canvas, 38 x 30 inches
Bequest of John Ringling, 1936, SN 58

Giorgio Vasari, the Renaissance critic, described this painting
as a portrait of a wife of a Turkish Sultan. However, it is more
likely a simple representation of a beautiful but imaginary
woman in exotic costume. Aristocratic collectors, such as the
Riccardi family from Florence who originally owned this work,
especially appreciated such paintings. Some scholars dispute
whether the *Sultana* was mainly painted by Titian or by his
workshop assistants. Given its illustrious provenance and
excellent quality, however, it is more likely a slightly damaged
but still-evocative original. Especially noteworthy is the
impression of vivid lifelikeness and presence achieved using
very standard portrait formulas.

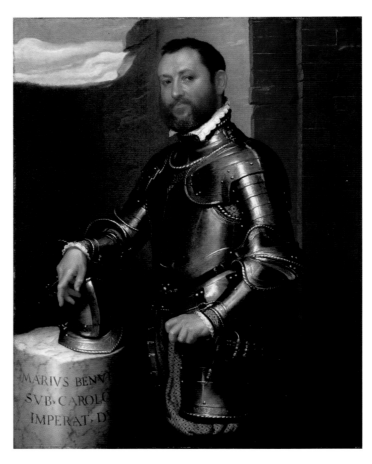

Giovanni Battista Moroni
Italian, c. 1520/25–after 1578,
active in Bergamo
Portrait of Mario Benvenuti,
c. 1560
Oil on canvas, 45 ½ x 35 ½ inches
Bequest of John Ringling,
1936, SN 106

According to the inscription on the column, Mario Benvenuti was a military commander under Holy Roman Emperor Charles V. This is an official military portrait in which the status and achievements of the sitter are commemorated. Such portraits are less psychologically or physiologically accurate than portraits such as Bassano's, below.

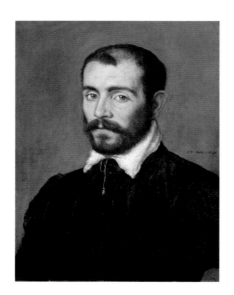

Leandro Bassano
Italian, 1557–1622, active in Venice,
Bassano del Grappa, and Prague
Portrait of a Man
Oil on canvas, 23 ¾ x 18 ¼ inches
Bequest of John Ringling, 1936, SN 91

The intense directness and naturalism of Leandro Bassano's portraits were an inspiration for later Italian painters such as Caravaggio and the Carracci family. Portraits with bold brushwork and palettes limited to black, white and flesh tones also inspired Dutch portraitists such as Frans Hals and Rembrandt.

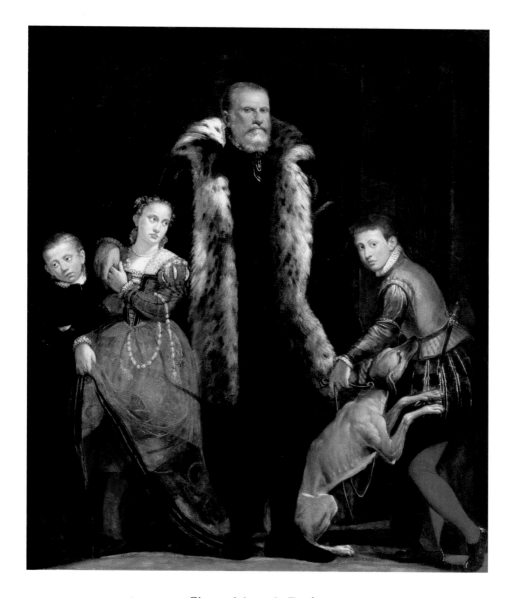

Giovanni Antonio Fasolo
Italian, 1530–1572, active in Venice and Vicenza
Portrait of a Family Group, c. 1561/1565
Oil on canvas, 86 x 71 ½ inches
Bequest of John Ringling, 1936, SN 83

Little is known of the wealthy family represented in this ambitious portrait. Giovanni Antonio Fasolo depended on precedents by his teacher Paolo Veronese for the complicated grouping. It appears to reveal the emotional lives as well as the status of the wealthy, probably noble, sitters. This portrait is one of the most important precedents for later group portraits by masters inspired by Venetian Renaissance painting such as Anthony van Dyck, Thomas Gainsborough and John Singer Sargent.

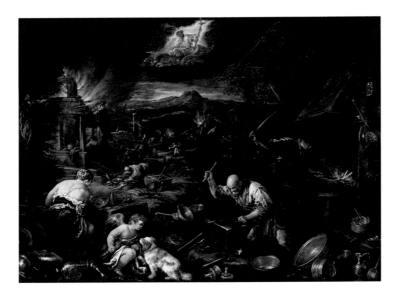

Representations of the four elements of Earth, Air, Fire, and Water were popular in Renaissance art. Here, Jacopo Bassano shows Fire set in a blacksmith's forge, while the Greek god Hephaistos rides in his chariot above. The use of competing sources of illumination from the forge and from the moon adds interest to the composition and foreshadows similar strategies in the later art of Caravaggio.

Jacopo Bassano
Italian, c. 1510–1592, active in Bassano del Grappa and Venice
An Allegory of Fire
Oil on canvas, 55 x 71⅛ inches
Bequest of John Ringling, 1936, SN 86

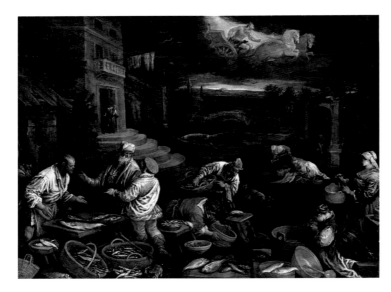

This and *An Allegory of Fire* were part of a series representing the four elements. Scenes incorporating many peasants and animals were a highly appreciated specialty of the Bassano family workshop. Here, Jacopo shows the element of Water set in a contemporary fish market. Overhead, the water-god Neptune drives his chariot through the sky. There are many versions of this painting. As was the practice in the Bassano workshop, one of Jacopo's sons, probably Francesco, may have assisted in the production of this work.

Jacopo Bassano
Italian, c. 1510–1592, active in Bassano del Grappa and Venice
An Allegory of Water
Oil on canvas, 55 x 71⅛ inches
Bequest of John Ringling, 1936, SN 87

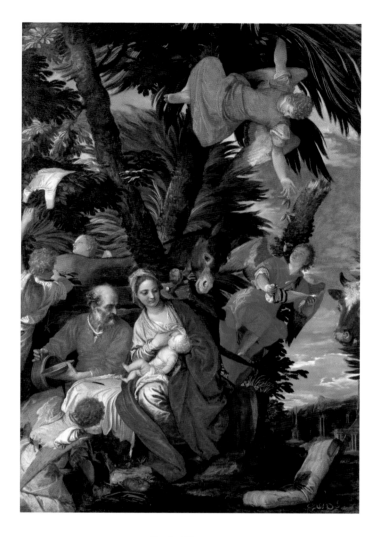

Paolo Veronese
Italian, 1528–1588, active in Venice and Verona
The Rest on the Flight into Egypt, c. 1580
Oil on canvas, 93 x 63 ½ inches
Bequest of John Ringling, 1936, SN 82

Idyllic visions of the Holy Family at rest in the countryside were a particular specialty of Paolo Veronese. The artist amusingly shows angels performing mundane household tasks. They hang the infant Christ's garments to dry on a tree and gather dates for the family's meal. Veronese's art was seemingly irreligious, and Inquisition examiners questioned him regarding his representations. A closer look at his paintings, however, reveals him to be a sophisticated painter of religious content as well as an astute observer of earthly folly and fallibility. The humor of this scene is undercut by references to Christ's eventual martyrdom. The tree branches crossing above the Virgin's head allude to the crucifix upon which Christ was martyred, and the bread and wine held by Joseph foreshadow the Eucharistic sacrament. Veronese's style was important for later artists because of his brilliant use of colors and his dazzling brushwork.

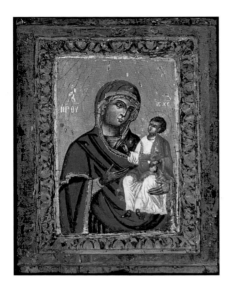

Eastern Europe or Greece
16th century (?)
Madonna and Child
Tempera on panel, 11 ¾ x 9 ⅛ inches
Gift of Karl A. Bickel, 1973, SN 915

This icon may be considered part of the Venetian tradition since Venice governed parts of Eastern Europe and Greece in the 16th century. El Greco began his career in the Venetian territory of Crete painting icons such as this, before moving to Venice where he learned the sophisticated technique practiced by Titian.

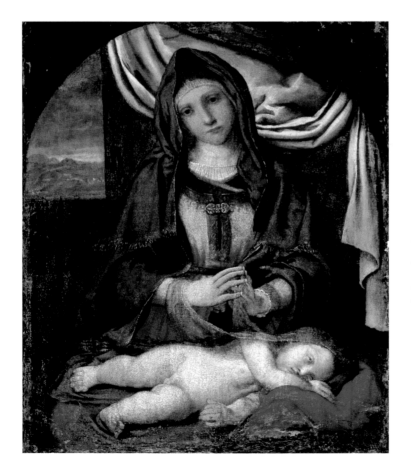

Lorenzo Lotto
Italian, c. 1480–1556, active in Venice and Northern Italy
Madonna and Child, c. 1547
Oil on canvas, 26 ⅝ x 22 inches
Bequest of John Ringling, 1936, SN 64

Despite its abraded condition due to damage and over-cleaning in the past, this painting shows the sensitivity, balance and subtle dignity characteristic of Lotto's late works. Both this painting and the icon above depict the double nature of the Virgin's relation to Christ as one of familial love and sacred reverence.

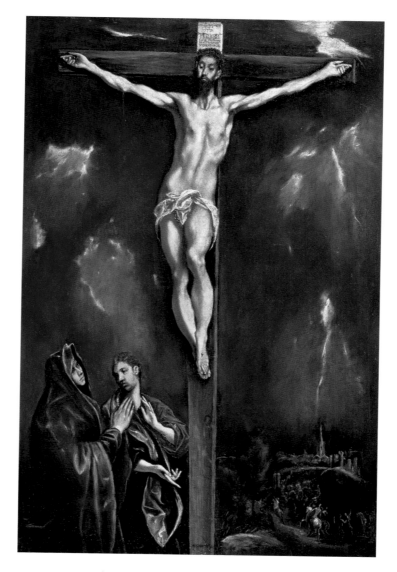

El Greco (Domenikos Theotokopoulos)
Greek, c. 1541–1614, active in Crete, Venice, Rome, and Toledo
and **Jorge Manuel Theotocopoulos**
Spanish, c. 1578–1631, active in Toledo
The Crucifixion with Mary and Saint John, c. 1603/05
Oil on canvas, 42⅜ x 27¾ inches
Bequest of John Ringling, 1936, SN 333

In his later years, El Greco collaborated extensively with his son, Jorge Manuel. In fact, this painting is probably one of many small copies El Greco made of larger paintings he had already completed. He produced copies so that Jorge Manuel would have a stock of images from which to cull after El Greco's death. Unlike modern notions of originality in which each work of art is unique, Renaissance family workshops, such as those of Veronese, Bassano and El Greco, continued to produce paintings for which they held the "copyright" many years after the founder's death.

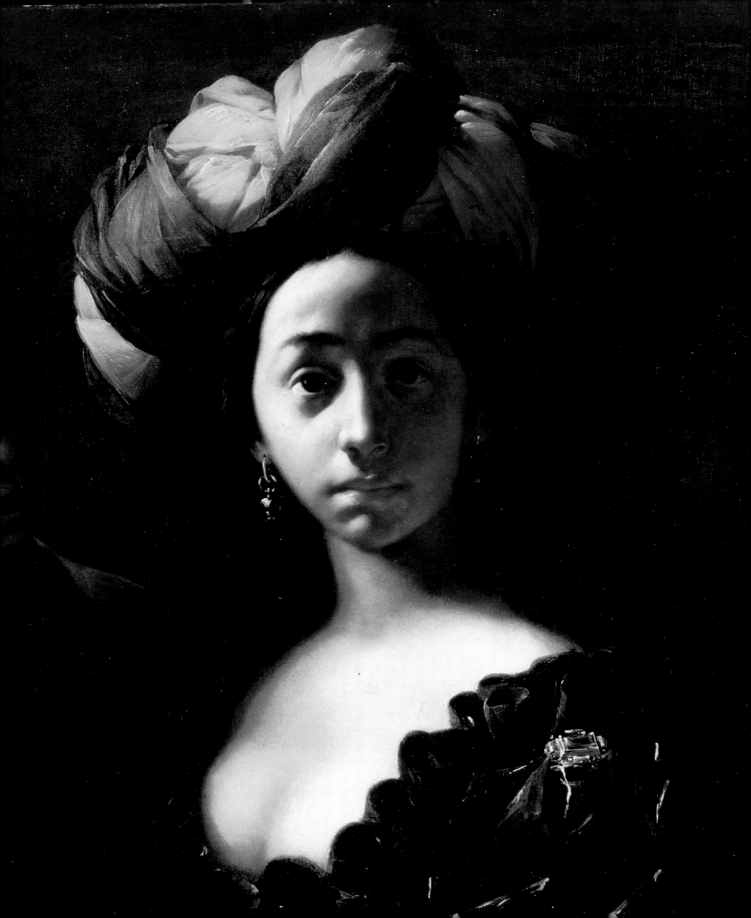

ITALIAN BAROQUE ART
The Age of Bernini

BAROQUE artists in 17th-century Italy aimed for *grandeur, splendor* and *magnificence* in style and for emotional force and expressiveness in content. Two artistic trends dominated the art of this period. The first stemmed from the revolutionary naturalism of Caravaggio's paintings of around 1600. Caravaggesque painting was realistic in both style and subject matter. It showed life-sized ordinary people set in dim shallow space.

The second tradition stemmed from Annibale Carracci who was active at the same time. He aimed to improve on nature and art and to reject Mannerism by adjusting styles popular in the Renaissance. For example, he took elements of Raphael's monumental classicism and tempered them with Titian's optical naturalism. The search for the most intense way to convey emotion and expression in art by Carracci and his followers eventually developed into the extravagant, imaginative and sometimes flamboyant style now called the High Baroque. Artists such as Ludovico David depicted grand figures from mythology and history acting out larger-than-life dramas with sweeping, operatic gestures.

Although the trends of naturalism and idealism seem diametrically opposed, they are better understood as a spectrum. Most of the artists who worked during this period in fact were inspired in equal parts by reality and fantasy.

The Baroque Age found a second Michelangelo in Gianlorenzo Bernini, a sculptor who was also an adept painter, architect and urban designer. Bernini's heroic sculptural projects in the Vatican and elsewhere depicted extraordinary states of religious emotion, as in his famous *Ecstasy of Saint Theresa.* At the same time Bernini promoted a new unity in all the arts, resulting in the kind of extravagant decoration in which each element is subjugated to overall visionary effect.

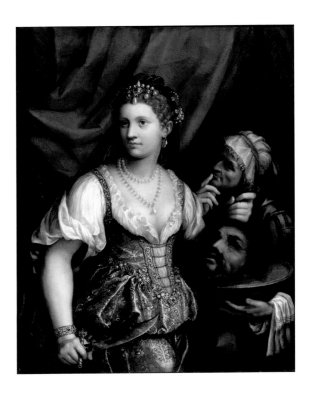

Fede Galizia
Italian, c. 1578–c. 1630, active in Milan
Judith with the Head of Holofernes, 1596
Oil on canvas, 47½ x 37 inches
Gift of Mr. and Mrs. Jacob Polak, 1969, SN 684

Judith, a devout Israelite woman, saved her people by entering the enemy's camp one night and decapitating the enemy leader, Holofernes. Fede Galizia, portrays Judith as a proud lady with beautifully rendered jewels. Galizia signed her own name on Judith's blade to identify herself with the virtuous heroine, and to suggest that her art was itself an act of faith, or *fede* in Italian.

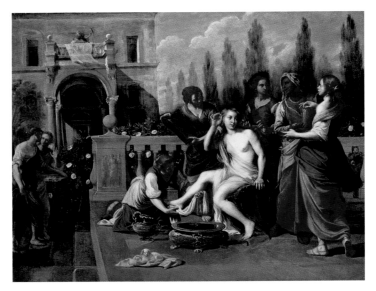

From a distant balcony, King David watches Bathsheba bathe. The Bible story tells us that David seduced her, and then sent her husband, his general Uriah, to die at the front lines of a battle. In time, David and Bathsheba's child was killed as God's punishment. This story is intended to illustrate that even great leaders and prophets are prone to human frailties. The famous Neapolitan painter Bernardo Cavallino may have collaborated with Micco Spadaro in this work.

Micco Spadaro (Domenico Gargiulo)
Italian, 1612–1675, active in Naples
Bathsheba at her Bath
Oil on canvas, 33¼ x 45½ inches
Gift of Asbjorn R. Lunde, 1976, SN 955

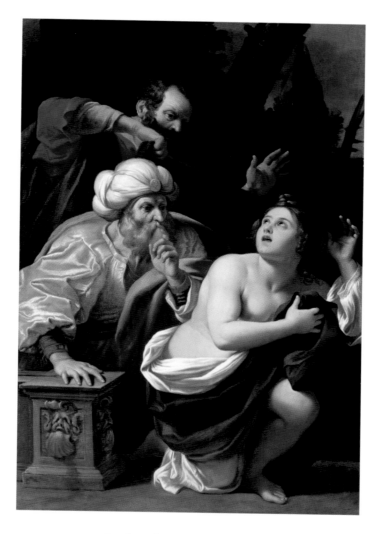

Attributed to **Agostino Carracci**
Italian, 1585–1602, active in Bologna and Rome
Susannah and the Elders, c. 1590/1600
Oil on canvas, 63 15/16 x 43 7/8 inches
Bequest of John Ringling, 1936, SN 111

This painting is one of the masterpieces of the classical, monumental style practiced by the Carracci family and their school. Here, the virtuous Hebrew woman, Susannah, is shown surprised at her bath by two lecherous elders. The force of the painting lies in the composition, which reduces the drama to its essential elements centered on the fearful Susannah. Despite its signature, this painting has been attributed to a wide variety of artists including Agostino's cousin Ludovico, his brother Annibale and his son Antonio, as well as other members of the Carracci circle, including Sisto Badalocchio. This confusion is compounded by the fact that the Carracci family, although they sometimes did not get along, worked together in Rome and Bologna and created a house style in which their works were sometimes indistinguishable.

Mattia Preti
Italian, 1613–1699, active in Naples, Rome, and Malta
Herodias with the Head of Saint John the Baptist, c. 1630/40
Oil on canvas, 47 ¼ x 67 ½ inches
Museum Purchase, 1985, SN 990

Here, one of the most terrible scenes in biblical history is presented in a chillingly calm fashion. The young child, Salome, holds the martyred St. John the Baptist's decapitated head while her satisfied mother, Herodias, presents it to a group of curious onlookers, presumably including King Herod. It is not uncommon for Baroque art to present horrific scenes in such a matter-of-fact way. Mattia Preti, a follower of Caravaggio in Naples, reveals his influence in the cropping of the figures by the frame and the dramatic contrast of light and dark, known as *chiaroscuro.* These stylistic features that Caravaggio and his followers used to enhance the illusionistic qualities of their paintings also appear in Strozzi's *An Act of Mercy* below.

The seven acts of mercy became a popular theme in Baroque art after Caravaggio painted an altarpiece on this subject for a Neapolitan church. These acts described in Matthew 25 of the Bible included feeding the hungry, clothing the naked, burying the dead, visiting the sick and imprisoned and housing travelers. Here, Bernardo Strozzi follows Caravaggio in giving a secularized genre-like interpretation to a religious theme. The brilliant pinks and greens, as well as the feathery brushwork, are typical of Strozzi's paintings. They derive from Van Dyck and Rubens, active in Genoa when Strozzi was young, as well as from Venetian painters.

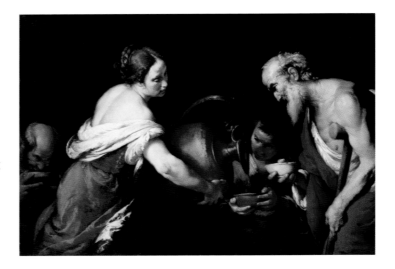

Bernardo Strozzi
Italian, 1581–1644, active in Genoa and Venice
An Act of Mercy: Giving Drink to the Thirsty, c. 1618/20
Oil on canvas, 52 ¼ x 74 ⅝ inches
Museum Purchase, 1950, SN 634

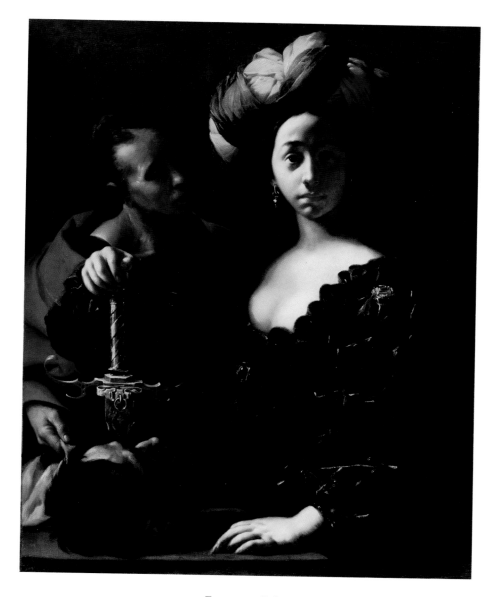

Francesco Cairo
Italian, 1607–1665
Judith with the Head of Holofernes, c. 1630/35
Oil on canvas, 46⅞ x 37⅛ inches
Museum purchase, 1966, SN 798

Unlike Fede Galizia's pompous celebration of Judith's triumphant act of faith, Cairo depicts the Jewish heroine as a simple young girl in an overly elaborate turban. She looks out at the viewer with an inscrutable expression. Is she proud or simply shocked at her own action? This uncertainty lends emotional realism to this depiction of the terrible exploit of murder, even though committed in the service of faith. Cairo was a Milanese follower of Caravaggio whose influence is witnessed here in the representation of biblical figures as ordinary contemporaries dressed in fancy costume.

Attributed to **Carlo Dolci**
Italian, 1616–1687, active in Florence
The Blue Madonna
Oil on canvas, 21 x 15¼ inches
Bequest of John Ringling, 1936, SN 136

In this painting the popular subject of the Madonna of Sorrows, *Mater Dolorosa* in Latin, is endowed with a physical presence and simplicity that greatly affects many pious viewers. The mix of sweetness and melancholy is typical of the religious pathos of Carlo Dolci's works. However, some scholars believe that this painting is not by Dolci, but by one of his close followers, such as Onorio Marinari.

Domenico Fiasella
Italian, 1589–1669,
active in Genoa and Rome
Christ Healing the Blind, c. 1615
Oil on canvas, 109⅜ x 71⅞ inches
Bequest of John Ringling,
1936, SN 113

This altarpiece and the one on the opposite page by Domenico Fiasella are concerned with healing. It has been conjectured that they were originally side altars painted for a chapel, perhaps in a hospital. *Christ Healing the Blind* shows a miracle recounted in Luke 7:21–22, "unto the many he gave sight." The painting on the opposite page derives from Luke 7:11–16, where Christ resurrected the son of a widow in the city of Nain.

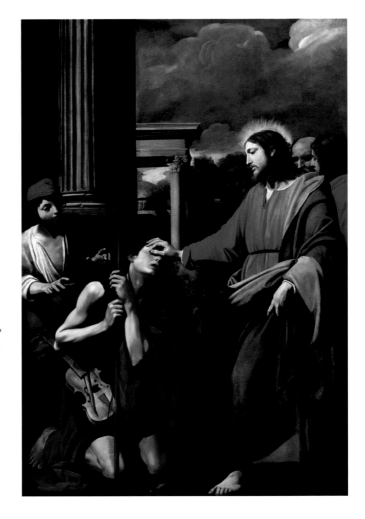

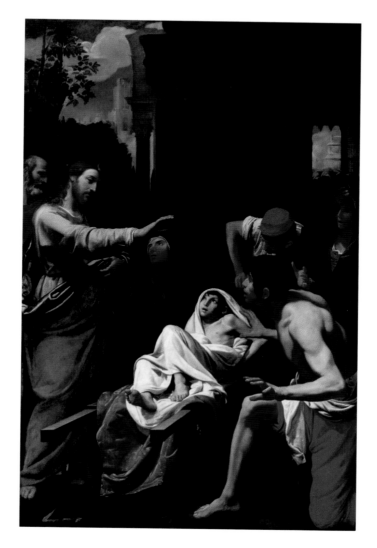

Domenico Fiasella
Italian, 1589–1669, active in Genoa and Rome
Christ Raising the Son of the Widow of Nain, c. 1615
Oil on canvas, 106 x 69 inches
Bequest of John Ringling, 1936, SN 112

These two altarpieces depict two awe-inspiring miracles of Christ as healer. Churchgoers receiving communion in 17th-century Italy probably saw these side altars very differently from the way we look at them today. The grandiose figure of the miracle-performing Christ was seen as mirroring the actions of the priest who was dispensing communion. Although the figures in the altar appear flat and distorted when seen from the front, they acquire a surprisingly three-dimensional appearance from a forty-five degree angle. In creating this dynamic, illusionistic composition, Fiasella was inspired by Caravaggio's famous altarpieces painted in Rome in the 1600s. In fact, these works were painted for Caravaggio's major patron, Vincenzo Giustiniani.

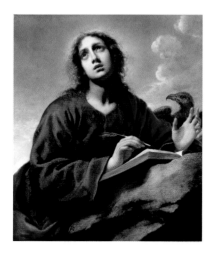

Carlo Dolci
Italian, 1616–1687, active in Florence
Saint John the Evangelist Writing the
Book of Revelation, c. 1650
Oil on copper, 10³⁄₁₆ x 8⅛ inches
Bequest of John Ringling, 1936, SN 137

Francesco Albani
Italian, 1578–1660, active in
Bologna, Mantua and Rome
Saint John the Baptist in the
Wilderness, c. 1600/06
Oil on copper, 19⅜ x 14⅝ inches
Bequest of John Ringling, 1936, SN 115

These two small and exquisite paintings on copper show the much-admired mastery of exact and highly finished painting typical of these artists. However, though both paintings present images of saints in communion with God, the differences between them are significant.

Francesco Albani shows us an evenly lit, brightly hued painting of the heroic nude in a classical pose that is influenced by Renaissance prototypes such as Raphael. Carlo Dolci, on the other hand, focuses more intently on the saint as an ecstatic visionary, as was sometimes common in the mid-17th century.

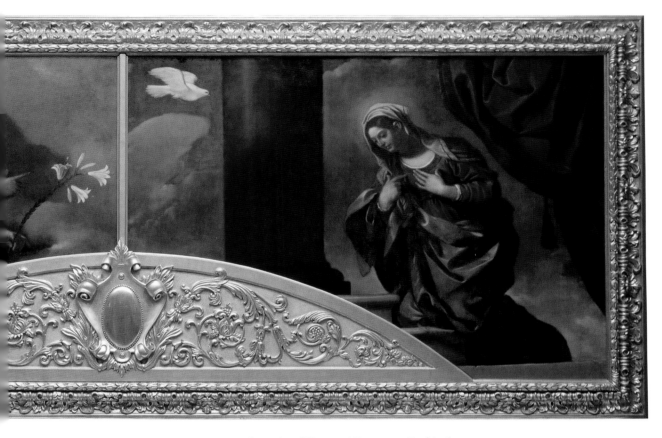

Guercino (Giovanni Francesco Barbieri)
Italian, 1591–1666, active in Cento, Bologna, and Rome
The Annunciation, 1628–1629
Oil on canvas, 76¼ x 108¾ inches
Bequest of John Ringling, 1936, SN 122

Each of these huge paintings contains a single monumental figure of approximately quadruple life size. To the left, the Archangel Gabriel floats forward to present the Madonna with a branch of lilies. The dove of the Holy Ghost precedes him. Though they are separate, the two canvases present a unified space. These immense paintings were originally placed over a sanctuary arch in the Church of Santa Croce in Reggio Emilia, near Bologna.

They were purchased by a British collector in the 18th century and remained in Britain, where Guercino's art was highly prized, until purchased by John Ringling. This work is a unique example in North America of a large Italian Baroque painting designed for a monumental architectural setting.

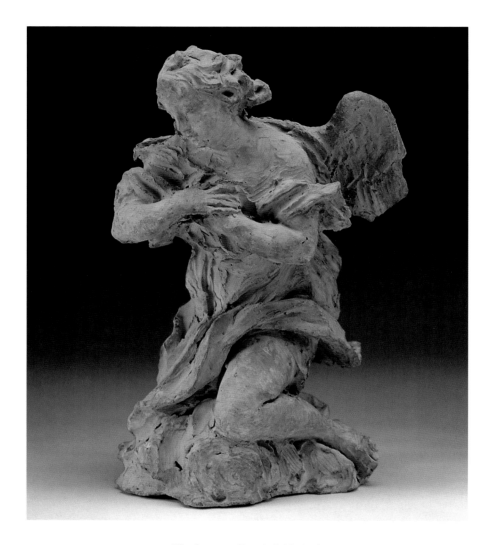

Gianlorenzo Bernini (design)
Italian, 1598–1680, active in Rome and Paris
and **Giuliano Finelli** (execution)
Italian, c. 1601–1653, active in Rome and Naples
Kneeling Angel, c. 1626
Terracotta, 6½ x 10½ x 6½ inches, Museum Purchase, 1960, SN 5445

The twisted, dynamic figure of the angel with agitated drapery is typical of Gianlorenzo Bernini's High Baroque style. This three-dimensional sketch, or *bozzetto* in Italian, may have been designed by Bernini for the pediment over the high altar of the church of Sant'Agostino in Rome. Like Rubens, Bernini employed many assistants for his grand projects. In this case, Bernini gave the actual execution of both this terracotta sketch and of the full-scale marble sculpture for the church to one of his best assistants, Giuliano Finelli, an important sculptor in his own right. However, at the time this work was made, it would have been credited to Bernini, not Finelli, since Bernini was the artist contractually responsible for the conception of the sculpture.

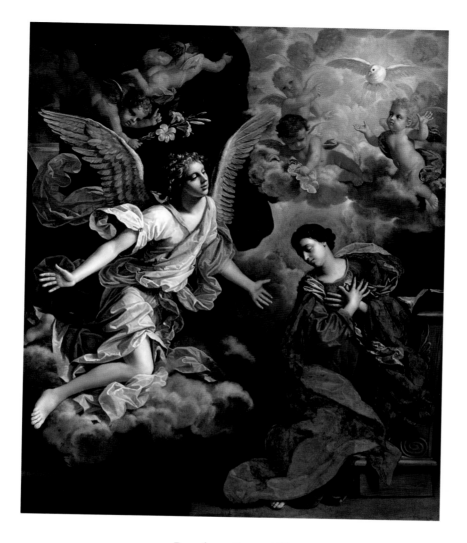

Benedetto Gennari II
Italian, 1633–1715, active in Bologna, Paris and London
The Annunciation, 1686
Oil on canvas, 100½ x 82¾ inches
Bequest of John Ringling, 1936, SN 131

It is interesting to compare this painting of the Annunciation by Benedetto Gennari with the treatment of the same theme by his uncle, Guercino, on page 71. Here, Gennari abandons the monumentality, naturalism, muted colors and simplicity of his relative's style. Instead, he chooses to imitate the High Baroque style of Bernini and Pietro da Cortona who used agitated poses, drapery and lovely tertiary colors. Catherine of Braganza, the wife of King Charles II, commissioned this painting for the Roman Catholic chapel in Whitehall Palace, London. It was probably removed from the palace when Protestantism was restored as the official religion of Britain and King James II was exiled to France in 1688.

ITALIAN PORTRAITURE

Portraiture was one of the most important kinds of painting in the 17th century. Because it depended on likeness rather than the artist's imagination, it was less highly regarded than mythological or religious subjects. However, artists sought to excel in this genre because there was a vast market for portraits, and an artist could be well rewarded by a satisfied patron.

Portraits produced during this time ranged widely in size and style. They could be larger-than-life or miniature, exact or very impressionistic in technique. Sculptured busts were also popular among the very wealthy. Although a few very personal and psychologically insightful portraits exist from this period, most portraits made in 17th-century Italy aimed for the most pompous and flattering portrayal of the sitter.

Salvator Rosa
Italian, 1615–1673, active in Rome and Naples
An Allegory of Study, c. 1649
Oil on canvas, 54⅜ x 38 inches
Bequest of John Ringling, 1936, SN 152

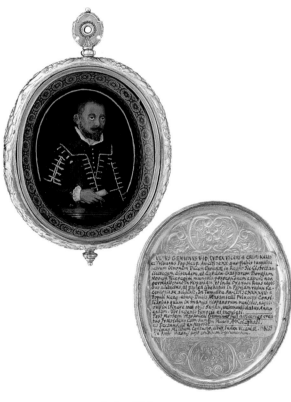

Italy, 17th century
Portrait of Giulio Genuino
Wax relief, gilt-copper case and other materials, 4 inches
Bequest of John Ringling, 1936, SN 1443.10

This young man at his desk was originally thought to represent Salvator Rosa himself. This idea arose because Rosa painted many allegorical self-portraits, and was highly regarded as both a poet and painter. However, the face in the painting does not resemble Rosa, who in other portraits has long straight hair and rather sharp features. Nonetheless, the figure may have been intended as showing the artist's abstract conception of himself as a philosopher and author.

Wax portraits are similar to painted portrait miniatures and commonly worn as jewelry and adornment. Giulio Genuino was an important figure in the history of Naples. He was a tribune of the people of Naples until after the Revolt of Masaniello, an uprising of the Neapolitans against their Spanish rulers. He was then made president of the High Court and a Judge of the Assizes.

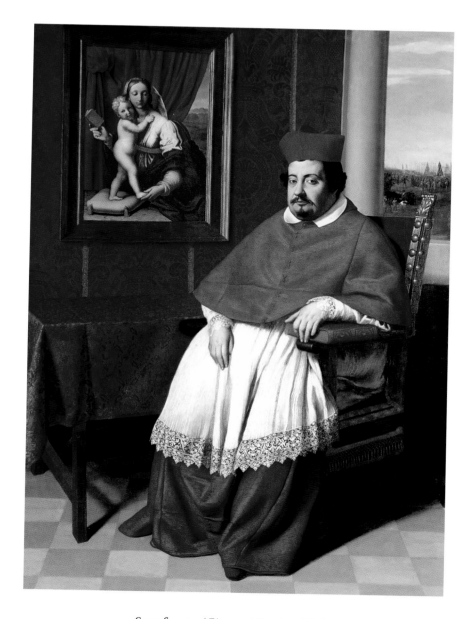

Sassoferrato (Giovanni Battista Salvi)
Italian, 1609–1685, active in Rome
Portrait of a Cardinal, c. 1651
Oil on canvas, 88⅛ x 64 inches
Bequest of John Ringling, 1936, SN 128

The identity of the sitter is still not conclusively resolved, though suggestions include the Cardinals Rondinini and Rapaccioli, and the important collector Camillo Massimi. The painting of the *Madonna and Child* in the background is a known work also by Sassoferrato. It is now in the collection at Burghley House, Stanford, Great Britain.

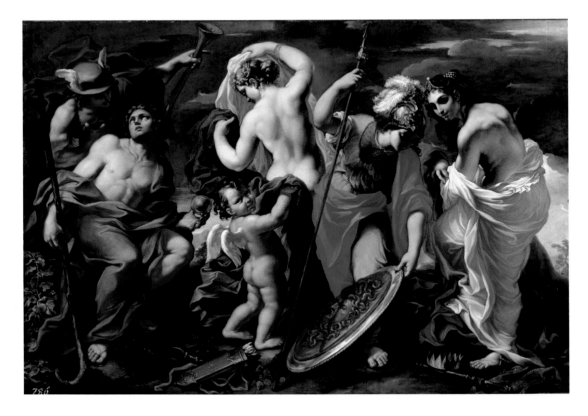

Ludovico David
Swiss, 1648–1728?, active in Rome and Venice
The Judgment of Paris, c. 1690
Oil on canvas, 68 x 96½ inches
Museum purchase, 1998, SN 11033

This work is a superb example of what is called the High Baroque style, characterized by twisting, sculptural forms, swirling draperies and unusual color and lighting effects. Here, David depicts the aftermath of a mythological contest in which the shepherd, Paris, had to choose one of three goddesses who would win a golden apple inscribed, "To the fairest." Each of the goddess contestants offered a reward for being chosen. Aphrodite offered the love of the world's most beautiful woman; Athena offered victory in battle; Hera offered land and riches.

Paris chose Aphrodite and was thus awarded Helen of Troy. According to the myth, the elopement of Helen and Paris set off the Trojan War, which led eventually to the founding of Rome. Elements of David's depiction are rather humorous—after being chosen, Aphrodite seems in no hurry to get dressed. Her son, Eros, protects her modesty by holding up her drapery and smiling at the viewer. At the time, David's comic treatment of the myth would have been highly prized for its wit.

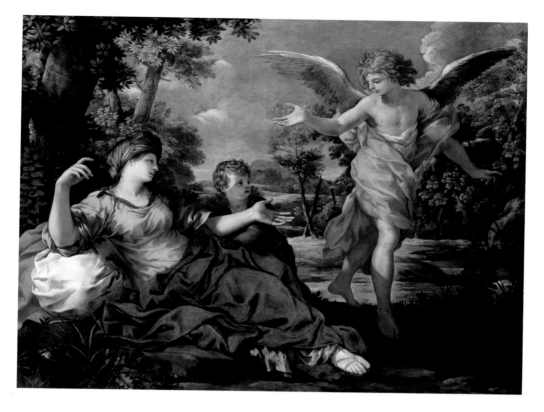

Pietro da Cortona
Italian, 1596–1669, active in Rome and Florence
Hagar and the Angel, c. 1637–1638
Oil on canvas, 45 x 58⅞ inches
Bequest of John Ringling, 1936, SN 132

Pietro da Cortona, along with Gianlorenzo Bernini whose *Kneeling Angel* was represented on page 72, are considered among the greatest masters to have practiced in the High Baroque style. Cortona is best known for the huge ceiling painting full of exaggerated, twisted figures depicting the glory of the Barberini family in their Roman palace. By contrast, this painting is almost classically serene. The artist shows the figure of Abraham's abandoned wife, Hagar, and her thirsting son, Ishmael, as ideal classical figures. Indeed, the figures of both the Sibylline Hagar and the supernaturally beautiful angel are derived from ancient statues.

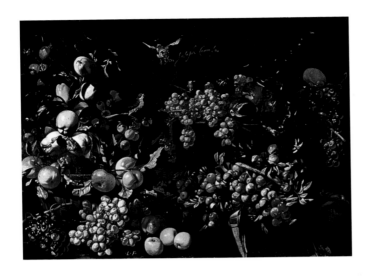

Luca Forte
Italian, c. 1615–before 1670,
active in Naples
Still Life with Fruit, c. 1640/47
Oil on canvas, 31 1/16 x 41 1/4 inches
Museum purchase, 1961, SN 715

Bartolomeo Bettera
Italian, 1639–c. 1687,
active in Northern Italy
Still Life with Musical Instruments
Oil on canvas, 36 5/16 x 47 7/16 inches
Gift of A. Everett Austin, Jr.
1951, SN 658

This was one of the first paintings to
enter the collection that was not part
of John Ringling's bequest. It was a
gift of A. Everett Austin, Jr., the first
director of the Ringling Museum
when it opened to the public in
1946. Since then, important works
of art have been added to the
collection by both gift and purchase.

Francesco Maltese
Italian, c. 1610–1660 in Rome
Still Life with Dog, c. 1660
Oil on canvas, 34 3/4 x 48 1/2 inches
Gift of Mr. and Mrs. U. Morgan
Davies, 1966, SN 806

ITALIAN STILL LIFE PAINTING

Sill life painting developed as an art form in its own right only in the late 16th century. Caravaggio's intense optical naturalism was a major influence on its development. Unlike Dutch still lifes which tended to show foodstuffs and flowers arranged as if they would have been in everyday life, Italian artists often took a more abstract approach where formal qualities such as shape and color determined the arrangement. This is especially evident in the still lifes by Bettera and attributed to Munari where guitars and tableware seem purposeless—they exist only to be painted by the artist and perceived by the viewer as evidence of the artist's skill. The still life by Forte is puzzling—the fruits do not seem to be arranged for preparation for eventual consumption, rather as symbols of nature's bounty (the bird carries the dedication to Don Carafa—a Neapolitan nobleman). Maltese's dazzling display of technique is full of humor as well, and the artfully decorated Papillon dog luxuriates in the artful space.

Attributed to **Cristoforo Munari**
Italian, 1667–1720, active in Florence
Still Life with Plates, c. 1706/09
Oil on canvas, 35⅛ x 47½ inches
Museum purchase, 1951, SN 660

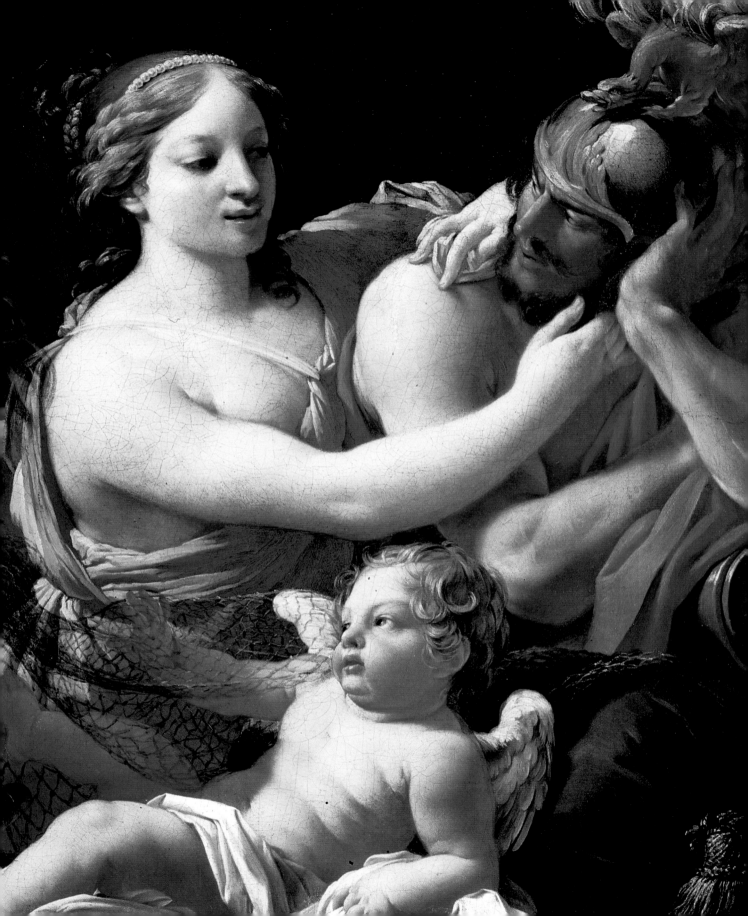

FRENCH BAROQUE ART
The Age of Poussin

THE ART of "French" Baroque is somewhat of a misnomer since many of its most important developments took place in Italy as well as France. Although a trip to Italy was an indispensable part of any Northern artist's education in his trade as early as Albrecht Dürer and Pieter Bruegel, some French artists who went to Italy never returned. They stayed because Roman papal and cardinalate courts and their administrators, as well as foreign ambassadors, provided extensive patronage for them. In Rome, colonies of foreign artists were founded, sometimes as informal associations of friends, other times as formally incorporated academies and guilds.

At the center of the French community was Nicolas Poussin. It is ironic that he is considered the greatest French artist, because he only once returned to France after he went to Rome in 1624. Poussin practiced the most elevated style, following his idol, Raphael, the Renaissance painter. He demonstrated his intellectual gifts in erudite and complex subjects. Poussin's art set the standard for French classicism, admired by artists such as Paul Cézanne and Pablo Picasso, who were active hundreds of years later.

Other artists who returned to France from Italy brought with them a variety of Italian styles. Nicolas Tournier followed Caravaggio's naturalism; Simon Vouet practiced both Poussin's restrained classicism and an overtly elaborate and sensual Baroque style. Other artists, such as Claude Vignon and François de Nomé, sought even more extravagant and eccentric effects. The sumptuous techniques of these artists reflect an important facet of French art during the 17th century—the rise of France as a great center of decorative arts because of the encouragement of Louis XIV.

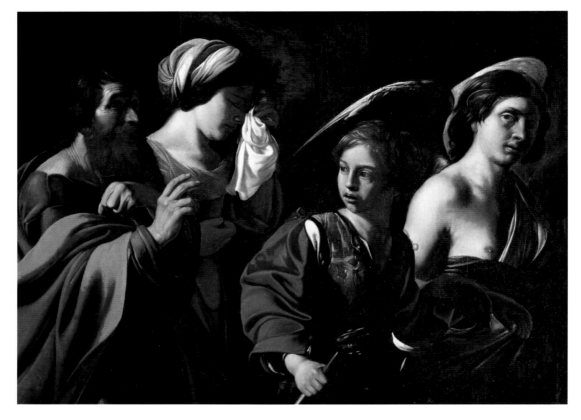

Nicolas Tournier
French, 1590–c. 1660, active in Rome and Southern France
Tobias Taking Leave of His Parents
Oil on canvas, 38 x 51 inches
Bequest of John Ringling, 1936, SN 110

Protected by the archangel Raphael, the young Tobias leaves his house while his heartbroken, devout and loving parents bid him farewell. They do not know that he will return with a beautiful wife, riches and a cure for his father's blindness. Nicolas Tournier followed the style of Caravaggio by showing the figures in half-length against a dark background, and by accentuating the contrast of light and dark.

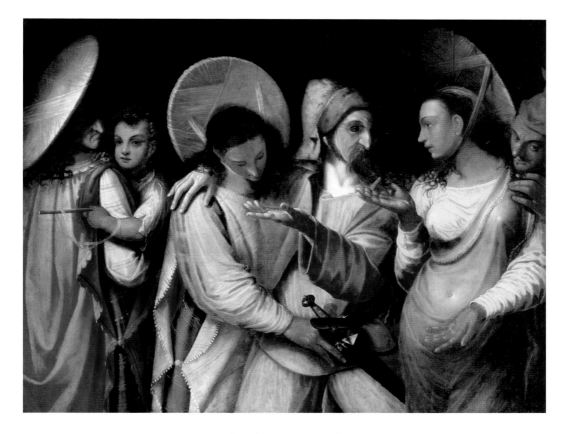

Attributed to **Nicolas Bollery**
French, active from 1585, died 1630
The Actors, c. 1595/1605
Oil on canvas, 46⁹⁄₁₆ x 58⅛ inches
Museum purchase, 1955, SN 688

The Actors seems to be one of the earliest treatments of a major theme in 17th-century art, that of wily women duping an "innocent" man. In this painting, two gypsy women, recognized by their costumes, trick a theatrical buffoon, or *zanni*. One of the gypsies, wearing the garb of a prostitute, reaches for the purse of the actor while the other distracts him. The retinue of accomplices also includes a procuress with a child.

The theme of deceit became common in art and theater during this period. It is best exemplified in famous paintings by Caravaggio and Georges de la Tour. While the artist of this painting is not known with certainty, the work is currently attributed to the late Mannerist artist Nicolas Bollery. He was described by his contemporaries as "an artist in Paris…painter of night scenes, animals, masquerades, Mardi-Gras, similar festivities…in somewhat the style of Bassano."

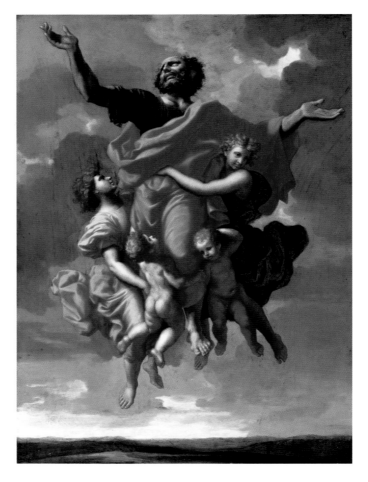

Nicolas Poussin
French, 1594–1655, active in Rome and Paris
The Ecstasy of Saint Paul, 1643
Oil on wood panel, 16⅜ x 11⅞ inches
Museum purchase, 1956, SN 690

In this small painting, Nicolas Poussin was faced with two huge tasks. He had to flatter his major patron as well as compete with the artist he most admired. The patron was Paul Fréart de Chantelou, a connoisseur who commissioned Poussin's major religious cycle, *The Seven Sacraments.* The artist whom Poussin most admired was the Renaissance master, Raphael, whose *Vision of Ezekiel* was owned by Chantelou.

According to the New Testament, during an ecstatic vision St. Paul was carried by angels to the Third Heaven. Poussin chose the subject of St. Paul both as a natural New Testament complement to the Hebrew prophet Ezekiel, as well as to honor his patron, Paul.

When the painting was finished, Poussin wrote a letter to Chantelou asking him never to show his painting next to that of Raphael. Instead, he suggested it be used as a cover for "that precious painting."

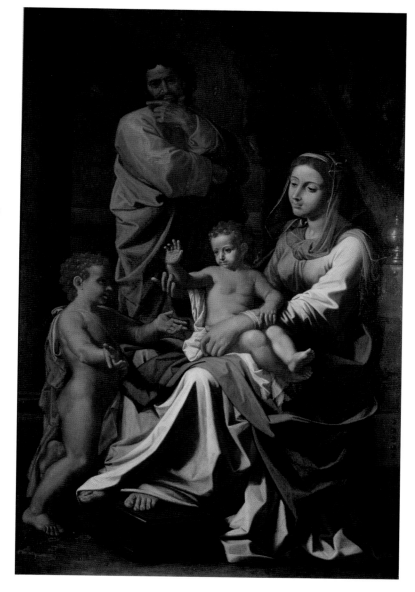

Nicolas Poussin
French, 1594–1655, active
in Rome and Paris
*The Holy Family with the
Infant Saint John the
Baptist*, 1655
Oil on canvas,
78¼ x 51½ inches
Bequest of John Ringling,
1936, SN 361

An example of Nicolas Poussin working on a small scale on the opposite page is a powerful comparison to this *Holy Family* showing him painting on his very largest scale. Indeed, these statue-like life-size figures are among the finest examples of Poussin's late style, which was called the "Magnificent Manner." In these late paintings, Poussin turned away from the observation of nature and towards a nearly abstract geometry. Here, there is little movement, but rather the majestic raising of the infant Christ child's hand as he imperiously blesses the young St. John the Baptist. His parents, Mary and Joseph, resemble hollow-eyed ancient bronzes. While a grandiose and moving statement of faith, the painting can also seem strangely unreal.

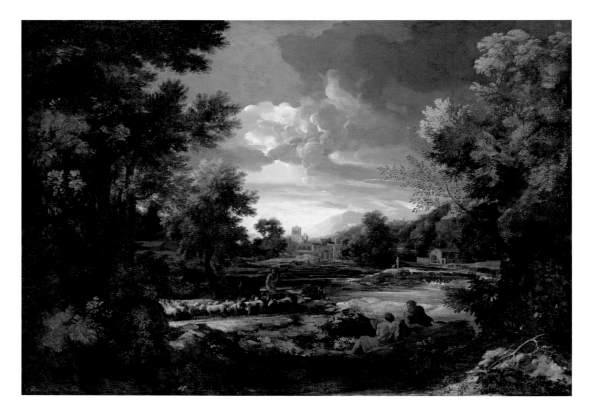

Gaspard Dughet
French, 1615–1675, active in Rome
A Valley after a Shower, c. 1655–1656
Oil on canvas, 38⅜ x 53¼ inches
Bequest of John Ringling, 1936, SN 362

These two works show different kinds of landscape painting that were popular in 17th-century France. Dughet's brightly lit view seems to show a believable countryside, though it is one with figures from the ancient past. In reality, Dughet's landscape has little to do with the observation of nature. Instead, it attempts to translate ancient poetry about country life, such as Virgil's *Eclogues* or *Georgics,* into pictorial terms. François de Nomé's painting, on the other hand, seems startlingly macabre and unrealistic. His landscapes and interiors are meant to reflect the artist's imagination as much as the historic past. No wonder he is considered a forerunner of the Surrealists in the 20th century.

François de Nomé (also called Monsù Desiderio)
French, c. 1598–c. 1644, active in Naples
Imaginary Tomb of a Crusader, 1618
Oil on canvas, 37¼ x 15¾ inches
Museum purchase, 1970, SN 215

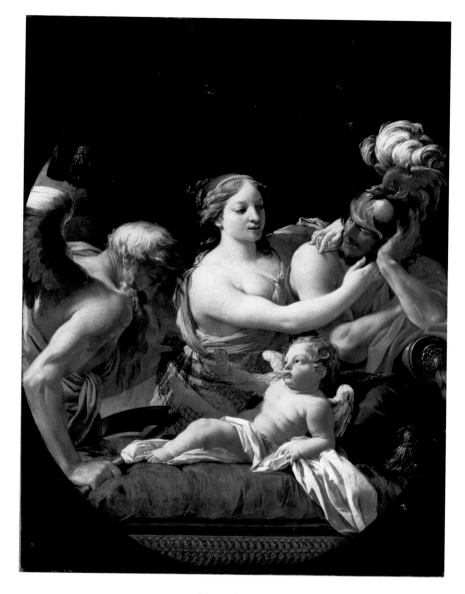

Simon Vouet
French, 1590–1649, active in Rome and Paris
Time Discovering the Love of Venus and Mars, c. 1640
Oil on canvas, 57 ½ x 42 ½ inches
Bequest of John Ringling, 1936, SN 360

Simon Vouet's painting is a complex literary allegory in a very sophisticated style. In ancient mythology, Venus was married to the smith Vulcan, but she had an affair with Mars, the god of war. Their lovemaking was exposed to the amusements of the other gods when Vulcan trapped them in a metal net he had made. From this illicit union was born the young Cupid, also known as Eros, Amor or Love. In the painting, the winged figure of Father Time, Chronos, reveals their love to the world in the form of the young Cupid. Meanwhile, Venus and Mars gaze smiling into each other's eyes—they have fallen into love's trap.

EUROPEAN
17TH-CENTURY WATCHES

Small watches came into fashion in the late 16th century. They were exquisite and expensive objects that demanded the crafts of the glasscutter, the goldsmith and the enamelist, as well as the clockworks maker. Usually, highly worked elaborate gilt covers protected the faces. Sometimes covers were made of crystal through which one could see the dials. Engraved or enameled scenes of mythology or Christian subjects decorated the faces. The primary shapes were fleur-de-lis, cruciform, rose, heart or oval. These small objects were relics of a revolution in technology that had wide societal implications—the hours now ruled people's everyday lives.

Various materials including
precious metals and crystal
Bequest of John Ringling
1936

A famous story from ancient history about the courtship of the Roman general Anthony and the Egyptian queen Cleopatra concerns a contest held in the form of a banquet. Each was to present dishes that would reflect their great wealth. Anthony presented exquisite morsels on elaborate gold tableware. Cleopatra seemed at first to have nothing prepared. Then she held out a cup of wine and dropped a large pearl inside, offering it to Anthony to drink. The pearl dissolved in the wine, and Cleopatra won the contest. Vignon's highly original style of painting employs widely varying brushstrokes and impasto that enhance the illusion of gold and jewelry and diaphanous silk.

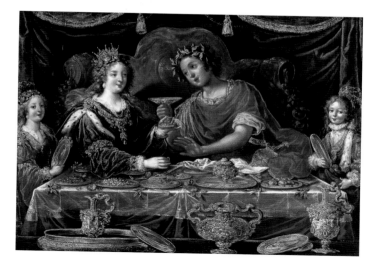

Claude Vignon
French, 1593–1670, active in Rome and Paris
The Banquet of Anthony and Cleopatra, c. 1640
Oil on canvas, 32¼ x 44¼ inches
Museum purchase, 1951, SN 653

This is one of the earliest surviving harpsichords with ornamentation typical of the classicizing designs of the period. The base is a 19th-century replacement in the French Rococo style. Although the keyboard is missing, the casing and decorations are intact. The interior of the lid reveals a scene of Apollo, the god of music, pursuing the nymph Daphne. Surely this depiction referred to the way listeners were unwillingly seduced by the sounds that originally emanated from the divine instrument.

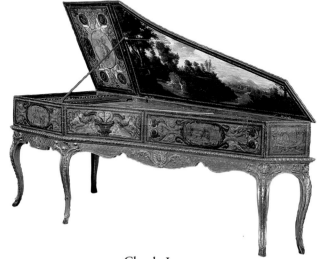

Claude Jacquet
French, active in Paris after 1632
Harpsichord, 1652
Carved, painted and gilded wood, 35⅝ x 89¼ x 32¼ inches
Bequest of John Ringling, 1936, SN 1108

BAROQUE ART IN SPAIN AND ITS DOMINIONS
The Age of Velázquez

THE APPEARANCE of paintings by the Venetian artist, Titian, in the mid-16th century totally transformed Spanish art. Although Spain had an important art tradition of its own before Titian, King Philip II (1527–1598) extensively patronized this Venetian artist, who was known for his open brushwork and for his dazzling light effects.

Philip II's grandson, King Philip IV, aimed to compete with his grandfather as a patron of art during the forty years he ruled Spain. This he accomplished both by employing the Flemish artist, Peter Paul Rubens, and by recognizing and fostering the talents of Diego Velázquez as his court painter.

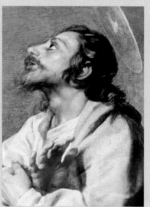

Many artists followed Velázquez's free brushwork and dignified compositional style. Among his followers were Juan de Pareja, Alonso Cano, and Juan Carreño de Miranda, as well as Velázquez's son-in-law Juan Bautista Martínez del Mazo, represented in the Ringling collection.

Spain's dominions during the 1600s included not only the Southern Netherlands, home of Rubens, and Naples, home of Jusepe de Ribera, but also portions of the Americas. Spanish artists were sent to the American continent by Philip IV to decorate the many monasteries and churches built for the conversion of the indigenous people to Catholicism. Spanish artists thereby both reflected and promulgated the style and beliefs of Spain across great distances.

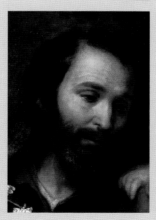

Attributed to
Juan Bautista Martínez del Mazo
Spanish, 1613–1667, active in Madrid
*Portrait of Doña Mariana of Austria, Queen
of Spain as a Young Woman*, c. 1652/53
Oil on canvas, 57¾ x 45 inches
Bequest of John Ringling, 1936, SN 337

Mariana, daughter of Emperor Ferdinand
III of Austria and Mary of Hungary,
became the second wife of her uncle,
King Philip IV of Spain. Their children
were often portrayed by the court painter,
Velázquez. One of the most famous
portrayals is in *Las Meninas*, whose
central figure, the Infanta Margarita,
strikingly resembles her mother. This
portrait of the young Mariana is very
likely painted by Velázquez's son-in-law
Martínez del Mazo, who worked closely
with his more famous father-in-law. It is
largely based on a prototype by Velázquez
now in the Prado Museum.

Juan Carreño de Miranda
Spanish, 1614–1685, active in Madrid
*Portrait of Doña Mariana of Austria, Queen of
Spain as Widow and Regent*, c. 1673
Oil on canvas, 68⅜ x 39¾ inches
Bequest of John Ringling, 1936, SN 338

After Philip IV's death in 1665, Mariana
ruled as Queen Regent until 1675. In
Carreño's portrait, Mariana is portrayed
seated in the Hall of Mirrors in the Alcázar
Palace in Seville. She wears the habit of a
nun, common dress for royal widows. This
portrait was probably based on a prototype
by Martínez del Mazo now in the National
Gallery, London. It differs, however, from
the model by emphasizing the maturity and
resiliency of the Regent, whose son Charles II
was the last Hapsburg monarch of Spain.

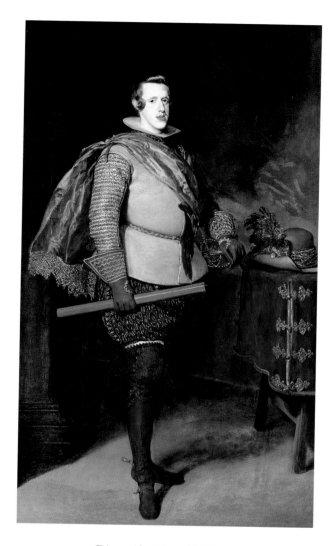

Diego (de Silva y) Velázquez
Spanish, 1599–1660, active in Seville and Madrid
Philip IV, King of Spain, c. 1625/28
Oil on canvas, 82⅜ x 47⅞ inches
Bequest of John Ringling, 1936, SN 336

Philip IV ruled Spain and its dominions for over forty years during the 17th century. Much of Philip's reign was spent at war, most notably the Thirty Years War. It was as a military leader that Diego Velázquez most often portrayed the monarch. Indeed, this painting is probably the earliest of his many military portraits of Philip. Velázquez made numerous changes to the composition of this painting, such as the outline of the monarch's cape, the position of the table and the armor. These repaints, or *pentimenti,* are now easily visible to the naked eye. They give testimony to the young painter's struggle to find an appropriate formula with which to portray the powerful king.

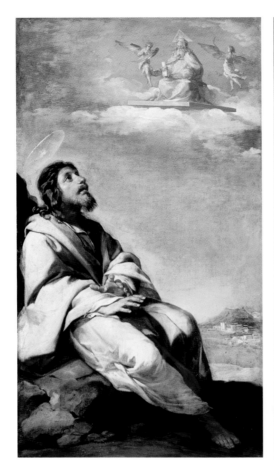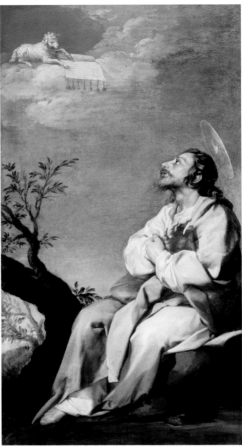

Alonso Cano
Spanish, 1601–1667, active in Granada, Seville, and Madrid
Saint John the Evangelist's Vision of God, left, and
Saint John the Evangelist's Vision of the Lamb, right, 1638
Each, oil on canvas, 28½ x 15¾ inches
Bequest of John Ringling, 1936, SN 344 and SN 345

These two paintings depict scenes of St. John's visions, recounted in the Apocalypse. The paintings were originally part of a large multi-paneled altarpiece that was in the convent church of St. Paula in Seville. Other paintings from this dispersed altar are now in the Louvre, Paris, and in the Wallace Collection, London. Here, Alonso Cano used highly keyed artificial colors and bright lighting to accentuate the visionary nature of the subject matter.

Cano was a pupil of Francisco Pacheco in Seville, where he became a lifelong friend of fellow student Velázquez. Cano's life was marked by turmoil. His wife was murdered in 1644. Although Cano had been suspected of hiring the assassins, he was ultimately acquitted. In addition to his work as a painter, Cano was also active as an architect and sculptor. His design for the façade of the Cathedral in Granada is his most notable work as an architect.

Jusepe de Ribera
Spanish, c. 1590–1652, active in Naples
Madonna and Child, 1643
Oil on canvas, 43¾ x 39¾ inches
Bequest of John Ringling, 1936, SN 334

The Madonna and Child perched on a lunar crescent is an unusual image of the Virgin referred to as the "Immaculate Virgin." The image was meant to promote visually the doctrine that Mary was free from original sin. The use of the moon to convey the idea of purity persists today in sayings such as "chaste as the moon."

The Immaculate Conception was an especially important propagandistic subject with Catholic artists of the 17th century. The image of the Immaculate Virgin was derived from the vision of St. John the Evangelist who, in the Apocalypse, described a woman "clothed with the sun, and with the moon under her feet." Ribera reveals his naturalist tendencies by depicting the Virgin as an ordinary woman. The smiling Christ child also brings a touch of humanity to this abstract concept.

Bartolomé Esteban Murillo
Spanish, 1618–1682, active in Seville
St. Joseph with the Standing Infant Christ
Oil on canvas, 42¾ x 33¾ inches
Bequest of John Ringling, 1936, SN 349

It is rare to see St. Joseph depicted as a major figure in religious paintings. More commonly the infant Christ is shown with His immaculately conceived Mother. However, in the 17th century St. Joseph did become a focus of his own cult, as did many other minor saints. Murillo was well known for his pictures of everyday life, and also of smiling children. Indeed, stripped of their haloes and religious attributes, the figures here could represent any loving father and happy child.

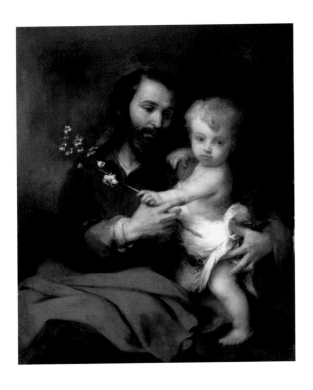

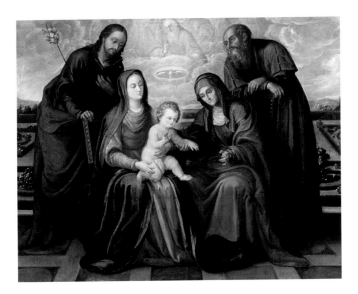

Nicolás Rodríguez Juarez
Mexican, 1667–1734, active in Mexico City
The Holy Family with Saints Anne and Joachim, 1699
Oil on canvas, 86¼ x 77¾ inches
Bequest of John Ringling, 1936, SN 353

Art played an important role in the Spanish colonization of the Americas. The need for paintings to decorate the many newly built churches and monasteries resulted in the migration of many Spanish-trained artists to the Americas. They not only founded hugely productive workshops, but also professional academies and artistic dynasties. Nicolás Rodríguez Juarez was a second-generation colonial artist; his grandfather, Luis, settled in Mexico in the early 17th century. Nicolás is best known for having provided many altarpieces for the Cathedral in Mexico City in the 1690s. Here, he depicts an idyllic vision of the Christian religion exemplified by the calm, happy Holy Family, with St. Anne and St. Joachim, Mary's parents, sitting in a carefully manicured European-style garden.

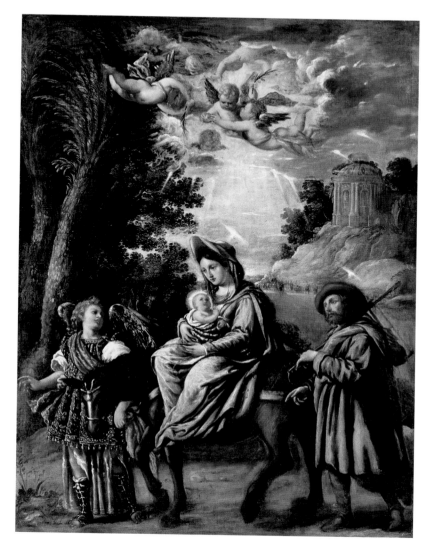

Juan de Pareja
Spanish, c. 1606/10–c. 1670, active in Seville and Madrid
The Flight into Egypt, 1658
Oil on canvas, 66½ x 49⅜ inches
Bequest of John Ringling, 1936, SN 339

Juan de Pareja, of Muslim descent, became an assistant to Diego Velázquez in the 1630s and accompanied him to Italy in 1649. In Rome, Velázquez painted a portrait of Pareja (now in The Metropolitan Museum of Art, New York) that so astonished the city's greatest artists and connoisseurs that Pope Innocent X immediately commissioned Velázquez to portray him in his robes of office. This portrait is now in the Doria Pamphili Gallery, Rome. Despite his long, close association with Velázquez, Pareja's style in this painting shows little trace of his more famous colleague's influence. Instead, Pareja looked to Italian artists of the 16th century, especially Titian, as models for his composition and his brushwork.

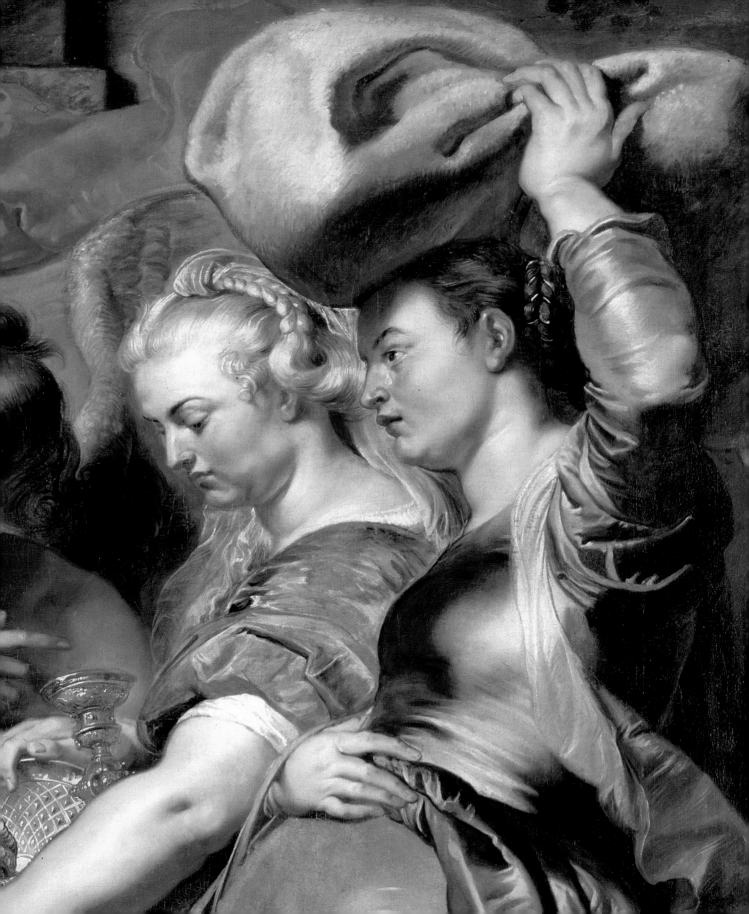

BAROQUE ART IN FLANDERS
The Age of Rubens

IN THE 17th century, the Northern Provinces of the Netherlands separated from the Southern Provinces and became a Protestant state, while the Southern Provinces remained under the rule of members of the Spanish Hapsburg dynasty. These royals from the Spanish Hapsburgs, including Philip IV's aunt, the Archduchess Isabella Clara Eugenia, and Philip IV's nephew, the Archduke Ferdinand, were both major patrons of Peter Paul Rubens.

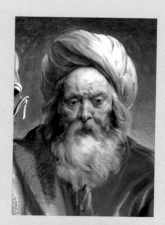

Rubens served these rulers not only as a painter, but also as a diplomat. He traveled extensively and was given major commissions in almost every Catholic country in Europe. Though Rubens was known as a painter of grandiose cycles that glorified monarchs, heroes and the faith (as in *The Triumph of the Eucharist* series), he was also an architect, a sensitive portraitist and an innovative landscape painter.

Above all, Rubens had a huge range of expression. When painting subjects from history, mythology and religion he was able to convey jubilation and tragedy with equal ability. Rubens' art, with its free brushwork and realistic sense of movement and emotion, quickly supplanted the elegant artificiality of earlier painters such as Abraham Janssens.

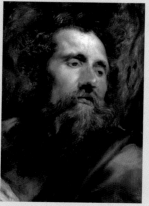

Indeed, Rubens became so popular that he needed many workshop assistants to aid him in the execution of his grandiose commissions. The best of these assistants, such as Anthony van Dyck, Frans Snyders and Jacob Jordaens, later branched out on their own and became admired specialists in their respective fields. Because of Rubens' influence, the still lifes, animal paintings and portraits of his pupils were much fuller in movement and color than their Dutch counterparts.

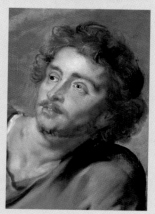

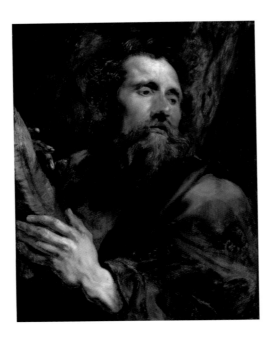

Anthony van Dyck
Flemish, 1599–1641, active in Antwerp,
Genoa, and London
Saint Andrew, 1621
Oil on wood panel, 25 ½ x 20 ¼ inches
Bequest of John Ringling, 1936, SN 227

This painting is one of a series of Christ and the Apostles now dispersed in worldwide museums and collections. It is a sensitive psychological portrayal of a religious visionary. St. Andrew's cross refers to his later martyrdom. This painting is typical of Van Dyck's first manner, in which the darkness of his forms and palette were heavily influenced by Caravaggio.

Also influenced by Caravaggio, Nicolas Régnier depicted St. Matthew writing his gospels with the divine assistance of the angel. Formal qualities such as realistic types, half-length format and the strong contrasts of dark and light are especially typical of works produced under Caravaggio's inspiration. Although born in Flanders, Régnier lived most of his life in Italy. He lived first in Rome, then in Venice, where his daughter Clorinda also became a famous painter.

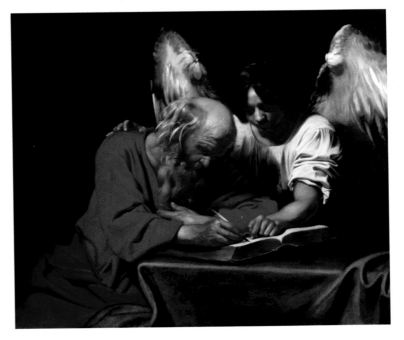

Nicolas Régnier (also called Niccolò Renieri)
Flemish, 1591–1667, active in Rome and Venice
Saint Matthew and the Angel, c. 1625
Oil on canvas, 42 ½ x 48 ¾ inches
Bequest of John Ringling, 1936, SN 109

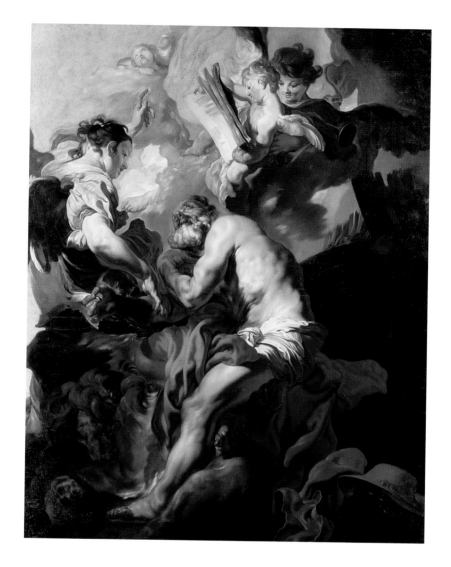

Johann Liss
German, 1597–1631, active in Antwerp, Rome, and Venice
The Vision of Saint Jerome
Oil on canvas, 80¾ x 61¾ inches
Bequest of John Ringling, 1936, SN 311

Unlike Nicolas Régnier's earthbound St. Matthew on the opposite page, Johann Liss' St. Jerome is a visionary ecstatic who received the word of God in a flash of inspiration. Accordingly, Liss' style is full-blown Baroque. Complex in color and swift in brushwork, the composition swirls upward so that we follow the transition from earth to heaven traversed by the saint. This magnificent altarpiece is believed to be the first of many versions of which the best known is in the Venetian church of San Nicolò da Tolentino. However, in that later work, Liss had already abandoned the influence of Flemish models, such as Rubens, still evident here in the ruddy flesh tones and thickly applied brushwork.

Jacob Jordaens
Flemish, 1593–1678, active in Antwerp
Boaz (left) ***Ruth and Naomi*** (right), c. 1641–1642
Each, oil on canvas, 76½ x 30¾ inches
Museum Purchase, 1984, SN 987-988

The subject for these paintings is drawn from the Biblical book of Ruth. Ruth, the seated young woman, was a pious widow who lived with her mother-in-law, Naomi. Ruth's simplicity and good conduct made her attractive to her older relative, Boaz. Since they lived in a time of famine, Boaz courted her with gifts of grain. They were later wed, and were considered to be ancestors of Christ through their great-grandson, David. These paintings were probably made by Jacob Jordaens to decorate his own house. Because of their steep, illusionistic perspective, best seen in the projecting shoe of Boaz and Ruth's bucket, the canvases are thought to have stood to either side of a high window or over an elaborate doorway.

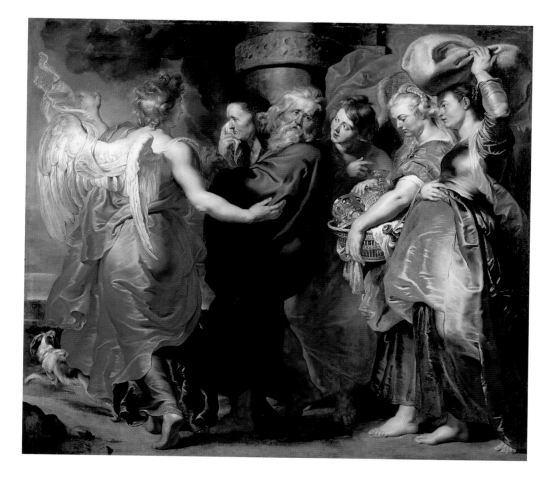

Peter Paul Rubens
Flemish, 1577–1640, active in Antwerp and throughout Europe
The Departure of Lot and his Family from Sodom, c. 1613/15
Oil on canvas, 86¾ x 96 inches
Bequest of John Ringling, 1936, SN 218

According to the Bible story, God disapproved of the morals of the inhabitants of Sodom, and therefore decided to destroy the city. Lot and his family were saved from this devastation because Lot had protected God's angelic messengers from the curiosity of the Sodomites. In this depiction, the angels lead Lot, his wife and daughters away from their home.

Rubens has chosen to present a moment of joy mixed with sorrow—gladness for being saved from destruction, but distress at the family's many sufferings. Although Lot and his family were spared God's wrath at that time, they were subsequently punished for other transgressions. Lot's wife was turned into a pillar of salt for not obeying God's edict not to look back at the annihilated city. Later, Lot's daughters, believing they were the last people on earth, conspired to make their father drunk and committed incest with him in order to procreate the world. Their descendents, the Ammonites, became the enemies of Israel. By showing the moment of highest drama, or *peripateia,* Rubens presents us with the equivalent in paint of an ancient tragedy.

103

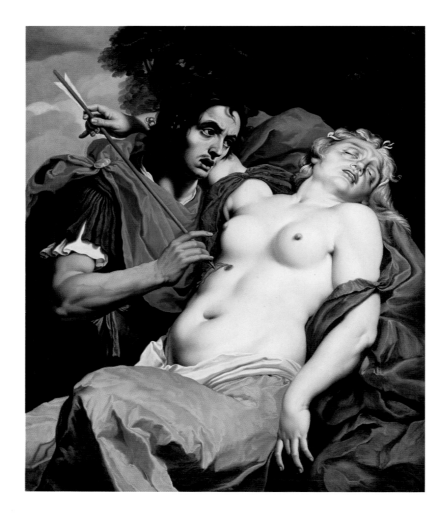

Abraham Janssens
Flemish, c. 1575–1632, active in Rome and Antwerp
Cephalus Grieving over the Dying Procris, c. 1610
Oil on canvas, 49½ x 41¾ inches
Museum purchase, 1999, SN 11035

This pathos-filled scene shows an episode in one of the great love stories of ancient literature as told by the Roman poet Ovid in *The Metamorphoses*. Cephalus and Procris were newly married when the jealousy of the gods forced these mortals to be unhappy by doubting each other's love. While hunting, Cephalus accidentally killed his wife, who had been hiding in the bushes in order to entrap him in a liaison with a nymph. Here, Abraham Janssens concentrates on the most dramatic moment of the tragedy. With horror, Cephalus realizes the consequences of his jealousy as he movingly receives Procris' dying embrace.

Janssens was the premier artist in Antwerp before Rubens returned from Italy after 1600. This painting shows the harsh and sculptural quality of Janssens' style. This elegant but mannered way of painting the human body was supplanted by Rubens' softer and more tender modeling of human flesh, as in *Pausias and Glycera* on the opposite page.

Peter Paul Rubens (figures)
Flemish, 1577–1640, active in Antwerp and throughout Europe
and **Osias Beert I** (flowers)
Flemish, c. 1580–1623/24, active in Antwerp
Pausias and Glycera, c. 1612/15
Oil on canvas, 80 x 76½ inches
Bequest of John Ringling, 1936, SN 219

The handsome young couple is the ancient painter, Pausias, and his lover, Glycera, celebrated for her skill at making floral wreaths. Pausias was famous for being the first to master illusionistic painting techniques. He employed his skill to reproduce Glycera's floral compositions with great exactness. This painting self-consciously celebrates the rivalry between art and nature. Which is more beautiful—Glycera's flowers or Pausias' paintings of them?

Sometimes the practice in the 17th century called for two painters to collaborate on a single work. Here, the exquisitely detailed flowers are by Rubens' collaborator Osias Beert. Because of the great expertise of this still life specialist whom Rubens employed, it is likely that the friendly competition between Pausias and Glycera has been repeated in modern terms; that is, with the viewer being asked to compare the skills of Beert with those of Rubens.

Exotic animals, both dead and alive, were the specialty of Frans Snyders, who sometimes collaborated with Rubens. Here, the expensive raw foodstuffs are shown to us as if waiting to be taken from the table by an unseen cook. A cat lurks under the table, waiting for a moment to snatch a treat from the abundant stock of this rich man's larder. The bounty depicted in this painting was certainly meant to stand for the wealth of its owner. There is little doubt that it was in this spirit that even rich men from later times, such as John Ringling, must have displayed and appreciated it.

Frans Snyders
Flemish, 1579–1657, active in Antwerp
Still Life with Dead Game
Oil on canvas, 66⅜ x 103 inches
Bequest of John Ringling, 1936, SN 234

Southern Netherlands, 17th century
Paintings attributed to **Frans Francken II** (Flemish, 1581–1642, active in Antwerp).
Cabinet Decorated with Scenes from the Old Testament
Various ebony-finished woods, metals, glass, and ivory, 28 x 28¼ x 13¾ inches
Museum Purchase, 1974, SN 1950

Unlike the Snyders above, luxury was not always synonymous with vice. Resplendent cabinets such as this one were made with the costliest materials (or with more reasonable facsimiles thereof) such as ebony, ivory, tortoiseshell and precious metals. In this case, the decoration of the cabinet with scenes from the Bible makes the object appear less ostentatious in its display of wealth. However, the decoration presumably had little to do with the contents of the chest. It was, indeed, a "treasure chest" made to hold small costly collectibles, medallions, jewelry and natural curiosities such as shells.

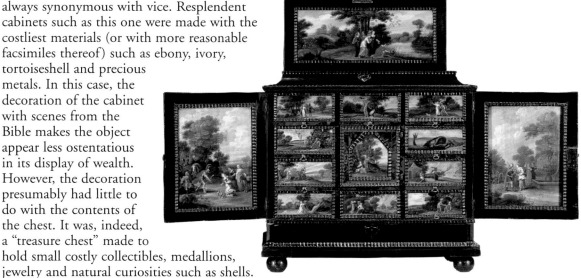

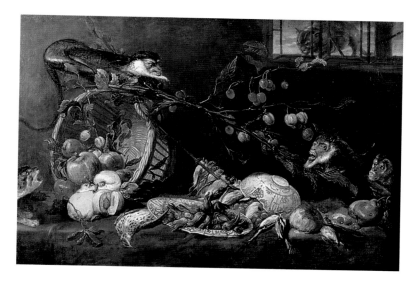

Frans Snyders
Flemish, 1579–1657,
active in Antwerp
*Still Life with Fighting
Monkeys*, c. 1635
Oil on canvas,
29½ x 42½ inches
Bequest of John Ringling,
1936, SN 235

To a casual modern viewer, these two paintings might seem very different. Frans Snyders shows a group of violent monkeys (above) and David Teniers a tavern interior (below). However, a 17th-century viewer of these works would have been moved to lively reactions and moral judgments. The beautifully painted surface of the Teniers' painting contrasts strongly with the humble nature of the idle peasants. While the rich clients of Teniers were probably meant to laugh at his subjects, the wealthy viewers of Snyders' painting were more sternly admonished. Men, represented by monkeys, fight over women, symbolized by cats. The result is a household of discord. Covet worldly things too much and you will be reduced to the level of these savage simians.

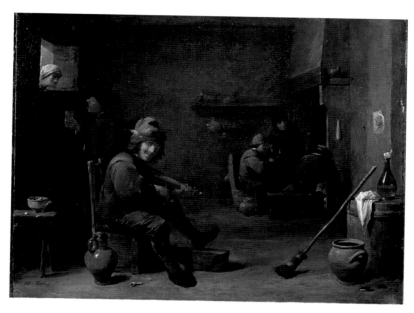

David Teniers II
Flemish, 1610–1690, active
in Antwerp and Brussels
Fiddler in a Tavern,
c. 1643
Oil on wood panel,
14¼ x 18¾ inches
Bequest of John Ringling,
1936, SN 243

THE TRIUMPH OF

Peter Paul Rubens' Cycl

IN THE EARLY part of the 17th century the religious and political struggle between the Netherlands and Spain resulted in the "Dutch Revolt" and the longest war in modern European history. The Southern Provinces remained under the control of Spain and the Catholic Church where they were ruled by members of the Spanish Hapsburg family who did everything in their power to uphold the Church and its doctrines.

The *Triumph of the Eucharist* series by Peter Paul Rubens was a commission for a huge propagandistic cycle on the doctrines and practices of the Catholic faith. The central subject was the Eucharist; the sacramental bread was also called a host or eucharistic wafer offered by the priest during the Mass. This sacrament became a key element in the controversy between Protestants and Catholics.

The doctrine of transubstantiation was ratified by the Catholic Church at the Council of Trent in 1551. This doctrine makes clear that for Catholics the bread and wine, which are consumed by the congregation during the Mass, undergo the miraculous transformation into the body and blood of Christ when they are blessed by a priest. In contrast, Protestants believed that the bread and wine symbolize the body and blood of Christ. This major difference of opinion led to radically opposed views of both the service and the role of the priesthood.

The series of paintings was ordered by Isabella Clara Eugenia, who governed the Southern Netherlands from 1599 to 1633, as a design for a set of tapestries she then gave to her convent, the Royal Discalced Nuns (*Las Descalzas Reales,* also called the Poor Clares) in Madrid. The Infanta's commission

THE EDICT

IF ANY ONE SHALL SAY THAT, IN THE MOST HOLY SACRAMENT OF THE EUCHARIST, THERE REMAINS THE SUBSTANCE OF BREAD AND WINE TOGETHER WITH THE BODY AND BLOOD OF OUR LORD JESUS CHRIST; AND SHALL DENY THAT WONDERFUL AND SINGULAR CONVERSION OF THE WHOLE SUBSTANCE OF THE BREAD INTO THE BODY, AND OF THE WHOLE SUBSTANCE OF THE WINE INTO THE BLOOD, THE SPECIES OF BREAD AND WINE ALONE REMAINING, WHICH CONVERSION THE CATHOLIC CHURCH MOST FITTINGLY CALLS TRANSUBSTANTIATION, LET HIM BE ANATHEMA.

Council of Trent, 1551,
Session 13, Canon 2

of the series by Rubens provided the convent with a suitable and permanent set of hangings for their biannual processions.

The main cycle was comprised of eleven thematic and narrative groups all relating to the theme of the Eucharist. Old Testament scenes such as *The Meeting of Abraham and Melchizedek* and *The Gathering of the Manna* prefigured the sacrament of communion. Two groups of figures related to the Eucharist are

THE EUCHARIST
for the Catholic Monarchy

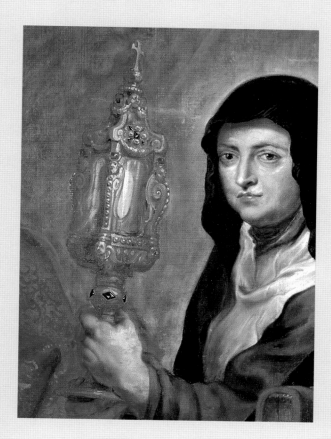

Isabella Clara Eugenia in the guise
of St. Clare carrying a monstrance, detail of
The Defenders of the Eucharist (page 115)

Hebrew temple built by King Solomon in Jerusalem. This is why Rubens designed the series of actual tapestries to represent curtains held up by *putti.* An additional related set of tapestries was hung around the altar, and represented members of the Spanish monarchy in the act of worship.

While preparatory paintings such as these cartoons were not usually considered as works of art in their own right, Isabella kept these cartoons, and sent the tapestries to Spain. The tapestries are still located at the Convent of the Poor Clares in Spain for which they were made. The cartoons themselves were considered such exceptional works of art that they were sent to Loeches, Spain by decree of Philip IV in 1648. Some were then taken by Napoleon's troops from this collection in 1808. In turn, some of those were acquired by the Duke of Westminster in 1818 for his home, Grosvenor House, in London, where they were widely admired.

Only seven of the cartoons now survive. Five are in the Ringling Museum. Two others, *Elijah and the Angel* and *The Triumph of the Catholic Faith,* are now owned by the Louvre. John Ringling bought four of the cartoons in 1926 from descendants of the Duke of Westminster. *The Triumph of Divine Love* was purchased by the Ringling Museum in 1980. The Museum's *Eucharist* series is the only example of a large-scale cycle by Rubens visible outside Europe.

shown in procession—characters from the New Testament who are depicted in *The Four Evangelists* as well as historical figures of the Catholic Church in *The Defenders of the Eucharist.* Finally, allegorical triumphs and victories such as *The Triumph of Divine Love* reinforced the series' propagandistic tone.

Together, the eleven original tapestries were meant to recall the eleven curtains that decorated the tabernacle of the original

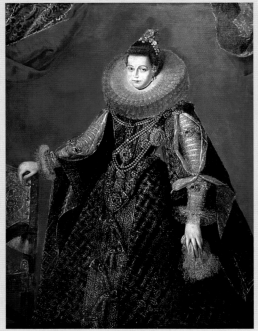

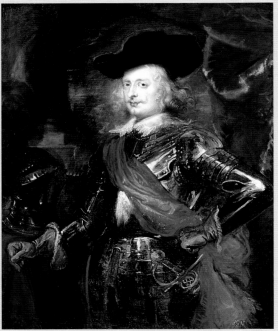

Gaspar de Crayer
Flemish, 1584–1669, active in Antwerp
Portrait of the Infanta Isabella Clara Eugenia,
c. 1620
Oil on canvas, 67¼ x 50⅛ inches
Bequest of John Ringling, 1936, SN 217

Peter Paul Rubens
Flemish, 1577–1640, active in Antwerp
and throughout Europe
Portrait of Infante Ferdinand, 1635
Oil on canvas, 45¾ x 37 inches
Museum purchase, 1948, SN 626

Isabella Clara Eugenia was a daughter of King Philip II of Spain. In 1599 she married the Archduke Albert of Austria and after his death became sole governess of the Southern Netherlands, now modern Belgium. She died in Brussels in 1633. Isabella was a major patron of Rubens from his early years, culminating with the commission for the *Triumph of the Eucharist* series. De Crayer was a follower of Rubens and was also extensively employed by Isabella and her successor the Archduke Ferdinand. Rubens portrayed the Archduchess dressed as St. Clare in the cartoon for *The Defenders of the Eucharist.*

Archduke Ferdinand, the younger brother of King Philip IV of Spain, was known as a military hero. He represented Spanish interests in Northern Europe as governor of the Netherlands after the death of his aunt, the Archduchess Isabella Clara Eugenia in 1633. He is here shown by Rubens as a military commander after he won a decisive victory against Protestant forces at Nördlingen in 1634.

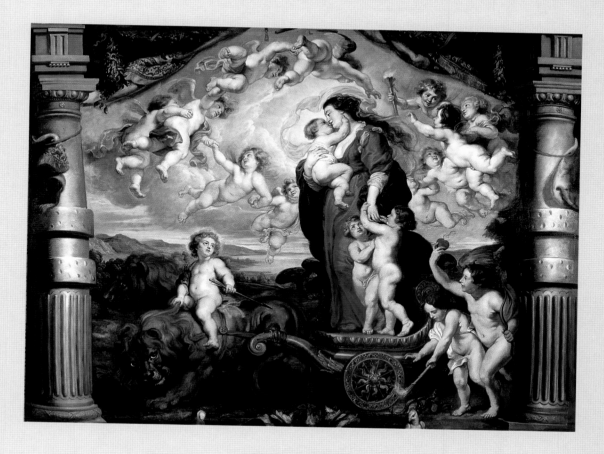

Peter Paul Rubens
Flemish, 1577–1640, active in Antwerp and throughout Europe
The Triumph of Divine Love, c. 1625
Oil on canvas, 152 x 204 inches
Museum Purchase, 1980, SN 977

Rubens depicted the "Love of God" as the motherly figure of Charity whose milk is sufficient to nourish all her children. Resembling the Virgin Mary, she is shown standing on a small processional chariot drawn by two lions. Beside her a pelican pierces its breast to feed its young, a sacrificial gesture symbolizing that of Christ's. A halo of flying *putti* (child-angels) fills the air. Three more putti are land-bound: one bends to burn intertwined snakes, traditional symbols of sin and evil; another raises a flaming heart and a bow. The third putto, astride one of the lions, brandishes the arrow of sacred love.

The theme of love, both sacred and profane, is thus announced by the putti using their cupid-like bow and arrow, the torch that ignites the feeling of love and the flaming heart. All three of these attributes recur throughout Rubens' composition. Notice, for example, that the spokes of the chariot wheel radiate alternating arrows and shafts of flame.

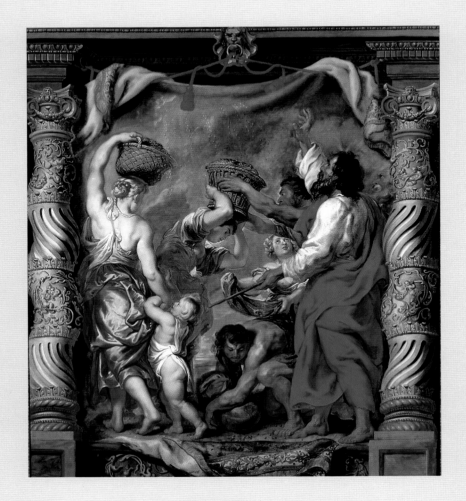

Peter Paul Rubens
Flemish, 1577–1640, active in Antwerp and throughout Europe
The Gathering of the Manna, c. 1625
Oil on canvas, 192 x 162 inches
Bequest of John Ringling, 1936, SN 211

The manna that the Israelites gathered in the desert, like the bread and wine offered
to Abraham by Melchizedek in the other Old Testament cartoon, prefigures the
New Testament Eucharist. The subject, taken from Exodus 16:13–36, represents a
second miraculous feeding, or divine nourishment, of the Israelites during their
journey through the Sinai desert. The white flakes of Manna that mysteriously fell
from Heaven are here shown as round wafers that resemble the host of the Mass.

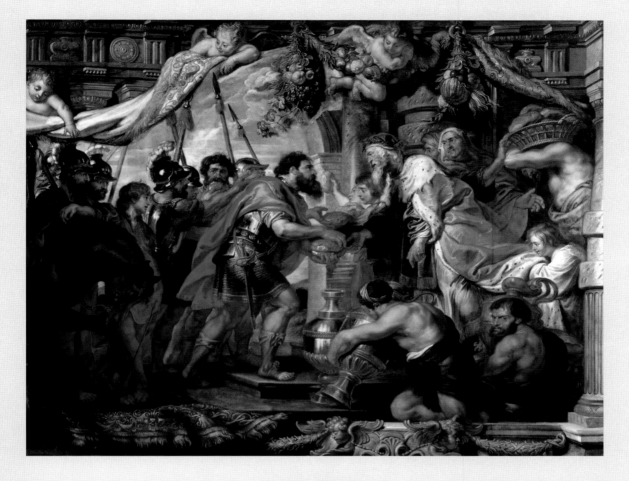

Peter Paul Rubens
Flemish, 1577–1640, active in Antwerp and throughout Europe
The Meeting of Abraham and Melchizedek, c. 1625
Oil on canvas, 175¼ x 224¾ inches
Bequest of John Ringling, 1936, SN 212

The largest and most ambitious artistically of the Ringling cartoons is *The Meeting of Abraham and Melchizedek*. The subject is an episode from Genesis 14:17–24, where the patriarch Abraham returns victorious from the battle of Dan. Melchizedek, priest-king of Salem, later called Jerusalem, offers Abraham bread and wine and blesses him. In return the patriarch offers the High Priest gifts from the spoils of battle. Rubens shows the offering of the bread and wine by the priest-king as a prefiguration of the Christian Eucharist and the institution of the papacy. Melchizedek, standing in the higher position, hands down the offering to Abraham, as if handing down of the Eucharist from the altar in the Catholic Mass. The figures attending the High Priest reflect the assistance of acolytes in the sacramental rite.

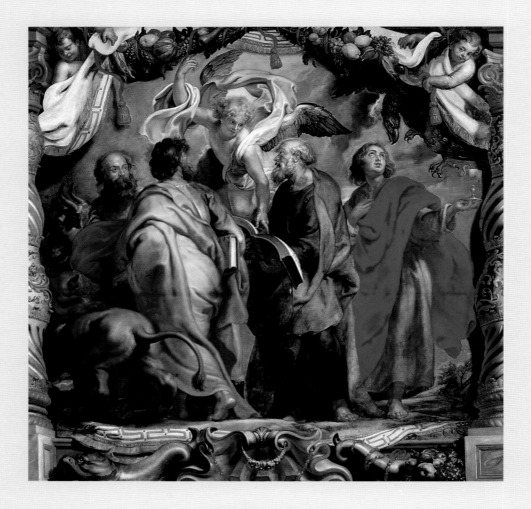

Peter Paul Rubens
Flemish, 1577–1640, active in Antwerp and throughout Europe
The Four Evangelists, c. 1625
Oil on canvas, 173 x 176 inches
Bequest of John Ringling, 1936, SN 213

The institution of the Eucharistic sacrament at the Last Supper was recorded by the Evangelists in the Gospels. Rubens' cartoon of *The Four Evangelists* displays a group of figures in motion. At the far left is St. Luke with his ox, symbolic of sacrifice. This beast is traditionally an attribute of Luke, since his Gospel begins with the sacrifice of Zachariah. Next to Luke is St. Mark, his Gospel under his arm. At his side walks the lion that alludes to the Christ of the Resurrection.

St. Matthew and the angel are given a central place. With one hand, the angel points to a gospel passage; with the other, he gestures heavenward, reflecting the divine inspiration with which Matthew wrote his Gospel. St. John, the youngest of the group, looks up at an eagle. The eagle, thought to be able to look directly into the sun, denotes John's vision of the Apocalypse. The cup with the snake refers to poison that John drank, proving his faith.

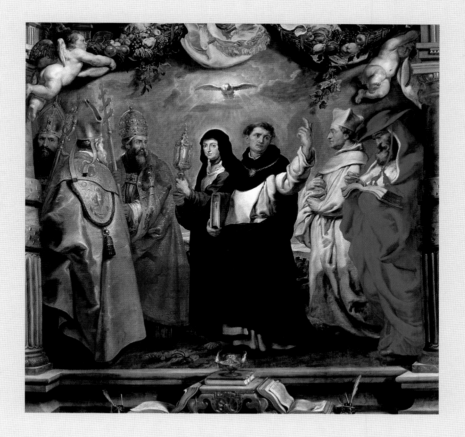

Peter Paul Rubens
Flemish, 1577–1640, active in Antwerp and throughout Europe
The Defenders of the Eucharist, c. 1625
Oil on canvas, 171 x 175 inches
Bequest of John Ringling, 1936, SN 214

In this companion piece to *The Four Evangelists,* Rubens has incorporated figures from early church history into a dramatic spectacle. On the far right is St. Jerome, dressed in cardinal's robes. Jerome's taking of the sacrament of the Eucharist at his last rites had become a favorite subject in painting among artists by Rubens' time. The book Jerome reads is his translation of the Bible into Latin. In front of Jerome in a white monastic habit and four-cornered hat is Norbert, the German bishop-saint. He carries the sacrament of the Eucharist bundled beneath his robes. In the center stands St. Thomas Aquinas in his Dominican habit, holding a book of his writings and pointing heavenward. This gesture mirrors that of St. Matthew in the cartoon of *The Four Evangelists* and thus reinforces the early Church fathers' role as proclaimers and defenders of the Eucharist doctrines. Next to St. Thomas is St. Clare, dressed in the Franciscan habit of the Poor Clares and holding a great monstrance. The features of St. Clare are those of Rubens' patron, the Infanta Isabella Clara Eugenia, Governess of the Netherlands. To the left of St. Clare is St. Gregory the Great, shown wearing papal robes and tiara and holding the papal staff. Gregory authored some of the most important texts of the Church, including most of the Canon and prayers of the Mass. Next to him is the bishop-saint Ambrose. Also an influential shaper of Church doctrine, he is best known for asserting the dogma of Divine Presence in the Eucharist. At far left and recognizable by his black beard, crosier and miter is St. Augustine. His writings on the Trinity explained various aspects of the sacrament of the Eucharist.

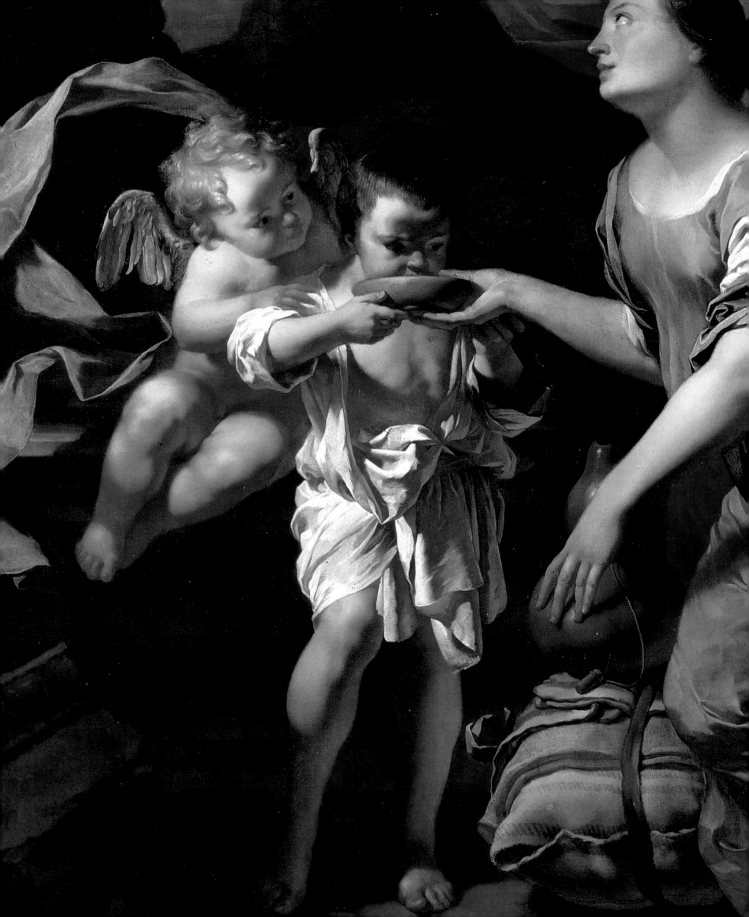

DUTCH AND OTHER
NORTHERN BAROQUE ART
The Age of Rembrandt

THE ART in this chapter reflects the society and history of 17th-century Netherlands (commonly called Holland). The minute, realistic style employed by these artists is now considered typically Dutch. "Optical naturalism" (the meticulous recording of the surfaces and textures of things) was part of the northern tradition since its beginnings (see paintings such as Lucas Cranach's *Portrait of Cardinal Albrecht* on page 37). Artists from the period such as Hendrick van Vliet may have been influenced by or employed such developments in optical science as the *camera obscura* (ancestor of the modern camera), the microscope or the telescope.

Views of interiors were particularly popular as demonstrations of artists' ability to record the appearance of everyday life, but sometimes these seemingly realistic paintings also contained symbolism expressing moral messages. The Netherlands was one of the richest countries in the world at this time, profiting from extensive trade and colonization in the Eastern Hemisphere and the Americas (hence the Brazilian landscape by Frans Post on page 124). The paintings trumpet the country's wealth and fertile land unequivocally.

Although Dutch and other Northern artists are not usually considered to have excelled in "history painting" (subjects from the Bible, history and mythology) to the same extent as they were preeminent in realistic scenes of everyday life, artists such as Rembrandt made a point of presenting imaginative dramas. Although Northern artists were sometimes accused of lacking imagination, this is patently not the case. Rather, artists may have been discouraged from producing large-scale history paintings because of such factors as the high market popularity of small realistic subjects for private collections, and the lack of patronage from the Church (Protestant churches did not contain altarpieces).

However, a small group of Northern artists did specialize in producing large, ambitious paintings of imagined subjects. The first such group (comprising Nicolas Régnier and Nicolas Tournier) followed the style of Caravaggio. Others such as Johann Liss followed Rubens' brightly colored, loosely brushed manner. Karel Du Jardin's icy classicism is the very antithesis of Liss' exuberance. Rembrandt and his students created a new style in which deeply moving imagined scenes were tempered with the close observation of anatomy, facial expression and light.

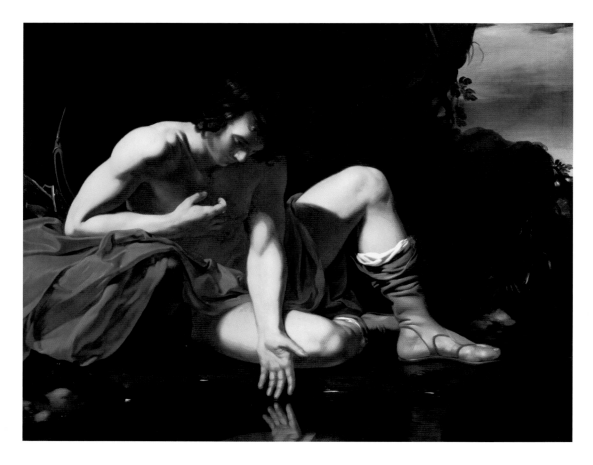

Attributed to a Dutch artist active in Rome
Narcissus, mid 1640s
Oil on canvas, 45 x 56⅜ inches
Museum purchase, 1969, SN 885

According to Greek myth, Narcissus was a youth who fell in love with his own reflection. This became a popular subject in Renaissance and Baroque art because it offered the opportunity to depict a beautiful male and because the mirror image of Narcissus was taken to symbolize the painter's ability to imitate nature and trick the beholder. The Italian painter Caravaggio and his many followers often painted beautiful boys such as Narcissus, in life-size formats, stark contrast of dark and light and limited range of colors. The artist who painted this work is presumed to be a Dutch follower of Caravaggio, although this question is not yet settled.

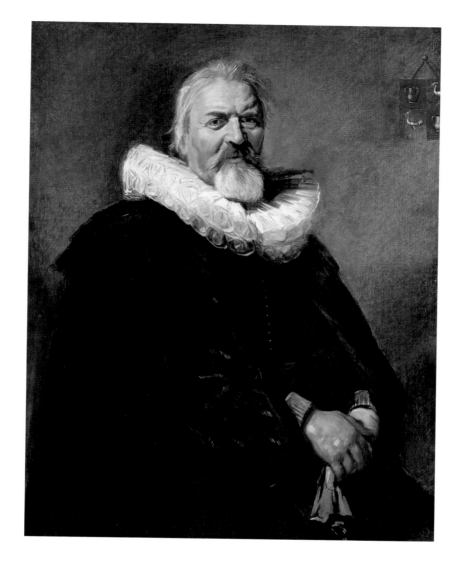

Frans Hals
Dutch, 1581/85–1661, active in Haarlem
Portrait of Pieter Jacobsz. Olycan, c. 1639
Oil on canvas, 43¾ x 34⅛ inches
Bequest of John Ringling, 1936, SN 251

This austere man was one of the richest brewers in Haarlem. He also served as mayor and acting diplomat of that Dutch city. Over time, Hals painted Olycan's entire family including a pendant to this painting—a portrait of Olycan's wife Maritge now in the Rijksmuseum, Amsterdam.

The Ringling painting reveals elements that made Hals one of the most highly respected portraitists of his time. The artist achieved a sense of liveliness by depicting the sitter turning as if about to speak. He also enlivened the surface with his quick handling of the brush. Hals followed the Venetian tradition, such as Bassano's *Portrait of a Man*, on page 56, by limiting his colors to a restricted palette of black, white and flesh tones and by aiming for a straightforward and natural presentation of the sitter.

Attributed to **Jacob Duck**
Dutch, c. 1600–before 1667,
active in Utrecht
*Soldiers and Women
in a Tavern*
Oil on panel,
21 x 28⅜ inches
Gift of Mr. and Mrs.
Frederick Caminer, 1961,
SN 734

Dutch painting often presented a moral commentary on contemporary life, though here the message is mixed. While Duck tempts us to enjoy the merrymaking of this licentious company, we are more likely meant to condemn the behavior of these soldiers and prostitutes. Since Holland had a small population, the country was forced to depend on foreign mercenary soldiers in the wars defending their state that consumed much of the 17th century. These soldiers were considered a necessary evil. Here they are seen wasting their hard-earned money by giving extravagant jewels to equally mercenary females. Such tavern scenes were a specialty of Duck's, although this particular painting may have been done by an as-yet-unidentified contemporary or follower.

Attributed to
Johannes Gerritsz. van Cuylenburch
Dutch, active 1655–1662 in Zwolle
and Amsterdam
A Smithy in Zwolle
Oil on canvas, 32 x 26 inches
Bequest of John Ringling, 1936, SN 271

In contrast to the scene of debauchery by Duck above, Van Cuylenburch, or possibly his contemporary Johannes Grasdorp, depicted an ideal of the honest, hard-working Dutchman to serve as a model of virtuous conduct. Despite the air of quiet in this carefully observed backyard in the small town of Zwolle, chaos is about to break out. The two roosters are about to fight and the dog in the foreground will snarl if anyone comes near its jealously guarded bone.

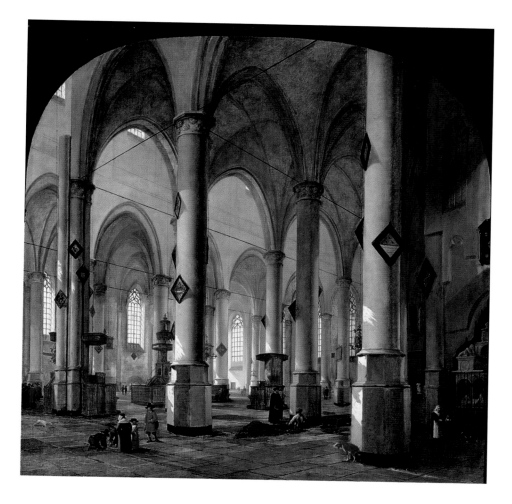

Hendrick (Cornelisz.) van Vliet
Dutch, 1611/12–1675, active in Delft
Interior of the Pieterskerk in Leiden, 1653
Oil on canvas, 55⅛ x 55¼ inches
Bequest of John Ringling, 1936, SN 288

Despite its realistic appearance, this painting of the church interior is meant to deliver a moral message. In this stark setting (Protestant churches in Holland at the time did not have altarpieces) the artist depicted stages of human life and premonitions of mortality. The dog urinating on a column symbolizes an animal's lack of understanding. Two different characterizations of children are depicted. On the left, a group of youngsters play, unaware of their divine surroundings. On the right, a woman is showing a tomb to a child, suggesting that time on Earth should be spent wisely. In the center, an old man looks at a tomb, well aware of his mortality.

Historians identify the Church of Peter in Leiden as the site where a congregation of Mayflower pilgrims prayed before their departure for the New World. The annual celebration of the liberation of Leiden from the Spaniards in 1574 is recognized as a precursor to Thanksgiving in America.

Dutch (Delft)
18th century (?)
Plate with a Figure in a Landscape
Faience, 14 inches
Gift of the Lewis and Eugenia Van Wezel
Foundation, 1965, SN 7305

In 17th-century Holland, landscape paintings became one of the most popular genres. This sudden abundance may be explained by a number of factors. One is that the Protestant Church in Holland forbade religious imagery, and artists therefore sought other subjects to paint. Also, the rise of a bourgeois art-collecting culture encouraged easily traded commodities such as paintings. Finally, Dutch artists experienced a new naturalistic impulse, that is, a preference for things seen rather than imagined. In the cases of both Potter's painting and the Delft plate, it is clear that the Dutch countryside was celebrated for its productivity and for the virtues of country life.

Paulus (Pietersz.) Potter
Dutch, 1625–1654, active in Amsterdam and The Hague
Cattle Resting in a Landscape, 1645
Oil on panel, 20 x 15 inches
Bequest of John Ringling, 1936, SN 281

Adam Pynacker
Dutch, c. 1620–1673, active in Italy, Schiedam and Amsterdam
Landscape with Hunters, c. 1665
Oil on canvas, 32 ¼ x 27 ¾ inches
Museum purchase, 1971, SN 896

In contrast to farming, hunting was a highly regulated, exclusive and status-oriented activity. Only aristocrats and other privileged persons were able to hunt, and they were only rarely granted licenses that carried stringent restrictions. It is in this context that paintings such as Pynacker's are best understood.

More than celebrations of sport or skill, these landscapes are symbols of their owners' nobility or their aristocratic aspirations. Dutch painters of Pynacker's generation who practiced in Italy typically depicted landscapes with strong contrasts of sunlight and shadow. Pynacker distinguishes himself from these artists of Italianate landscapes by the skill and exactitude with which he portrays the native flora of Holland.

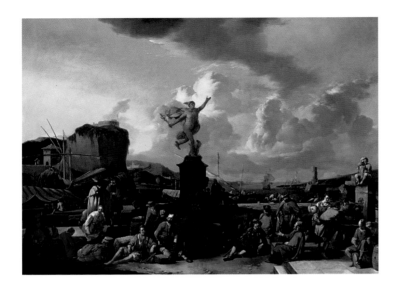

Johannes Lingelbach
German, 1622–1674, active in
Amsterdam and Italy
An Imaginary Harbor, 1667
Oil on canvas, 33½ x 45 inches
Bequest of John Ringling, 1936,
SN 272

On the previous pages we have observed the art that celebrated every aspect of life in urban and rural Holland. On this page we see a different aspect of Dutch culture—that of a great seafaring nation. During the 17th century, Holland was at war with Spain and other Catholic countries not only because of religious differences, but also because of competition over the wealth in the New World and the Far East. These paintings by Johannes Lingelbach and Frans Post depict the importance of the colonial expansion of the Dutch Empire.

Lingelbach portrayed a peaceful Mediterranean port where people of differing nationalities wait for their ships. The scene might seem realistic, but the port is entirely imaginary. It is presided over by Mercury, the god of peace and business. Lingelbach's message, therefore, is that commerce will flourish in times of accord.

Post was an artist who was sent by the government on expeditions to South America in the 1630s. This painting of a sugar plantation was done long after Post returned from Brazil and served to remind its Dutch owner of a faraway place that was also a source of great wealth.

Frans (Jansz.) Post
Dutch, 1612–1680, active in Brazil
and The Netherlands
Rural Landscape in Brazil, 1664
Oil on wood panel, 13½ x 16¼ inches
Bequest of John Ringling, 1936, SN 275

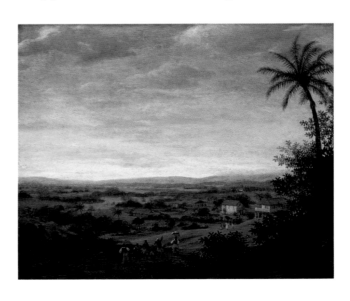

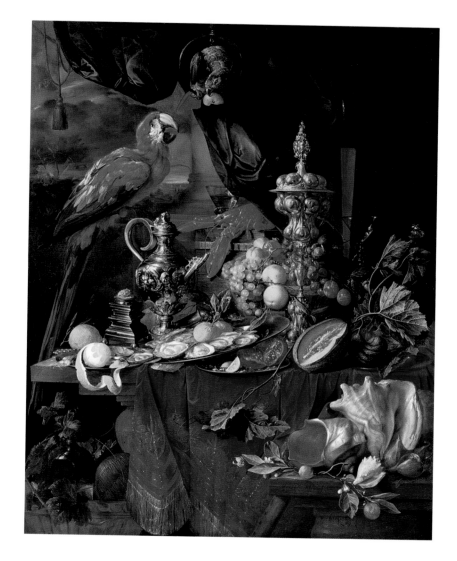

Jan Davidsz. de Heem
Dutch, 1606–c. 1684, active in Antwerp
Elaborate Tabletop Still Life with Foodstuffs, Exotic Animals, and Precious Objects, late 1640s
Oil on canvas, 59¼ x 46¼ inches, Bequest of John Ringling, 1936, SN 289

Jan Davidsz. de Heem moved easily between the worlds of Dutch and Flemish art. Dutch by birth, he practiced his art in Antwerp, possibly for religious reasons. There, he became associated with Rubens and his extravagant Baroque style. De Heem, however, retained his Dutch clientele because they appreciated his illusionistic skill and the rarity of the objects he depicted.

Sometimes De Heem's still lifes are interpreted as moral warnings against excessive enjoyment of ephemeral worldly things. Certainly these flowers may rot, the silver tarnish, the food spoil and the birds fly away. All this is secondary to the pride with which this magnificent display has been put together. Note that most of the objects depicted are evidence of wealth from Dutch colonies in South America, including exotic birds, spices, pepper, rare shells, gold and silver.

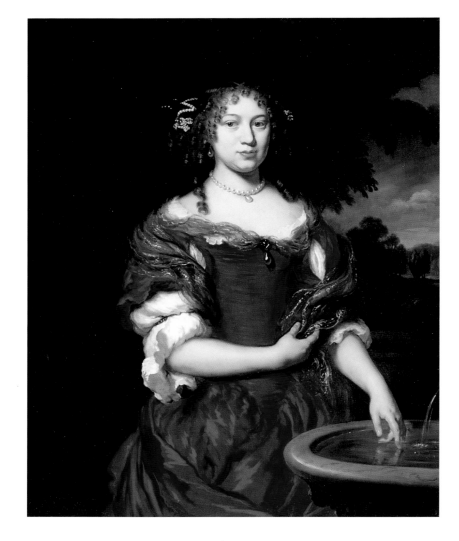

Nicolaes Maes
Dutch, 1634–1693, active in Amsterdam
Portrait of Anna Hofstreek, 1674
Oil on canvas, 45 ⅛ x 36 ⅛ inches
Bequest of John Ringling, 1936, SN 265

Although Nicolaes Maes began his career as Rembrandt's pupil, he changed his style in the decades around the date of this painting. Under Rembrandt's influence in the 1650s, Maes painted subjects from domestic daily life, such as maids or nurses, for which he used wide, rough brushstrokes resembling his master's. However, by the 1660s he had gained an aristocratic clientele and began to specialize in highly idealized portraits using elegant poses derived from Van Dyck, and delicate brushwork and luxurious textures, as in the expensive fabrics and jewels shown here. Anna Hofstreek's pose is unusual and symbolic. It is meant to show that Anna is as chaste as the clear water in the fountain in which she dips her fingers.

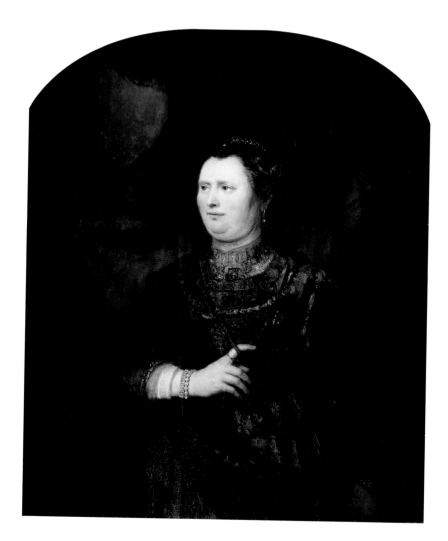

Studio of **Rembrandt (Harmensz.) van Rijn**
Dutch, 1606–1669, active in Leiden and Amsterdam
Portrait of a Woman, early 1650s
Oil on panel, 47 ½ x 39 ⅛ inches
Bequest of John Ringling, 1936, SN 253

This imposing woman is shown in one of a pair of portraits of an unidentified married couple. The portrait of her husband, dressed in armor, is in the Fitzwilliam Museum in Cambridge. Rembrandt often practiced portraiture in which his subjects were dressed to resemble characters from literature, history or the Bible, though this woman and her husband are undoubtedly contemporary bourgeois or aristocrats. More precisely, it has been suggested that this sitter may have been costumed as a heroine from the popular play about the history of Amsterdam, *Gysbrecht van Amstel,* by Joost van den Vondel.

It is likely that this portrait was produced by one of Rembrandt's assistants under the master's supervision. Like Rubens, Rembrandt had a large workshop in which paintings were executed by others according to his design, though they were considered by his clients as his own.

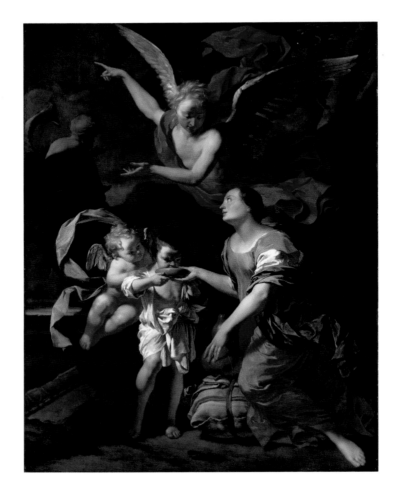

Karel Du Jardin
Dutch, c. 1622–1678, active in Amsterdam and Rome
Hagar and Ishmael in the Wilderness, c. 1662
Oil on canvas, 73¾ x 56¼ inches
Bequest of John Ringling, 1936, SN 270

Karel Du Jardin is thought to be the most accomplished of the Dutch "classicists." These painters differed from Rembrandt and his followers by using harmonic colors rather than shades of gray, brown and black, even light instead of harsh shadows, and idealized physical types rather than real models. This painting is in almost every respect stylistically different from Rembrandt's *Lamentation* on the opposite page.

Particularly indicative of Du Jardin's style are the elegant draperies and polished marble-like surfaces of the figures and faces. Du Jardin's treatment of this subject is similar to that of the Italian Baroque artist Cortona's *Hagar and Ishmael* on page 77. In both of these works, the artist uses the story of the angel appearing from heaven to save Abraham's wife Hagar and her son as an opportunity to arrange figures in balletic poses and expressive, but formal, attitudes.

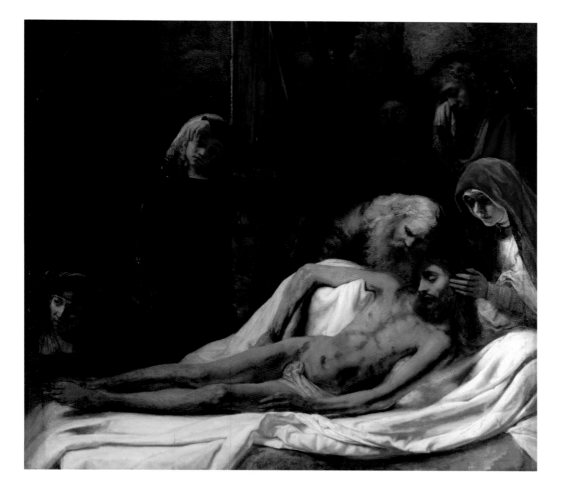

Student of **Rembrandt (Harmensz.) van Rijn**
Dutch, 1606–1669, active in Leiden and Amsterdam
Lamentation, c. 1650
Oil on canvas, 71 x 78 ¼ inches
Bequest of John Ringling, 1936, SN 252

The power of this painting consists in its utter realism and lack of self-conscious artistry, since the subject of Christ's death is usually treated with greater pomp, solemnity and passion. Here, the figures silently watch and weep while Christ's body lies on the ground, completely exposed to the viewer's gaze. It is not the body of a muscular hero or athlete, as Rubens would have fashioned, nor is his pose especially elegant. Instead, the artist has chosen to use the body of a slender young model who was often used in Rembrandt's studio in the 1640s.

This life-size figure was perhaps an exercise in copying life as much as it was portraying a religious theme. The straightforward attitude towards storytelling stemming from realism is typical of Rembrandt's teaching. In fact, this image was probably a student exercise based on a Rembrandt composition. Perhaps this work is by Samuel van Hoogstraten, an aristocratic student of Rembrandt, who later wrote a biography of his master.

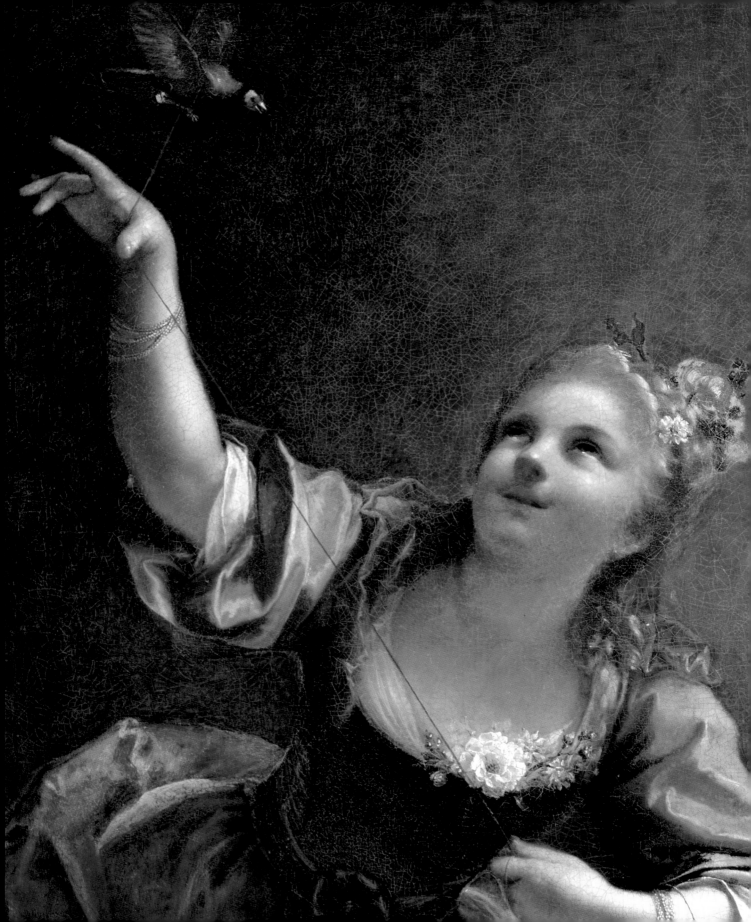

ROCOCO ART IN EUROPE
The Age of Tiepolo

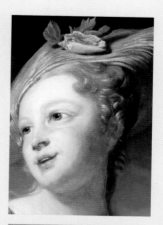

THE ROCOCO (from the French for "rock-work") was a stylistic movement based on asymmetry, lightness and artificiality. Artists found inspiration in natural forms such as irregular rocks (especially in grottos), flowers and shells. The 18th-century love of the exotic also found expression in the taste for things Chinese *(chinoiserie).*

The Rococo style was born simultaneously in Italy and France and quickly spread throughout Europe. It found its greatest and longest lasting favor in Germany, and the German courts attracted artists from all of Europe (the Italian Giambattista Tieoplo produced one of his greatest masterpieces in Würzburg). The king of Prussia, Frederick the Great, was himself an amateur architect and designer of Rococo ornament of exceeding wit. The German Rococo style was also used extensively in churches, where its lightness gave the illusion of heavenliness, and its bizarre, irregular forms endowed religious figures with deep pathos.

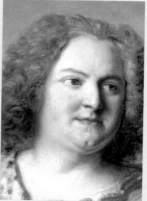

The theater and the visual arts had been interconnected in Europe since the Renaissance. However, 18th-century artists increasingly used theatrical subject matter because of the theater's great popularity in that era, and also because of many artists' own inherent sympathy for comic and tragic subjects. Many paintings can thus be considered akin to theatrical genres. Even allegorical subjects, representations of abstract concepts such as Faith, Magnanimity or Hope were given comic inflection and symbolic figures themselves took on lively personalities. Tiepolo's *Magnanimity* and *Glory* seem more like opera singers in terrible moods than lofty concepts meant to flatter princes, and Francesco Guardi's *Hope* and *Abundance* look like two country women on a stroll.

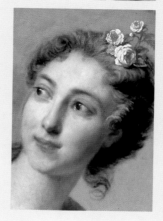

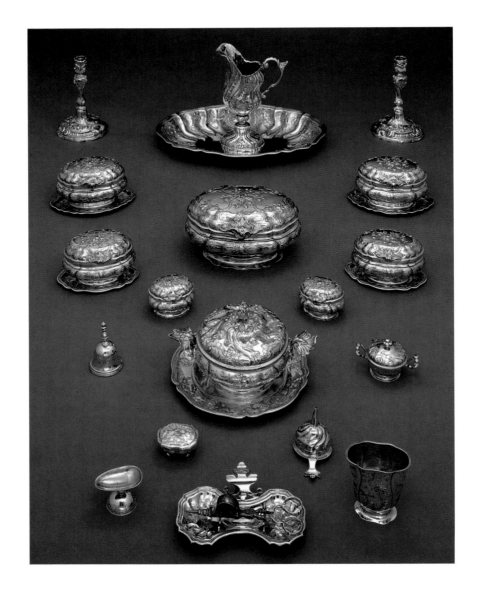

Germany (Augsburg)
18th century
Traveling Set, c. 1755–1757
Silver-gilt (vermeil) and other materials
Museum purchase, 1950, SN 1539.1–1539.32

Augsburg was one of the chief European centers of silversmithing beginning in the Renaissance. By the 18th century, travel sets such as these were produced in quantity for foreign customers. This set, which comprises utensils for both eating and dressing, is said to have been made for a Swedish nobleman. Numerous craftsmen signed the various pieces. Their differing artistic personalities can be discerned in the highly stylized birds, flowers and scrolls that decorate these elegant items.

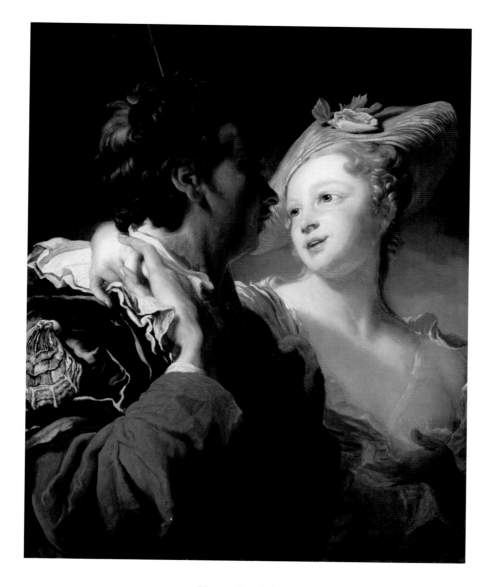

Pierre Goudréaux
French, 1694–1731, active in Mannheim
The Lovers' Pilgrimage
Oil on canvas, 32 3/16 x 25 5/8 inches
Museum purchase, 1952, SN 671

The themes of the "pilgrimage to the island of love" and the worship of Venus were especially popular in the Rococo period. Here, the shell worn on the sleeve and the staff held by the man indicate that he is such a pilgrim. Of course, people did not literally worship the gods of love. Instead, this subject was a metaphor for the emotion of desire and the physical state of arousal. Though French, Pierre Goudréaux was active in the courts of Germany where Rococo art was especially prized. The artist's richly applied brushwork and creamy highlights enhance the sensual appeal of these beautiful young lovers.

Jean-Marc Nattier
French, 1685–1766, active in Paris
Portrait of an Aristocratic Youth as Bacchus
Oil on canvas, 57½ x 45¼ inches
Bequest of John Ringling, 1936, SN 380

An official portraitist of the court of Louis XV, Jean-Marc Nattier specialized in highly idealized portraits of court personages in the guise of ancient gods and goddesses such as Vesta, Venus or Hebe. Here, the amusingly ungodlike figure of the heavyset youth has been made into the image of Bacchus, the God of Wine. It is unlikely that the artist meant to suggest that this young man had an over-fondness for wine. Instead, the sitter, formerly thought to be Louis XV himself, may be shown as a relation of the Jupiter-like king or, instead, as costumed for a court play. The lion and grapes especially show the sophisticated painting handling for which Nattier was highly regarded.

Noël-Nicolas Coypel
French, 1690–1734, active in Paris
Portrait of Madame de Bourbon-Conti as Venus, 1731
Oil on canvas, 54 ⅜ x 42 inches
Bequest of John Ringling, 1936, SN 381

There were many famous and intelligent women who bore the name Bourbon-Conti. The one portrayed here may be Louise-Diane d'Orléans, princesse de Conti, the daughter of Phillipe II, Duke d'Orléans. Phillipe was Regent of France before 1723 when King Louis XV ascended the throne. The sitter's father thus gave his name to the *Régence* (Regency) period—a time when French culture turned away from the rigidity of Louis XIV style.

The new informality promoted during this period is especially evident in this portrait. The figure of the princess is turning in a graceful spiral, enveloped in light and air while little cherubs decorate her with flowers. Like the costume portraits of Cranach, on page 37, and Rembrandt, on page 127, the Princess is shown in the guise of an important person, in this case the Goddess of Love.

Sebastiano Conca
Italian, 1680–1764,
active in Naples
*The Vision of Aeneas in the
Elysian Fields*, c. 1735/40
Oil on canvas,
48⅝ x 68½ inches
Bequest of John Ringling,
1936, SN 168

In this painting, Sebastiano Conca portrays an episode from *The Aeneid* by the Roman poet Virgil. This poem tells of the hero Aeneas—a Trojan warrior considered to have been the founder of Rome. In this exploit, he has descended into a part of the underworld, called Elysium, where souls of men wait to be reborn. Here, the helmeted hero listens to his own father, Anchises, who shows him a prophecy about the future grandeur of Rome in the form of the great heroes, poets and philosophers who will populate the city. These include the poet Virgil himself, shown with a lyre and looking out at the viewer on the left. Aeneas's mother, Venus, is above in her chariot. She was the victor in the contest of the judgment of Paris that was the cause of the Trojan War (see painting by Ludovico David, on page 76).

France (Niderville)
18th century
Covered Dish, c. 1765
Tin-enameled earthenware (faience),
7½ x 11¾ x 10⅜ inches
Museum purchase, 1953, SN 7248

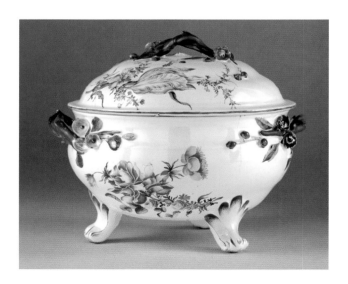

Flowers appeared everywhere in 18th-century art, even in unexpected places such as Conca's Elysium (illustrated above). Fine tableware was particularly well-suited for floral decoration. Here, the meticulously described sprigs are casually tossed with elegance and artistic abandon.

Giambattista Tiepolo
Italian, 1727–1804, active in
Venice, Germany, and Spain
*An Allegory Representing the Glory
and Magnanimity of Princes*, c. 1760
Fresco (later transferred to canvas),
148 x 75 inches
Museum purchase, 1951, SN 652

These imposing life-size figures
were once elements of a large fresco
decoration for a room that was perhaps
in a villa or palace near Venice. The
scheme for this decoration may have
been a series of imaginary sculptures
integrated into the painted architecture
of the room. Here, we are meant to
see two bronze sculptures in front of
a marble obelisk; they probably stood
over a doorway or a mantel and were
originally seen from below. Tiepolo's
decorations achieved the perfect
marriage of bombast and irony.
The "Glory of Princes" is portrayed
as an over-haughty woman, while
"Magnanimity" seems to clutch his
gold very closely.

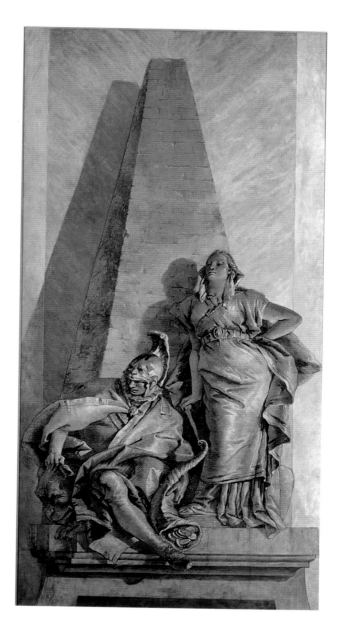

Francesco Guardi
Italian, 1712–1793,
active in Venice
Hope and *Abundance*,
late 1740s
Oil on wood panels,
each 63 ½ x 30 ¾ inches
Bequest of John Ringling,
1936, SN 189, SN 190

The allegories of the Christian virtues of Hope, with her anchor, and Abundance, with her bounteous basket of wheat, are unlike the grand operatic figures observed on the previous page by Francesco Guardi's brother-in-law Giambattista Tiepolo. Here, instead of Tiepolo's sarcastic portrayals, Guardi represents these two personages as abstract religious concepts, charming and unselfconscious country maidens taking a walk by the sea. These panels were probably the shutters to the great organ in the Venetian church of Arcangelo Raffaele. This church organ is considered a major monument of European Rococo art because the free brushwork and bright tonalities used by Guardi in its decoration foreshadow impressionism.

Du Paquier Factory
Austria (Vienna), 18th century
Figure of a Vegetable Peddler, c. 1765/70
Porcelain, 7 x 2 ¾ x 3 ½ inches
Museum purchase, 1949, SN 7245

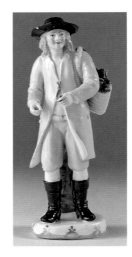

In a contradiction typical of the period, this humble vegetable peddler is fashioned in one of the most expensive and rare materials of the time— porcelain. The Oriental secret of porcelain was discovered in Europe only around 1700. Throughout the 18th century it was highly prized for its intrinsic beauty and its ability to be shaped into exquisitely detailed, small-scale objects such as this. The peddler may have been a table decoration playfully carrying his lettuces to the plates of the aristocratic diners. Though the figure is not greatly idealized, it possesses a dignity and pathos typical of much grander statuary.

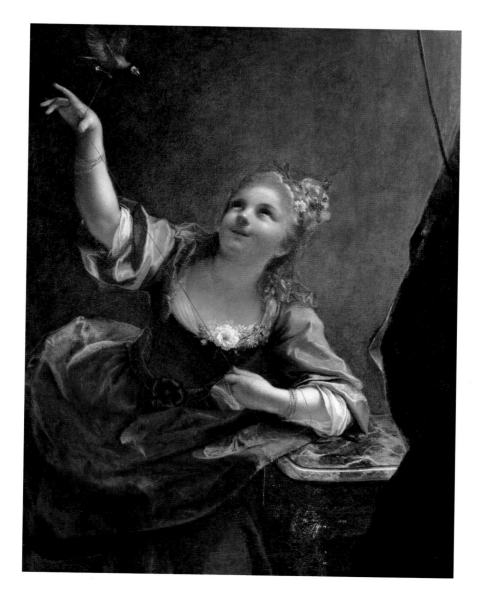

Jean Raoux
French, 1677–1734, active in Paris
Girl Playing with a Bird on a String, 1717
Oil on canvas, 45¼ x 34⅝ inches
Bequest of John Ringling, 1936, SN 375

In the 18th century, paintings of subjects from everyday life (called "genre scenes") became very popular. Scenes of playing children were especially popular as interest in child psychology grew. One of the major themes of these paintings was childhood innocence or its absence or loss. Here, the charming girl treats the bird as a toy and seems to delight in its helplessness. However, it is more likely that this seemingly innocent image may instead represent a misogynist cliché of the sentimental fiction of the time—the innate cruelty of women who toy with men's affections.

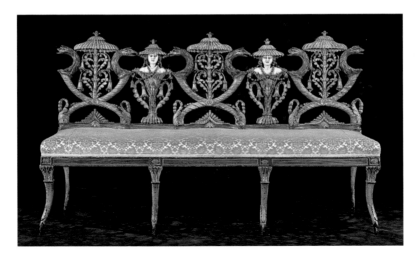

Michelangelo Pergolesi
Italian, before 1770–1801, active in Venice and London
Suite of Fantastically Carved Furniture, 1803–1805
Carved, lacquered, painted wood and reverse painted glass, 38 x 63¼ x 19¼ inches
Museum purchase, 1949, SN 1533

This is part of a large suite of furniture that extravagantly mixes neoclassical, oriental, and animal motifs in a way meant to be amusing and highly decorative. The Ringling Museum possesses two settees and two chairs of this suite. Michelangelo Pergolesi was a specialist in ornamental designs who is best known for his collaboration with the English architect Robert Adam. Although designs by Adam and Pergolesi were usually composed of classical motifs, this furniture incorporates Chinese-style (or *chinoiserie*) figures.

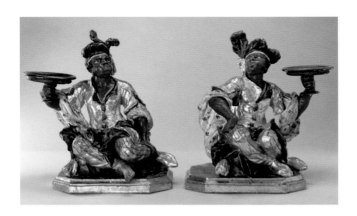

Attributed to **Giovanni Giuliani**
Italian, 1633–1744, active in Venice
Two Blackamoors, early 18th century
Terracotta with gilding and polychrome,
Each 15¾ x 15 x 9⅞ inches
Museum purchase, 1949, SN 7270–7271

Exotic subjects fascinated Rococo artists. This is not only the case with oriental subjects as in the furniture above. Moorish figures of fancifully dressed slaves, called Blackamoors, were especially popular shaped as ornamental statues, vases and torch stands. Here the artist has created a striking pose for the figures that probably were meant to hold candles. In order to amuse 18th-century European viewers, the artist exaggerated the facial features of the figures.

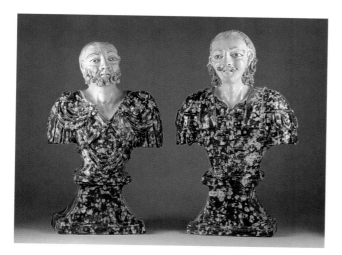

These rare busts from a little-known provincial factory in Southern Italy are made of earthenware, a common material, decorated to resemble expensive jasper, a red quartz gemstone. Designed to imitate classical models such as imperial busts, the subjects of tragedy and comedy are treated with a solemnity that belies their stereotyped subject matter and the inherent silliness of such humanized allegorical figures.

Malvica Factory
Palermo, Italy, 18th century
Bust of Tragedy/Bust of Comedy
Tin-enameled earthenware (*faience*), 26⅝ and 28¼ inches
Museum purchase, 1962, SN 5021/SN5022

Giovanni Domenico Ferretti
Italian, 1692–1768, active in Florence
Harlequin as Painter, c. 1740s
Oil on canvas, 38½ x 30½ inches
Museum purchase, 1950, SN 643

This is one of a large series of paintings probably painted as a decoration for an 18th-century Florentine academy of drama. They later belonged to the famous German 20th-century stage director, Max Reinhardt, from whose estate they were purchased. Most likely, these paintings do not represent scenes from real plays, but rather stock figures from the *commedia dell'arte*, which portrayed everyday situations. Here, the scoundrel Harlequin paints a wealthy maiden's portrait. Instead of beautifying her as such portraits usually do, the cruel painter represents her as much uglier than she evidently is.

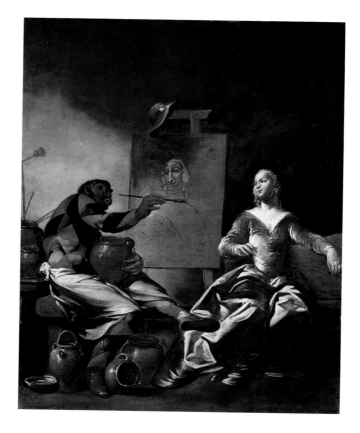

ENGLISH SILVER

Silver was a major vehicle for expressing the ideas of Rococo artists and artisans. In the undecorated vessels here, the sinuous and sensual shapes are as seductive as any surface ornament. The beautiful curves and shapes of these objects seem almost to move and breathe. When ornamentation is added, as in the George III mug, the effect of visual sumptuousness and natural expressiveness is doubly enhanced.

George II Cream Jug/Sauce Boat, 1747
Silver, 3⅞ x 3⅝ x 2⅞, 3⅝ x 6¼ x 3⅝ inches
Gift of Mr. and Mrs. Percy R. Everett,
1969, SN 7388/SN 7002

George II Half Pint Mug, 1751
Silver, 4⅜ x 3⅛ inches
Gift of Mr. and Mrs. Percy R. Everett,
1969, SN 7390

William Parry
England (Exeter)
George III Silver Half-Pint Mug, 1778
Silver, 4 1/16 x 2⅝ inches
Gift of Mr. and Mrs. Percy R. Everett,
1969, SN 7386

George III Teapot, 1795
Silver, 6⅛ x 10½ x 4¼ inches
Gift of Mr. and Mrs. Percy R. Everett,
1969, SN 7389

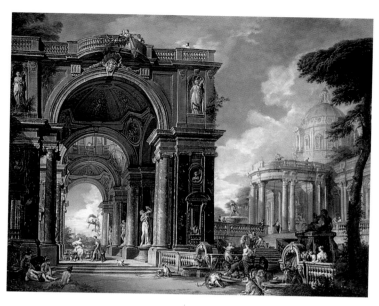

Giovanni Paolo Pannini
Italian, 1691–1765, active in Rome
Circe Entertaining Odysseus at a Banquet (above), and *Hermes Appears to Calypso* (below), c. 1718/19
Oil on canvas, 51 x 63⅜ inches, 50⅞ x 64⅜ inches
Bequest of John Ringling, 1936, SN 172, SN 171

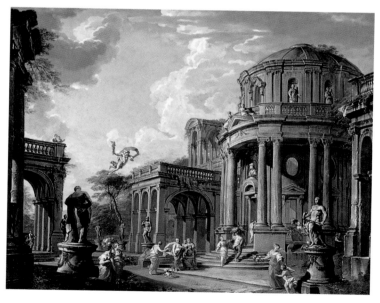

These two paintings of classical scenes date to the earliest years of Giovanni Paolo Pannini's career. The elaborate architecture is not real, but rather stems from the artist's imagination. The foregrounds of both paintings depict myths of ancient heroes and *femmes fatales* as recounted in Homer's *Odyssey*. In *Circe Entertaining Odysseus at a Banquet,* the Greek hero falls under the spell of the enchantress who has turned his companions into wild beasts. In *Hermes Appears to Calypso,* the sorceress Calypso, holding Odysseus captive, is given the command to release him.

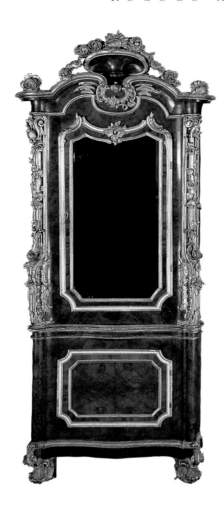

Johann Christian Hoppenhaupt
German, active 1746, died 1778–1786
Two-part Corner Cabinet, c. 1745
Carved and gilded walnut, 107 x 41 inches each
Museum purchase, 1951, SN 1185-1186

Johann Christian Hoppenhaupt was extensively
employed by the royal family of Prussia, both
at the Berlin Palace and at King Frederick the
Great's retreat, Sans Souci in Potsdam, where he
is best remembered for his design of the music
room. In the extravagant design of this cabinet,
the simplicity of the lower portion acts as a foil
against the swelling form and elaborate decoration
of the upper case. There, Hoppenhaupt seems
to have abandoned all pretense at architectural
solidity. The columns framing the mirror look
like trees bursting into flower and leaf. The whole
is framed by a broken pediment with aquatic and
vegetable motifs. Surely this furniture piece is as
much a work of the artist's imagination as any
painting in the collection.

Jeremiah Theus
Swiss, 1719–1774, active in
Charleston, South Carolina
Portrait of John Faucheraud Grimke, c. 1762
Oil on canvas, 30 3/16 x 25 3/16 inches
Museum purchase, 1982, SN 982

Jeremiah Theus was an artist who brought
the Rococo style of portraiture to America.
Trained in Switzerland, he moved to
Charleston, South Carolina around 1735.
His portraits are known for the straightforward
and open expressions of the sitters, representing
two ideals of the Age of Enlightenment—
honesty and dignity. Here, the young sitter's
pose, dress and accoutrements indicate the
aristocratic aspirations of his wealthy family.
The painting is set in a beautifully carved
American Rococo frame.

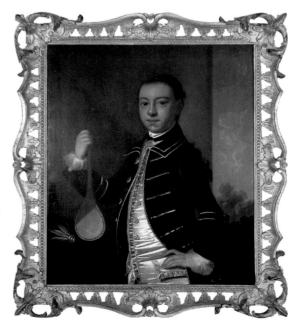

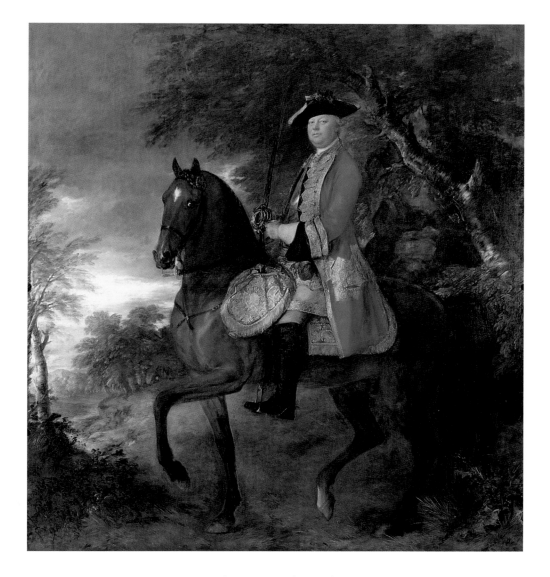

Thomas Gainsborough
British, 1727–1788, active in Suffolk, Bath, and London
Portrait of Lieutenant General Philip Honywood, 1765
Oil on canvas, 128 ¹⁵⁄₁₆ x 118 ¼ inches
Bequest of John Ringling, 1936, SN 390

This is Thomas Gainsborough's largest painting, and the only one of his equestrian portraits to show the rider seated on his horse. Here, Gainsborough sought to emulate the pictorial methods successfully employed by earlier artists such as Titian and Anthony van Dyck who combined grand scale with fluid brushwork. Honywood, who was six-foot–three-inches tall, was a veteran of many battles. He retired in 1746 after having suffered twenty-eight wounds. This painting shows him as a military hero, but if it were not for his sword and military dress he could easily be mistaken for a country gentleman riding on his estate.

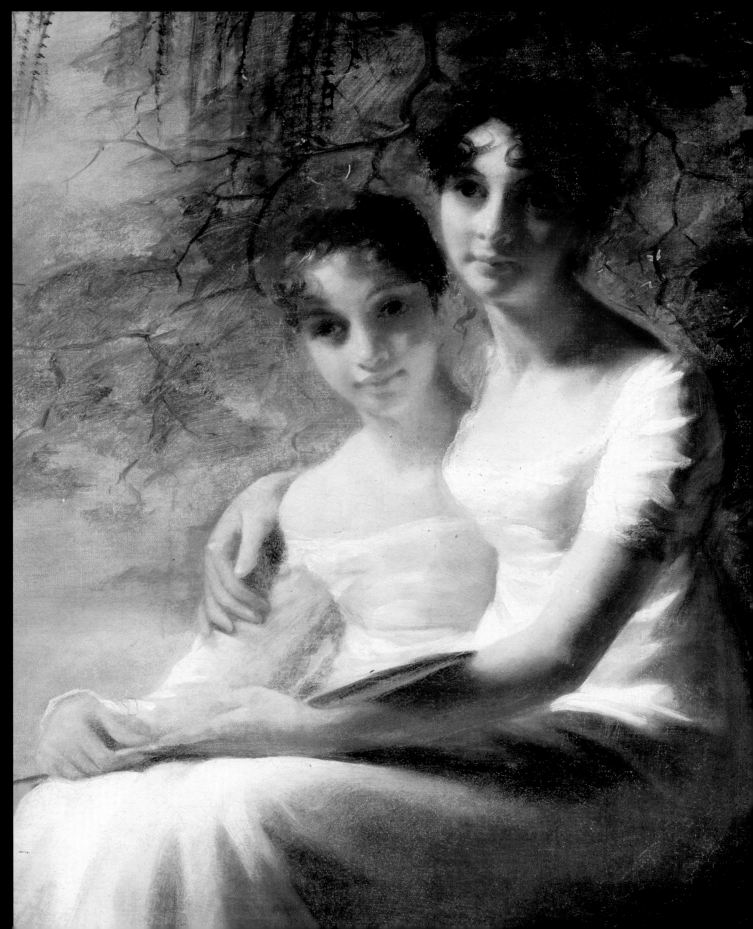

NEOCLASSICISM AND THE GRAND TOUR
The Age of Reynolds

THE RINGLING Museum's later 18th-century collection is dominated by life-size aristocratic portraits and by landscapes reflective of the phenomenon of the Grand Tour. Mythological and allegorical paintings are in the reserved and grandiose style called Neoclassicism.

Neoclassicism was a style of painting meant to react against the frivolity and excesses of the Rococo style. Henceforth, the gods of ancient mythology, religious figures and great nobles were to be painted in an appropriately dignified manner. While the Rococo movement looked to the lively brushwork and agitated compositions of artists such as Rubens, Neoclassicists looked back to the most classical elements of Renaissance and Baroque painting. Raphael and Annibale Carracci became the most admired models for Neoclassical artists who sought to emulate their seriousness of tone and elevated concept of beauty derived from ancient statues. This style reached its apogee with the artist Jacques-Louis David around the time of the French Revolution.

The trip through Europe called the Grand Tour was considered an important component of the education of young English aristocrats. While traveling they not only admired and collected ancient statuary in Italy, but also they were major patrons of both portraiture and landscape. Painted views of foreign cities, called *vedute* in Italian, were purchased in great quantity by traveling English lords. Indeed, the Venetian artist Canaletto found English patronage so lucrative that he went to live and paint in London between 1746 and 1755. Our Venetian views by Canaletto are in fact from his London period.

Because grand English country houses contained large collections of paintings and statues, they can be considered ancestors of the modern museum. This ancestry is palpably felt at the Ringling Museum because Ringling acquired many paintings from such houses when their contents were dispersed at auction in the early 20th century.

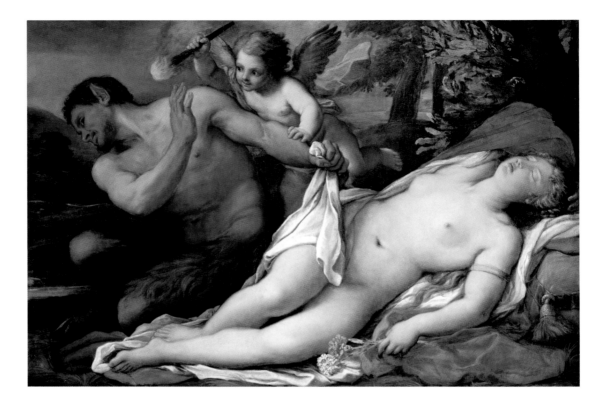

Guiseppe Chiari
Italian, 1654–1727, active in Rome
Eros Revealing a Sleeping Venus to a Bashful Satyr, c. 1720
Oil on canvas, 44⅛ x 63⅜ inches
Bequest of John Ringling, 1936, SN 163

The soft brushwork and amorous subject of this painting are typical of Rococo art. However, the monumentality and idealization of the figures are reminiscent of more severe Renaissance models and thus look forward to Neoclassicism—a style ultimately perfected by Jacques-Louis David in France in the 1790s. Here, as in Ludovico David's *Judgment of Paris* of about seventy years earlier, on page 76, the mythological theme is treated in a burlesque manner. Venus' mischievous son Cupid (Eros) is setting the animalistic satyr's heart ablaze by showing his own mother's beautiful body. This painting is one of a pair; the other shows Venus chastising her son for his constant escapades.

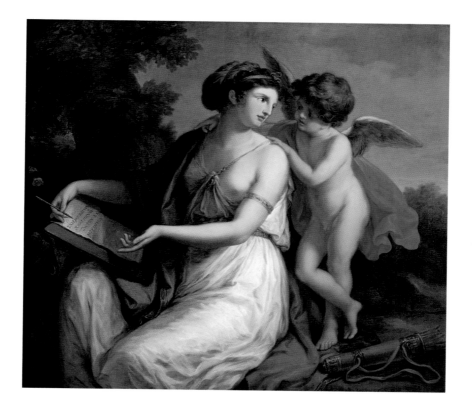

Angelica Kauffman
Swiss, 1741–1807, active in London and Rome
Sappho Inspired by Love, 1775
Oil on canvas, 52 x 57⅛ inches
Bequest of John Ringling, 1936, SN 329

Angelica Kauffman's painting shows the further development of the Neoclassical style favored by Chiari on the opposite page. Unlike Chiari, Kauffman treats the subject not lightly but rather with the lofty philosophical pretensions of Neoclassicism. The Greek poet Sappho is shown here as a majestically beautiful figure with features as perfect as those of Raphael's Madonnas. It is no wonder that sublime and profound thoughts emanate from her. Eros is not shown as base or comical but rather as the instigator of the greatest of all emotions. Thus he whispers inspiration in Sappho's ear as she writes her *Ode to Aphrodite*, "So come again and deliver me from intolerable pain." Kauffman, a friend of Joshua Reynolds, was the most celebrated woman artist of the 18th century. It is likely that her choice of the most famous woman poet of antiquity as a subject, was considered by her and her circle to be a clever one.

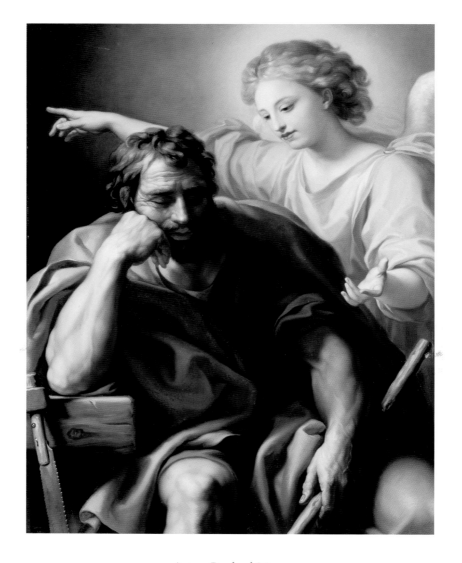

Anton Raphael Mengs
German, 1728–1779, active in Dresden, Rome, and Madrid
The Dream of Joseph, c. 1773
Oil on wood panel, 43¾ x 34 inches
Bequest of John Ringling, 1936, SN 328

The German painter Anton Raphael Mengs made a name for himself in Rome where he became, with his friend, the archaeologist Johann Winckelmann, one of the leaders of the Neoclassical movement. This picture shows the influence of Renaissance art on Mengs. Joseph the carpenter is derived from figures in Michelangelo's Sistine Chapel ceiling, while the angel who brings news that his wife Mary will bear the Son of God is comparable to Renaissance angels such as those portrayed in Ghirlandaio's *Madonna and Child* on page 41. This painting shows the clarity of conception typical of Mengs. The stark, rugged, sleeping Joseph is sharply contrasted with the radiant blond angel.

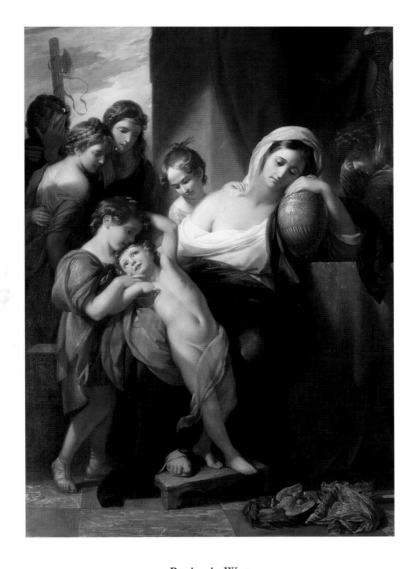

Benjamin West
American, 1738–1820, active in Pennsylvania, Rome, and London
Agrippina and Her Children Mourning Over the Ashes of Germanicus, 1773
Oil on canvas, 80 x 56½ inches
Bequest of John Ringling, 1936, SN 403

Agrippina and her children are observed mourning the death of her husband, Germanicus, a popular Roman general. While on a foreign campaign, Germanicus was believed to have been poisoned on the orders of his uncle, the Emperor Tiberius. Tiberius would later murder Agrippina and two of her sons. The surviving child, Gaius, here seen in the foreground, became the notoriously cruel Emperor Caligula. Benjamin West's stoic message is simple—out of the greatest good (Germanicus) can emerge the greatest evil (Caligula). West was the foremost American Neoclassical artist. This masterpiece shows the intense influence Italian art exerted upon West during his years in Rome. It was exhibited at the Royal Academy in London in 1773.

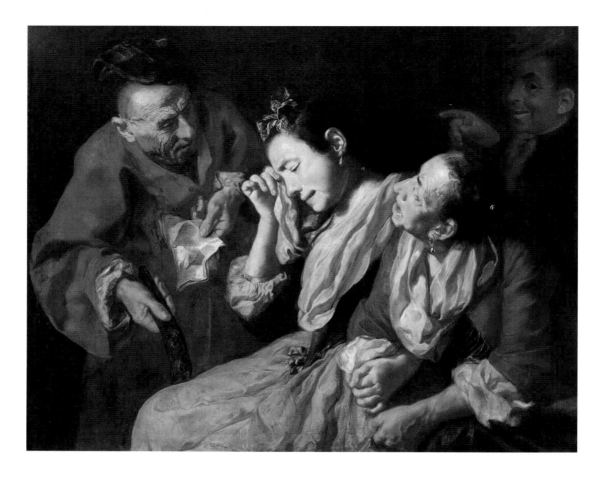

Gaspare Traversi
Italian, 1722/24–1770, active in Naples and Rome
The Detected Love Letter, c. 1760
Oil on canvas, 34½ x 42¾ inches
Bequest of John Ringling, 1936, SN 170

A young girl's amorous intrigue has been detected. Probably her younger brother, smiling in the background, was the one who revealed her secret. Her angry father threatens her with a strap while her mother reaches into the pocket of her dress. A torn pocket is a metaphor for lost virtue. Such bourgeois comic-dramas were invented in the 18th century. The realism of the subject and its direct depiction have parallels in contemporary theater, such as the plays of Carlo Goldoni, and stand in sharp contrast to the high-minded classicism of paintings such as Kauffman's on page 149.

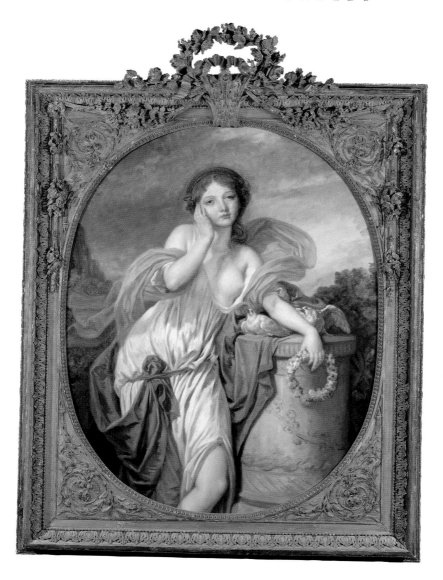

Jean Baptiste Greuze
French, 1725–1805, active in Paris
Meditation, c. 1780
Oil on canvas, 53 x 43⅜ inches
Bequest of John Ringling, 1936, SN 382

The young girl meditating is not contemplating the higher aspects of Love, as in Kauffman's *Sappho* on page 149, but rather whether she should remain a virgin. The intact wreath of flowers she holds indicates her virginity. If—as is likely—she is a Roman vestal virgin, her dilemma is serious indeed, for the punishment for Roman vestal virgins who break their vows was to be buried alive. Her devotion to the concept of chastity is indicated by the position of her arm by which she prevents two doves from mating. This painting—long thought to be unfinished—is in fact an example of the sketchy style Jean Baptiste Greuze used to emulate the late work of the Baroque painter Guido Reni. The elaborate 18th-century frame was probably expressly made for the painting as its floral motifs relate to the subject.

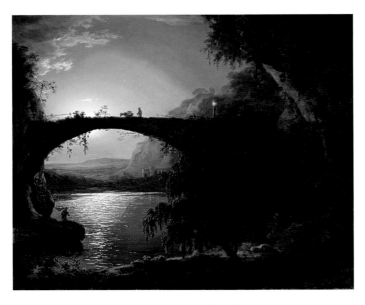

Joseph Wright of Derby
British, 1734–1797, active in Liverpool, Italy, Bath, and Derby
Moonlight Landscape, c. 1785
Oil on canvas, 25 ½ x 30 ½ inches
Museum Purchase, 1972, SN 906

Joseph Wright of Derby was a painter who, like earlier artists such as Jacopo Bassano, on page 58, and Caravaggio, was interested in observing the effects of natural and artificial light. Derby's most famous paintings show dramatic scenes of scientific experiments set by night and lit by candlelight. This landscape is typical of Derby's synthesis of the traditional landscape with evocative illumination. While Derby's other night landscapes show violent contrasts such as exploding volcanoes this is a placid scene. The juxtaposition of the moon—and the solitary lamp on the bridge—wittily contrast the grand light produced by nature with that crudely made by humans.

Luca Carlevaris
Italian, 1663–1729/30, active in Venice
*Venice: Piazza San Marco Towards the
Basilica of San Marco*, c. 1725
Oil on canvas, 24 ¼ x 40 inches
Museum purchase, 1953, SN 669

Luca Carlevaris
Italian, 1663–1729/30, active in Venice
*Venice: Piazza San Marco Towards the
Piazzetta*, c. 1725
Oil on canvas, 24 ¼ x 40 inches
Museum purchase, 1953, SN 670

Luca Carlevaris was one of the first Italian artists to produce exact city views in the manner of 17th-century Dutch painters. His skill consisted in marrying topographical accuracy with a perspective that was not overly artificial. He introduced weather and shadow effects that were fresh and unprecedented, as in the bravura handling of the misty, shrouded vignette of the stage lower left. Additionally, his bustling characters provided anecdotal interest. His works were highly prized by foreign travelers for their evocativeness and humor, and his compositions greatly inspired his follower in Venetian view painting, Canaletto.

Canaletto (Giovanni Antonio Canal)
Italian, 1697–1768, active in Venice and London
Venice: Piazza San Marco, Seen from Campo San Basso and
Venice: The Riva Degli Schiavoni Towards the East, 1760s
Oil on canvas, each 16⅛ x 12¼ inches
Bequest of John Ringling, 1936, SN 186, SN 187

This pair of exquisite small paintings exemplifies Canaletto at his most daring. The artist treats us to vertiginously steep perspective views, rather than detailed portraits of the façades of important buildings. The depictions of individual buildings are subordinated to the larger idea of giving us an appreciation of the shapes of important Venetian public spaces. In the painting at left all we see is one corner of the Basilica of San Marco and at right the Doge's palace is seen at a distance and in sharp recession. These compositions were chosen not only because Canaletto had a taste for exaggerated perspective, but also so that they would clearly be legible from a distance and on the crowded wall of a large collection. They are thinly painted—probably because they were never meant to be seen from near. Although they give the impression of having been painted on the spot, they were more likely painted after drawings completed while Canaletto was living in London between 1746 and 1755.

In 1710, the Meissen factory near Dresden was the first European workshop to produce pure white "hard-paste" porcelain after the Oriental manner. This material was prized for its purity of color and its possibilities for decorative detail. As this piece demonstrates, porcelain produced at Meissen was made with a variety of rich techniques including raised decoration, enameled glazes, gilding and painting. This tureen was the centerpiece of a large dinner service, and as the most prominent piece on a table, it is most lavishly decorated. Most importantly, while the number and variety of motifs were wide— encompassing Neoclassical, oriental, floral and Rococo elements—the final product was balanced and unified.

Germany (Meissen)
18th century
Covered Tureen and Underplate,
c. 1775/80
Hard-paste porcelain, 11 inches
Museum purchase, 1951, SN 7239

Italy (Palermo)
Late 18th century
Chair from the Villa of the Prince of Palagonia, Bagheria, Sicily, 1799–1802
Wood, glass (painted to simulate lapis lazuli), metal mounts, 38 ¼ x 22 inches
Gift of A. Everett Austin, Jr., 1955, SN 1802

This chair is from a large and famous suite of furniture made for the Prince of Palagonia, Francisco Il Gravina, a reputed alchemist and undoubted eccentric. His home in Sicily is known for its extravagantly decorated rooms and its strange gardens with sculptures of dwarves and monsters. The geometric decoration of the large suite from which this chair comes is relatively reserved, but the faux-painted glass resembling lapis lazuli would have been especially striking when the set was seen in its entirety.

The Ringling Museum has four pieces of this suite including two settees and two side chairs. The other pieces are in The Metropolitan Museum of Art, New York, and The Art Institute of Chicago.

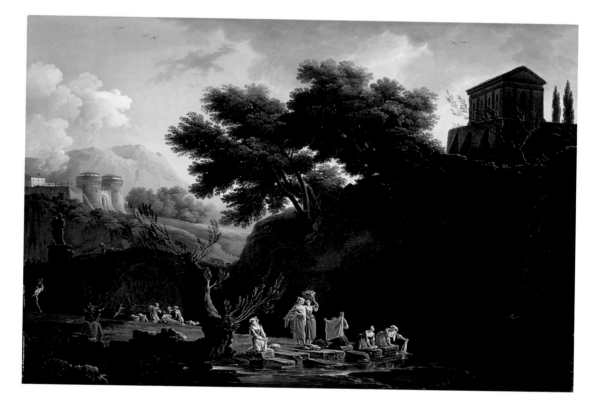

Joseph (Claude-) Vernet
French, 1714–1789, active in Rome, Naples, and France
Les Blanchisseuses ("The Laundresses"), late 1740s
Oil on canvas, 31 ½ x 45 inches
Museum purchase, 1975, SN 944

This is an imaginary view, or *capriccio* in Italian, of a calm Italianate landscape in which laundresses do their chores near buildings from different historical periods, including a medieval castle and a classical temple. Such paintings were often produced in pairs; the pair to this painting may have represented the opposite qualities—storm instead of calm, night instead of day. Although paintings such as this did not depict real places, such imaginary views of idealized peasants living with both nature and grand old buildings were widely appreciated as expressions of the Italian temperament.

George Watson
Scottish, 1767–1837, active in Edinburgh
The Sisters (Georgina and
Elizabeth Reay), c. 1810
Oil on canvas, 60¼ x 46⅛ inches
Bequest of John Ringling, 1936, SN 395

George Watson was a follower of
the innovative Scottish portraitist
Henry Raeburn to whom this painting
was first attributed. Like his master,
Watson did not idealize these naturally
beautiful girls by posing them as
ancient statues or lofty aristocrats.
Rather, this picture charms the viewer
into an intimate yet respectful dialogue
with the sitters. The sisters' loving
sentiments for each other and their
happiness in nature identifies them
as the kind of women who were
often idealized in the 18th century
by philosophers such as Jean-Jacques
Rousseau.

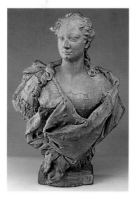

Franz Xaver Messerschmidt
German, 1736–1783,
active in Vienna and Munich
*Portrait Bust of the Empress
Maria-Theresa of Austria,*
c. 1760s
Terracotta,
31¼ x 21 x 11½ inches
Museum purchase,
1963, SN 5020

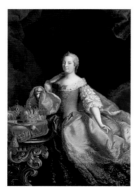

Martin van Meytens II
Swedish, 1695–1770,
active in Vienna
*Portrait of Empress Maria-
Theresa of Austria,* c. 1745/50
Oil on canvas, 79 x 54¾ inches
Bequest of John Ringling,
1936, SN 325

Empress Maria Theresa of Austria was
one of the most important monarchs of
her century. Though her father Charles
VI named her as his successor, her
claim to the throne of the Holy Roman
Empire was contested and caused the
Austrian War of Succession, which
lasted from 1740 until 1748. This war
embroiled much of Europe, including
Britain, and later led to the Seven Years
War in which the Marquis of Granby,
whose portrait by Reynolds is opposite,
was a hero. Meytens' full-scale imperial
portrait shows the monarch with the
crowns of the provinces she regained
after the war. Messerschmidt, by
contrast, is more interested in conveying
her proud character through her
countenance rather than through
her costume and accessories.

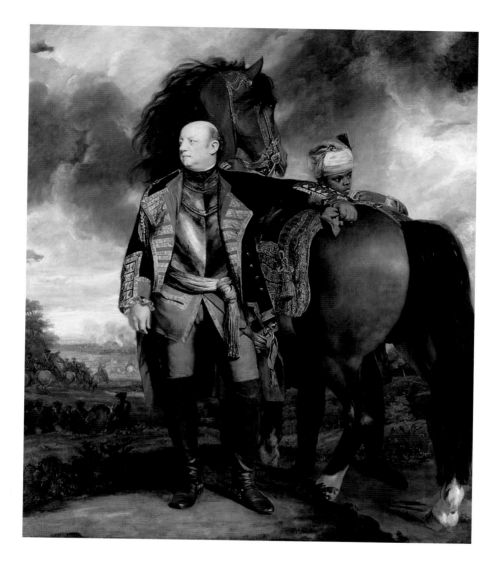

Joshua Reynolds
British, 1723–1792, active in London
John Manners, Marquis of Granby, 1766
Oil on canvas, 97 x 82⁵⁄₁₆ inches
Bequest of John Ringling, 1936, SN 389

Joshua Reynolds modified the traditional equestrian portrait in which subjects are shown sitting on their horses. By showing Granby about to mount instead of already atop his steed, Reynolds emphasizes his mental preparation for battle. Granby was a staunch partisan of the House of Hanover, the reigning family in the England of his day. He raised at his own expense a regiment called the "Leicester Blues" and was a hero in the Seven Years War (1756–1763) as well as many other battles. In the year this portrait was painted, Granby was promoted to the rank of commander-in-chief. Remarkably, this painting was commissioned by Granby as a gift for his former enemy in the Seven Years War, the French Marshall Victor-François, 2nd Duc de Broglie.

THE NINETEENTH CENTURY
The Belle Epoque

AFTER the French Revolution, the purpose and style of art changed dramatically from the Old Masters of the Renaissance and Baroque periods represented comprehensively in the Ringling Museum. Religious art was no longer the primary object of patronage, nor were imposing portraits of aristocrats a major fashion. Painting instead was employed to depict states of emotion and the life experience of the painter or bourgeois patrons. Artists no longer painted primarily for church or state commissions but rather for public exhibition and private patrons. Originality became a major factor in an artist's ability to attract attention and buyers, and hence, artists actively searched for novelty in their styles and subjects.

This was a century in which artistic movements followed one another in quick succession. The fiery excitement and energy of Romanticism as practiced by Eugène Delacroix challenged the icy Neoclassicism of Jacques-Louis David and his follower Jean-Auguste-Dominique Ingres. Edouard Detaille's *Battle Scene* is a good example of a later Romantic painting. At mid-century, Realism and Historicism conflicted. Rosa Bonheur's realistic and earthy scene of plowing and Ferdinand Roybet's fancifully dressed connoisseurs exemplify the contrast of the two styles. Finally, Impressionism and Post-Impressionism abandoned the limited preconceptions of reality practiced in painting until then, and endowed art with new lightness and autonomy from nature. Symbolism, as in Edward Burne-Jones' *The Sirens*, looked to both mythic archetypes and everyday life for inspiration.

The 19th century is not as comprehensively represented in the Ringling Museum as is earlier European art. Most notable is the absence of the Impressionists Manet, Monet, Renoir and others. There are many reasons for this. With few exceptions, Ringling did not collect what he would have considered to be "modern art." Instead he strived to make the historic collections of the museum as complete as possible. Evidence also indicates that he thought the Impressionists were already overpriced. However, the few examples of 19th-century art that he bought show that Ringling was not entirely immune to the luster of the belle époque period. He also was especially concerned with glamorous provenance and was proud of owning art previously displayed in the magnificent houses of such famous families as the Astors, Vanderbilts and Huntingtons.

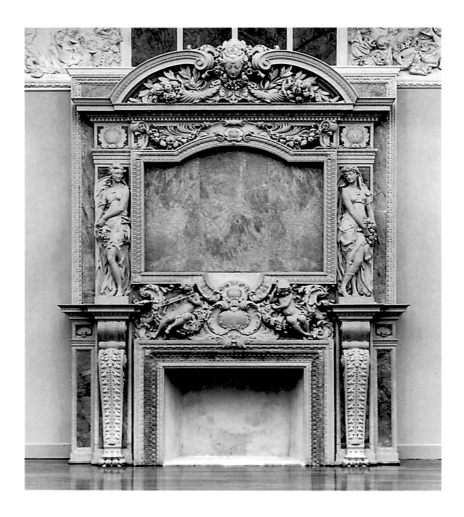

Karl Bitter
American, 1867–1915
Fireplace from the Huntington Mansion, about 1889/94
Marble
Bequest of John Ringling, 1936

The Collis P. Huntington Italian-style palazzo designed by George Post was once located where Tiffany's now stands at the corner of Fifth Avenue and 57th Street in New York City. Its marble interior fittings were made by one of the American Gilded Age's most gifted sculptors, Karl Bitter, a student of Augustus Saint-Gaudens. This fireplace demonstrates the brilliance of Bitter's detailed naturalistic carving technique as well as an admirable overall harmony of design. After this home to the transportation millionaire was torn down in early 1926, Ringling purchased the fittings and had them installed in what was then the Museum's auditorium. Ringling thus amassed fragments from the homes of America's most socially prominent families including the Vanderbilts and the Astors, and enhanced his museum with prestigious provenance as well as brilliant design.

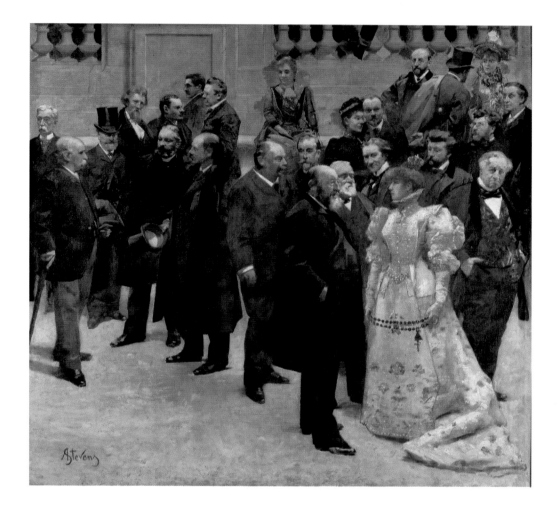

Alfred Stevens
Belgian, 1823–1906, active in Brussels and Paris
A Portrait Group of Paris Celebrities, 1889
Oil on canvas, 92¾ x 96¾ inches
Bequest of John Ringling, 1936, SN 439

This painting is a section from the original *Panorama du Siècle* (Panorama of the Century), which was created for the Paris Universal Exhibition of 1889. It was 120 meters long, twenty meters high and contained 641 identifiable portraits of famous men and women who lived between 1789 and 1889. The enormous painting was installed in a rotunda created for it in the Tuileries Gardens in Paris and was one of the sights of the city. The painting was then exhibited in Chicago, St. Louis, Brussels and Barcelona. Unable to secure a permanent installation, Stevens cut it into sections that were distributed proportionately to shareholders. This section shows Sarah Bernhardt as the central figure of the decade. She is dressed in the costume of her role as the Queen in Victor Hugo's *Ruy Blas*, and is surrounded by prominent dramatists, other writers and musicians.

Richard Morris Hunt
American, 1827–1895, active in Paris and the United States
Two Rooms from the Astor Mansion, 5th Ave. and 65th St., New York, 1891–5
Bequest of John Ringling, 1936

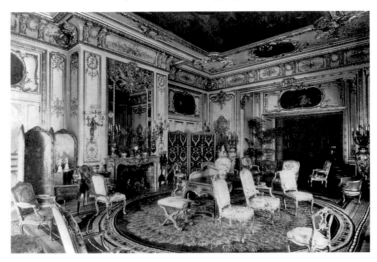

The Cream Salon of Mrs. Caroline Astor

Ringling bought these rooms at the 1926 sale of the residence of Mrs. William Backhouse Astor (née Caroline Schermerhorn). While Ringling was no doubt attracted by the fine design of the rooms, he was not insensitive to the glamour of their previous owners. Caroline Astor was one of the most powerful society women America ever produced. New York high society comprised the "Four Hundred" people on her invitation list. Richard Morris Hunt, also the architect of The Metropolitan Museum of Art, designed the exterior of the Astor mansion in the French Renaissance style, but its interiors were decorated in a wide variety of historical vocabularies. The rooms themselves were fabricated by the Allard workshop in Paris.

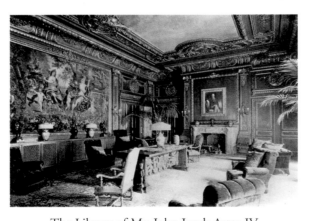

The Library of Mr. John Jacob Astor IV

The Astor mansion was in fact a double residence for the socialite Caroline Astor and her son John Jacob IV. The French Rococo Louis XV style employed in the cream salon was considered to be the epitome of femininity and was thus appropriate for Mrs. Astor's intimate salon. The library is in the Régence style. When Caroline died in 1908, John Jacob decided to convert this room, originally a dining room, into a library, which was easily accomplished by simply adding bookcases to the original woodwork. After acquiring the rooms at auction in 1926, Ringling installed them in the Museum. He intended them to be used for receptions, but they are now appropriately viewed as works of art in their own right and shown as period rooms.

Jean Baptiste-Edouard Detaille
French, 1848–1912,
active in Paris
French Artillery (An Episode in
the Franco-Prussian War,
1870–1871), 1873
Oil on canvas, 49 x 63 inches
Bequest of John Ringling,
1936, SN 446

John Ringling purchased these two paintings out of the 1926 Astor sale in New York City either to add to his small collection of 19th-century art or perhaps as relics of the Astors to display with the rooms he bought at the same time (opposite page). Both paintings are examples of the French academic style with its preference for highly detailed and precisely realistic surfaces. However, the two subjects are treated very differently despite their superficial stylistic similarities. Ferdinand Roybet (below) shows an imagined episode from 17th-century artistic life, while Edouard Detaille shows a horrific event from a traumatic war in the recent past. The hallucinatory effect of Detaille's chilling realism perhaps explains the interesting fact that Salvador Dalì considered Detaille the greatest French painter.

Ferdinand Roybet
French, 1840–1920,
active in Paris
The Connoisseurs, 1876
Oil on canvas, 48 x 59 inches
Bequest of John Ringling,
1936, SN 441

Chiurazzi Foundry
Naples, Italy
Laocoön, about 1900/20
Bronze cast, 89 x 66 x 34½ inches
Bequest of John Ringling, 1936, SN 5084

Ringling purchased many bronze reproductions of famous ancient sculptures from this eminent Neapolitan firm. Chiurazzi was the only company licensed by the Vatican and other collections to reproduce their great ancient works so that they could be admired by a broad public and studied by artists. With both aims in view, Ringling purchased these examples. Some were placed in the Courtyard of the Museum, while others were to have been placed in a great sculpture hall that was never built and are now dispersed about the Museum grounds. This sculpture, depicting the ancient priest Laocoön grieving at his sons' strangulation by snakes, was considered the greatest example of tragic emotion in art from the time it was rediscovered in the Renaissance.

Gustave Doré
French, 1832–1883, active in London and Paris
The Acrobats, about 1880/83
Bronze, 50¾ x 9¾ inches
Bequest of John Ringling, 1936, SN 5338

Although Gustave Doré is now best known as an illustrator for such books as *The Divine Comedy, Faust* and the "Doré Bible," he was equally successful as a painter of religious subjects and landscapes. It was only late in life that he turned to sculpture, producing commissions for monuments as well as occasional smaller bronzes. *The Acrobats* demonstrates Doré's interest in anatomy. The work also has an allegorical meaning. The well-defined figures struggle to attain balance and stability, but it is the strength of only one man that holds them up–a testament to human ambition, and perhaps folly.

Carl Marr
American, 1858–1936, active in Wisconsin and Munich (Germany)
The Mystery of Life, 1879
Oil on canvas, 66 x 95 inches
Bequest of John Ringling, 1936, SN 408

Carl Marr is another expatriate American painter, although rather than living in France or Italy like most other Americans, he lived in Germany. There he took up the academic style and in fact became a professor at the Munich Academy of Painting. This painting of a mysterious subject is considered his masterpiece. It combines many late-century styles and themes including loose impressionistic brushwork, academic treatment of anatomy and a vaguely symbolist theme. *The Mystery of Life* is meant to move and strike awe in the viewer with its overwhelming pathos.

FANS FROM THE RINGLING COLLECTION

The Ringling Museum has a collection of over 300 fans from the period 1750–1930. Illustrated here are examples of the major types of materials and decorations found in the late 18th and early 19th centuries. The earliest fan on this page is in the Neoclassical style and resembles Pompeian wall decoration (lower right). The lace fan (lower left) is among the rarest and most expensive type. More typical are those painted on paper or parchment. Of the latter, two designs predominate—those painted in vignettes or those with illustrations covering the whole sheet. In both cases, the decorations are meant to evoke the 18th century or earlier. Less nostalgic fans proclaim political allegiances, while those decorated with cats and dogs are simply meant to tease or amuse the viewer.

SN1951.10A, SN1951.14, SN1951.58, Gift of Mr. and Mrs. Irving G. Snyder, from the Collection of Helen Campbell Kerr, 1974
MF88.14.1, MF88.14.13, MF88.14.17, MF93.9.4, MF93.5.5,
Gift of Elsa James Zelley, in memory of her mother Elsa Konig Nitzsche, 1988

Rosa Bonheur
French, 1822–1899, active in Paris and Fontainebleau
Ploughing in Nivernais (Labourages Nivernais), 1850
Oil on canvas, 52½ x 102 inches
Bequest of John Ringling, 1936, SN 433

Rosa Bonheur was one of the most prominent and unconventional female artists of the 19th century. She was widely admired for her skill at painting animals—she first exhibited in the Salon before her twentieth birthday—while society censured her masculine attire and behavior, and her open lesbianism. This painting is a copy by Bonheur herself of a state commission celebrating the virtues of country life. The practice of replicating one's own work was well established in the 19th century. The title refers to Nivernais, which was a former province of central France near the city of Nevers. Bonheur shows the herd as heroic beasts, triumphant in the brightly lit fertile landscape and little concerned with the gnat-like prodding of the herdsman.

Louis Comfort Tiffany
American, 1848–1933,
active in Europe and New York
Favrile Vase, early 20th century
Glass, 11¼ x 9¾ inches
Gift of Mrs. Ivy Osborne, 1982, MF 82.16

These disparate objects show the persistence or rediscovery of past styles in the 19th century. "Royal Doors" stood in the middle of the icon screen in orthodox churches–only priests and bishops were allowed to pass through them. Our examples, while painted in the 19th century, follow exactly the technique and subject matter of such icons from centuries earlier. By contrast, Tiffany's vase attempts to resurrect the Roman technique of favrile iridescent glass which captured and diffused light and provided rich coloristic effects. Here the decoration of ivy leaves reinforces the Neoclassical effect of the design and shape of the perfectly proportioned vase.

Russia (Moscow)
19th century
*Royal Doors Showing the Annunciation
and the Four Evangelists*
Originally from the Church of the
Resurrection in Moscow, c. 1850
Tempera on two shaped panels,
75 x 41 x 1½ inches
Bequest of Mr. Karl A. Bickel,
1973, SN 911.a, SN 911.b

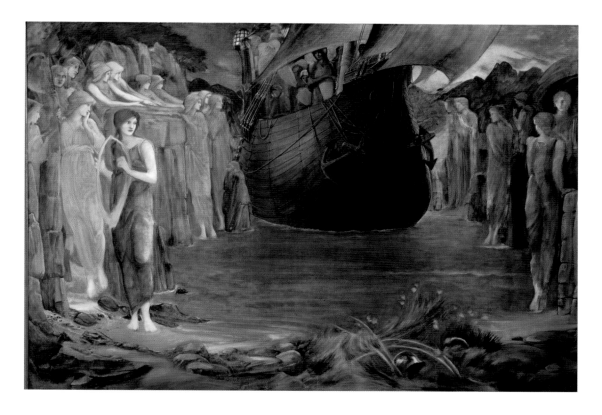

Edward (Coley) Burne-Jones
English, 1833–1898, active throughout Britain
The Sirens (Les Femmes Chasseresses), c. 1891/98
Oil on canvas, 84 x 120⅞₆ inches
Bequest of John Ringling, 1936, SN 422

The Sirens by the English Pre-Raphaelite artist Edward Burne-Jones is usually thought to allude to the story of the ancient hero Ulysses' temptation by these ancient female singers who lured men to their deaths on the cliffs. The artist's own account of it is more abstract: "*It is a sort of Siren-land—I don't know when or where—not Greek Sirens, but any sirens, anywhere that lure men on to destruction. There will be a shore full of them, looking out from the rocks and the crannies in the rocks at a boat full of armed men, and the time will be sunset. The men shall look at the women and the women at the men, but what happens afterwards is more than I care to tell.*" This painting achieves Burne-Jones' wish to create an atmosphere of mystery and dread.

Eugène Boudin
French, 1824–1898, active in Paris and surrounding areas
A View of Dunkirk, 1880
Oil on canvas, 16⅛ x 31⅞ inches
Bequest of John Ringling, 1936, SN 436

These two small paintings by Eugène Boudin show characteristics of Impressionist style and technique in their quick brushwork, highly keyed fractured color and vivid sense of visual immediacy. They also relate back to earlier techniques such as Veronese's or Bassano's painterly handling, as well as to landscape formats developed by 17th-century Dutch artists.

Eugène Boudin
French, 1824–1898, active in Paris and surrounding areas
A Marine Scene, 1878
Oil on bristol board, 12¼ x 18¼ inches
Bequest of John Ringling, 1936, SN 435

Edouard Vuillard
French, 1868–1940
Le Dejeuner de Francine
Pastel on Academy board, 24¾ x 33³⁄₁₆ inches
Gift of Mr. and Mrs. Norman L. Jeffer, 1967, SN 683

Edouard Vuillard, a follower of the Impressionists, specialized in intimate domestic scenes. The simple scene of a young girl having her breakfast becomes a pretext for Vuillard to display beguiling Art Nouveau-like lines and subtle coloristic effects. Vuillard turns the viewer into a voyeur by showing things at odd angles and by his "unfinished" technique, both of which force a more active participation in the act of looking. The pictorial interest of this work lies as much in the artist's ability to recreate the experience of seeing, as it does in revealing an intimate scene of domestic life.

THE TWENTIETH CENTURY
Abstraction And After

UNLIKE ART of the Renaissance and Baroque periods, which sought to reaffirm the social and religious attitudes of their viewers, 20th-century art was often conceived to unsettle and undermine such certitude. This contrary attitude is seen as a legacy of the Realist and Impressionist movements. The 19th-century artists' abandonment of traditional pictorial subjects and stylistic formulas shocked viewers at the time—good examples are provided by the work of Courbet, Manet, Monet and Van Gogh, all of whose greatest works were greeted with contempt and derision by the broad public. The tendency of artists to produce works that shocked audiences became even more pronounced with 20th-century movements such as Cubism, Abstraction, Dada, Surrealism, Pop and Op Art and others.

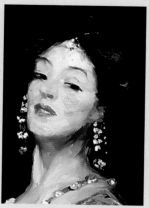

The Ringling Museum's collection of 20th-century art is not comprehensive and although the first Picasso painting to be publicly shown in Florida was displayed here, he is not yet included in the permanent collection. Nonetheless, the 20th-century collection does provide glimpses of some of the most important movements. It is especially strong in certain periods, thanks to the enthusiasm of directors, curators and collectors. Since the arrival of the first director, A. Everett Austin, Jr. in 1946, this collection has been an important source for exhibitions of local, national and international repute.

As the State Art Museum, the Ringling well-represents Florida's contemporary artists in both the permanent collections and in exhibitions. Though some of the art in the modern collection may well be foreign to what we suspect was John Ringling's taste, the collecting and exhibiting of works by living artists is in perfect keeping with his idea to found an art school (today the Ringling School of Art and Design) and to make the Museum the center of the community's cultural life.

The following selection illustrates major trends in modern art that oscillate between representational and non-representational. Masterpieces of realism by Reginald Marsh and Robert Henri are from the early part of the century, and the later part of the century is well-represented, with works by Thomas Struth and Barbara Kruger. Non-representational artists also span the century. Arthur Dove and Marcel Duchamp's early works vie with Frank Stella and Richard Anuszkiewicz from the 1970s. Between these extremes lie other intriguing works, not least among them the vibrant Surrealist culture represented by Eugene Berman's decorations for the Asolo Theater.

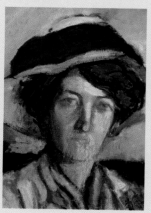

This teeming monumental composition shows Reginald Marsh's interest in contemporary social caricature while demonstrating his dependence on the fast painterly technique and dynamic compositions of artists like Rubens. Here, the crowd surges together at the base of a platform upon which a barker draws its attention to two beautiful women. One of them stands calmly even though she is roped with her arms akimbo to a cross-like structure. Is she simply advertising a knife-throwing act, or is this painting symbolic of the folly of the indifferent crowd to the suffering of the Christ-like woman?

Reginald Marsh
American, 1898–1954
Wonderland Circus, Sideshow Coney Island, 1930
Tempera on canvas stretched on masonite, 48¾ x 48 inches
Museum purchase, 1976, SN 951

Thomas Hart Benton
American, 1889–1975
Interior of a Farm House,
1936
Tempera on board,
18 x 30 inches
Museum purchase,
1976, SN 950

This painting is a sketch for a mural in the Missouri State Capitol Building, one of the numerous commissions Thomas Hart Benton executed for the Works Progress Administration (WPA) during the Great Depression. Like Marsh, Benton was very influenced by the dynamic fluid compositions of the Baroque as well as by Renaissance experiments in perspective. It is interesting to compare Benton's style with Rubens' (see *Eucharist* series, on page 108). The title, *Interior of a Farmhouse,* may be something of a misnomer. While the stove of the farmhouse is indeed the central element, outside the structure Benton shows activities of every kind in both urban and rural settings, presenting a true panorama of everyday life.

Robert Henri
American, 1865–1929
Salome, 1909
Oil on canvas, 77½ x 37 inches
Museum purchase, 1974, SN 937

Robert Henri was the leader of the "Ash Can School" that promoted realism in American painting. His radical insistence on not idealizing his subjects led to sometimes scandalized reactions to his works. Such was the case with this portrait of the singer Mademoiselle Voclezca in the title role of Richard Strauss' opera *Salome*. Compare Henri's treatment of the theme with the Caravaggesque Baroque depictions of female heroines by Francesco Cairo and Mattia Preti, on pages 66 and 67, by whom he was influenced. Henri's painting is a much more lively depiction. He skillfully incorporated spatial formulas developed most fully by Diego Velázquez, and brushwork derived from Frans Hals in order to show the performer's full-length figure in ecstatic and provocative motion.

Arthur (Garfield) Dove
American, 1880–1946
Mars Yellow, Red and Green, 1943
Oil on canvas, 28 x 18 inches
Museum purchase, 1973, SN 935

Arthur Dove was one of the first American artists to explore the language of abstraction. In this important later painting, irregular bands of color run through, surround and radiate from a central shape that seems neither to float or to move. The dynamic tension between stasis and motion is the focus of the painting. By contrast, Marsden Hartley's *Shell* derives its pictorial language from Cubism, while not strictly adhering to that movement's principles.

The lines surrounding the shell do not reflect its facets as they would in pure Cubism. Rather, they show off the shell as a magical or talismanic object. Hartley had a deep relation to the sea, which he viewed as the giver and taker of life. Thus, both these paintings refer to life forces—both tangible and abstract.

Marsden Hartley
American, 1877–1943, active in New York,
Maine and Nova Scotia
Shell, 1929
Oil on composition board, 18 x 15 inches
Gift of Mr. and Mrs. William L. Moise, 1965, SN 794

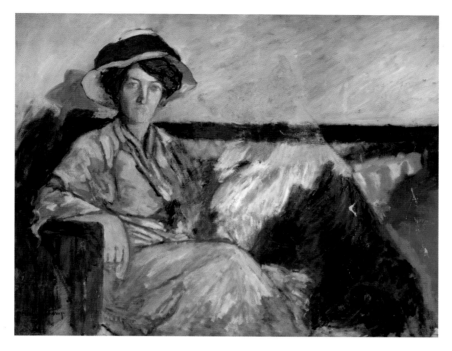

(Henri-Robert-) Marcel Duchamp
French, 1887–1968, active in Paris and New York
Portrait d'Yvonne Duchamp-Villon, 1907
Oil on canvas, 28 x 35¾ inches
Gift of Mary Sisler Foundation, 1978, MF 79.1.3

Marcel Duchamp was the foremost artist in the movement called Dada. He caused a scandal in 1917 by exhibiting a urinal as a work of art at the Society of Independent Artists. The coat rack in *Trap* exemplifies this strategy of exhibiting "readymades," or found objects, as artworks. By placing the coat rack on the floor instead of on the wall, he subverts the object's usual function. *Trap* thereby reverses the natural order of things such as gravity and physical space. Duchamp creates an illusion that many viewers find troubling and vertiginous. This radical artist had more conventional beginnings—the portrait of his sister-in-law Yvonne is executed in a post-Impressionist style not distant from that of Vuillard on page 173. The Ringling Museum possesses one of the world's most significant collections of Duchamp's early work.

(Henri-Robert-) Marcel Duchamp
French, 1887–1968,
active in Paris and New York
Trébuchet (Trap), 1917 (1964 edition)
Wood and metal, 39⅜ x 4⅝ inches
Gift of Mary Sisler Foundation, 1978, MF 78.7

THE ASOLO THEATER

A. Everett Austin, Jr., the Ringling Museum's first director, began the contemporary collection and exhibited artists such as Picasso, who had never been seen in public museums in Florida. He believed that the art of the past and the present should meet, a belief represented very well in the use to which he put the Asolo Theater. Austin had this historic Empire-style interior brought from Italy and reconfigured in a modern building where the first performances of Sarasota's orchestra, symphony and ballet were held. For the gala opening production, Goldoni's comedy, *La Serva Padrona*, Austin had sets designed in a neo-Baroque style by his friend, the Surrealist artist Eugene Berman.

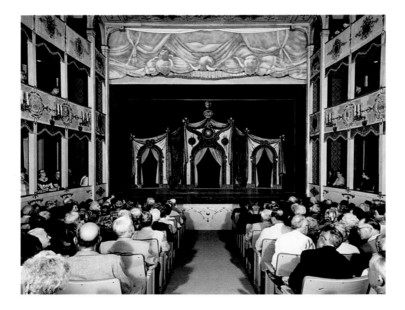

The stage of the theater decorated with Eugene Berman's settings for Goldoni's Venetian comedy, *La Serva Padrona*

The Empire-style boxes of the Asolo Theater as seen from the stage in a period postcard.

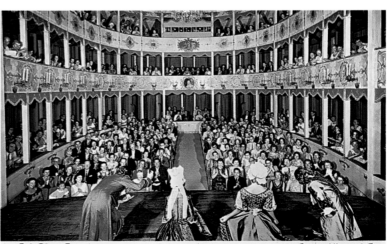

Asolo Theater Interior Ringling Museum of Art

Yves Tanguy
French, 1900–1955
The New Nomads (Les Nouveaux Nomades), 1935
Oil on canvas, 31¾ x 27⁷⁄₁₆ inches
Gift of the Estate of Kay Sage Tanguy, 1964, SN 782

The New Nomads is a characteristic landscape by this Surrealist artist. The nomads in the title are nowhere to be seen, and the absence of human figures is made even stranger by the fact that this composition was painted over a still faintly visible human figure. Yves Tanguy nevertheless uses typical landscape formulas such as perspective, light and shadow to create illusionistic depth. However, this painting is better defined as a "mindscape" than a landscape. It depicts the world of the imagination and reveals phantoms from a time that seems never to have existed.

ART IN SARASOTA

Art in Sarasota in the mid-20th century developed around the Ringling Museum and the friendships of artists with each other and with "Chick" Austin. Syd Solomon (opposite) became the most dominant figure in this group, and at the beginning of his career he taught classes at the Museum. He practiced a lyrical mode of Abstract Expressionism throughout his activity in Sarasota. His friends David Budd and Jimmy Ernst worked away from Sarasota at times. Budd practiced an intensely personal brand of abstraction characterized by thickly encrusted, monochrome impasto and minimally structured panels. Jimmy Ernst's *Terminal II* is typical of the dynamic asymmetry of his early works. He later painted symmetrically composed paintings with abstracted natural and Native American motifs.

These artists formed the first Sarasota art colony, along with other artists such as Jon Corbino and Conrad Marca-Relli. Later, artists such as Robert Rauschenberg, John Chamberlain and Richard Anuszkiewicz were also active in the Sarasota area. Contemporary with these artists was the architectural achievement called the Sarasota School of Architecture, an innovative Modernist style, exemplified by architect Paul Rudolph, that is now the focus of reassessment and new admiration.

Jimmy Ernst
American, 1920–1984
Terminal II, 1952
Oil on canvas, 25 x 18 inches
Gift of Mr. and Mrs. Moses F. Mager,
1976, SN 953

David Budd
American, 1927–1991
Polyptych, 1979
Oil on canvas, 72 x 36 inches (each panel)
Museum purchase, 1997, SN 11031

Solomon, Syd
American, 1917–
Silent World, 1961
Liquitex on gesso panel, 55⅛ x 47⁵⁄₁₆ inches
Museum purchase, 1962, SN 742

Richard Anuszkiewicz
American, 1930–
Quartered Red Cadmium, 1977
Acrylic on canvas, 90 x 180 inches
Museum purchase, 1977, SN 956

Richard Anuszkiewicz's immense canvas is in the tradition of Geometric Abstraction, which explores the interaction of shape and color as exemplified by the work of Bauhaus artist Josef Albers. The very strict geometry of this canvas is not immediately evident because the striking color combinations force the eye to not recognize the intensive interrelationship of the repeating, variously scaled squares. Anuszkiewicz's work combines elements of Minimalist art with those of Op Art. Visitors who stare long at this painting will see the colors and shapes appear to "dance," an effect enhanced by the subtle change of the background color from blue to green.

Warren Platner
American, 1919–
Chair and Ottoman from the Platner Lounge Collection, 1966
Nickel, steel, wool and other materials, 39 x 40 x 35 inches, 15 x 25 x 25 inches
Manufactured by Knoll International

Optical effects such as those described above were characteristic of furniture of the same epoch. Here, the red pillows appear to float off the ground. The bent-wire construction of the bases produces optical illusions such as the "quivering" effect evident even in this photograph. Warren Platner's chairs self-consciously refer to the "Jet Age" with their wing-like aerodynamic arms and optimistic large scale. They celebrate the sumptuousness of 20th-century American culture and are seen as works of art and feats of engineering in their own right.

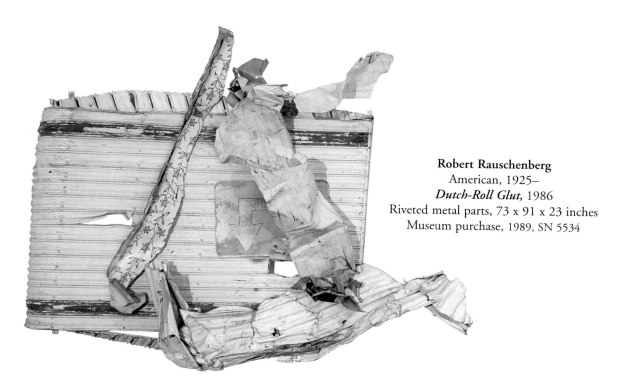

Robert Rauschenberg
American, 1925–
Dutch-Roll Glut, 1986
Riveted metal parts, 73 x 91 x 23 inches
Museum purchase, 1989, SN 5534

These two assemblages of metal fragments are very dissimilar despite their common technique and materials. Robert Rauschenberg's title refers to a series of works he called "*gluts*" produced in the 1980s. They are composed of pieces of found metal, in this case, siding from a mobile home. A "Dutch-roll" is defined as a "combination of directional and lateral oscillation of an airplane"—a term that could refer to the floating appearance of the metal parts. Thus, Rauschenberg aims to convey a lyrical effect of movement and delight in observing the artist's process. By contrast, John Chamberlain's agglomeration of auto body parts is more forceful than lyrical. *Added Pleasure* is aggressively put together and seemingly carelessly covered with spray paint. The sculpture is muscular in volume, and the compressed parts seem to expand rather than contract.

John Chamberlain
American, 1927–
Added Pleasure, 1975–1982
Painted and chromium plated steel, 111 x 53 x 36 inches
Museum purchase, 1983, SN 5533

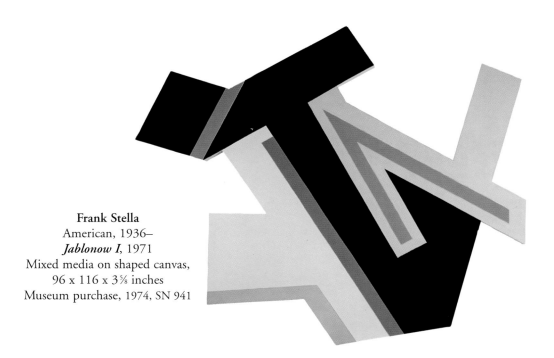

Frank Stella
American, 1936–
Jablonow I, 1971
Mixed media on shaped canvas,
96 x 116 x 3⅝ inches
Museum purchase, 1974, SN 941

Frank Stella and Joel Shapiro were both at the forefront of the Minimalist movement that espoused an artistic language that can seem totally abstract and without meaning. Although both of these pieces appear abstract, they are meant to be referential. In *Jablonow I*, Stella takes some of the premises of abstract painting, such as Arthur Dove's on page 178, farther by repeating the dynamic asymmetry of the forceful abstract lines in the very shape of the canvas. The result is a "shaped" canvas that is both a painting and a sculpture. Surprisingly, Stella found his inspiration for this painting in photographs of ruins of Polish synagogues destroyed in World War II.

In *Untitled 1/2*, Shapiro also seems to disavow the usual premise of sculpture as a representational medium. Indeed, this sculpture seems to be a hopelessly inexpressive object—an iron rectangle strangely ennobled by being placed on a base. Yet, by the simple device of adding window-like openings to the iron box, Shapiro indicates that it might be seen as a representation of a house or a temple. Thus, the viewer is confronted by a sense of some further mystery.

Joel Shapiro
American, 1941–
Untitled 1/2, 1975
Cast iron with plaster base, 3½ x 7⅛ x 7¾ inches
Gift of Sylvia G. Zell, 1985, MF 85.8

Izhar Patkin
American, 1955–
***Don Quijote Segunda Parte**, 1987–1989*
Anodized aluminum, 92 x 75 x 40 inches
Museum purchase, 1990, SN 5536

In reaction to the formality and abstraction of Minimalist art, some artists in the 1980s began to use the figure in an overt and highly ironic way. At the time it was made, Izhar Patkin's *Don Quijote Segunda Parte* seemed primarily to refer to kitsch because it borrowed from popular culture and used industrial and non-traditional artistic materials. Now—at the distance of some years—the sculptor seems both rather sincere and successful in his attempt to create monumental public sculpture of a recognizable subject in a historicist idiom. This work is neo-Rococo in style and its pastel colors and flower-like modeling reflect Don Quixote's strange perception of himself as a fine-looking dandy.

Barbara Kruger
American, 1945–
Untitled (Who will write the history of tears?), 1991
Photographic silkscreen on vinyl, 60 x 148 inches
Foundation purchase with funds provided by the National Endowment for the Arts,
The John E. Galvin Charitable Trust, and The Modern Art Council, 1991, MF 91.1

Haim Steinbach and Barbara Kruger both inherited a great deal from the Dada movement of the 1910s/20s. Steinbach's most obvious debt is to Duchamp's "readymades" (see page 179). Here, Steinbach has taken common everyday objects and turned them into art by placing them on pedestal-like shelves, ennobling humble garbage cans and lava lamps. The strange combination of the solid but empty garbage cans and the ever-changing blobs of color and light in the lava lamps is meant to unsettle the viewer. Kruger's monumental combinations of word and image are also derived from Dada, as well as from propaganda and the advertising medium that she originally studied. Kruger's confrontational and accusatory work is meant to cause aesthetic disgust and unease and she purposefully poses social and moral questions that are difficult to understand, much less answer.

Haim Steinbach
American, 1944–
00: 06 (2,4 L) (shelf), 1988
Mixed media construction,
30½ x 90¼ x 21 inches
Museum purchase, 1989, SN 5535.1

Thomas Struth
German, 1954–
National Gallery 1, London, 1989
Cibachrome print, 71 x 77 ¼ inches
Museum purchase, 1990, SN 11009

It is fitting to conclude this book about the Ringling Museum with one of Thomas Struth's photographs of museums. In this immense photographic print, Struth clinically depicts the National Gallery in London as a cold, alien place in which art made for richly decorated churches and aristocratic homes is shown in a neutral and scientific setting. Struth's museum photographs encourage viewers to examine their own historical distance from the works of art as displayed in modern museums. How different this feeling is from the optimism with which Ringling brought works from the European past to America with the intention of recreating the original experience of them!

SUGGESTIONS FOR FURTHER READING

The publisher is The John and Mable Ringling Museum of Art unless otherwise indicated.

Austin, Jr., A. Everett, Julien Levy, and Virgil Thomson. *A. Everett Austin, Jr.; A Director's Taste and Achievement.* Hartford, CT: Wadsworth Antheneum, 1958.

Austin Jr., A. Everett. *The Asolo Theater in Sarasota at the John and Mable Ringling Museum of Art,* 1952.

Buck, Patricia Ringling. *The John and Mable Ringling Museum of Art,* 1988.

Craven, Roy C. *Indian Sculpture in the John and Mable Ringling Museum of Art.* Gainesville, FL: University of Florida Press, 1961.

De Groft, Aaron H. *John Ringling in perpetua memoria: the legacy and prestige of art and collecting.* Ph.D., diss., Florida State University, 2000.

De Groft, Aaron, Mark Ormond, and Gene Ray, eds. *John Ringling: Dreamer, Builder, Collector: Legacy of the Circus King,* 1996.

Duval, Cynthia. *500 Years of Decorative Arts from the Ringling Collections, 1350–1850,* 1982.

Duval, Cynthia and Walter J. Karcheski. *Medieval and Renaissance Splendor: Arms and Armor from the Higgins Armory Museum, Worcester, Massachusetts, and Works of Art from the John and Mable Ringling Museum of Art, Sarasota, Florida,* 1983.

Gaddis, Eugene R. *Magician of the Modern: Chick Austin and the Transformation of the Arts in America.* New York: Knopf, 2000.

Gilbert, Creighton. *The Asolo Theater,* 1959.

Janson, Anthony F. *Great Paintings from the John and Mable Ringling Museum of Art.* New York: The John and Mable Ringling Museum of Art in association with Harry N. Abrams, 1986.

Kershaw, Norma, ed. *Ancient Art from Cyprus: the Ringling Collection,* 1983.

The Museum that John Built, gallery guide, 1959.

Nakamura, Toshiharu, ed. *European Baroque Paintings from the John and Mable Ringling Museum of Art and the Bob Jones University Museum and Gallery.* Tokyo: Tokyo Shinbun, 1997.

Robinson, Franklin W., William H. Wilson, and Larry Silver. *Catalogue of the Flemish and Dutch Paintings, 1400–1900,* 1980.

Smith, Roberta. *Abstraction in Question,* 1989.

Sobotnik, Kent. *Central Europe 1600–1800,* 1972.

Spike, John T. *Baroque Portraiture in Italy: Works from North American Collections,* 1984.

Suida, William E. *Catalogue of Paintings in the John & Mable Ringling Museum of Art,* 1949.

Sutton, Denys. *Masterworks from the John and Mable Ringling Museum of Art, the State Art Museum of Florida.* New York: Wildenstein Galleries and the Tampa Museum, 1981.

Tomory, Peter. *Catalogue of the Italian Paintings before 1800,* 1976.

Vilas, C.N. and N.R. Vilas. *The John and Mable Ringling Museum of Art,* 1942.

Walk, Deborah W. *A Guide to the Archives of The John and Mable Ringling Museum of Art: the State Art Museum of Florida,* 1994.

Weber, Nicholas Fox. *Patron Saints: Five Rebels Who Opened America to a New Art 1928–1943.* New York: Alfred A. Knopf, 1992.

Weeks, David C. *Ringling: The Florida Years, 1911–1936.* Gainesville, FL: University Press of Florida, 1993.

Wilson, William H., ed. *Papers presented at the International Rubens Symposium: April 14–16, 1982, the John and Mable Ringling Museum of Art, the State Art Museum of Florida,* 1983.

Wilson, William H. *Dutch Seventeenth Century Portraiture, the Golden Age,* 1980.

INDEX OF ARTISTS